Everybody's left this house. It's in absolute ruins and the dog doesn't even know where to go. He's alive and he's just sitting there on a piece of the house. He was there at 11:00 or whatever it was when I showed up and he was there at 3:00 when I left. I mean this guy was sitting there...staring at his house.

So. . .
you're just not there very often when something like that happens
and it just — I think it leaves you, I mean, that is such a big thing. You know, it just sticks with you.

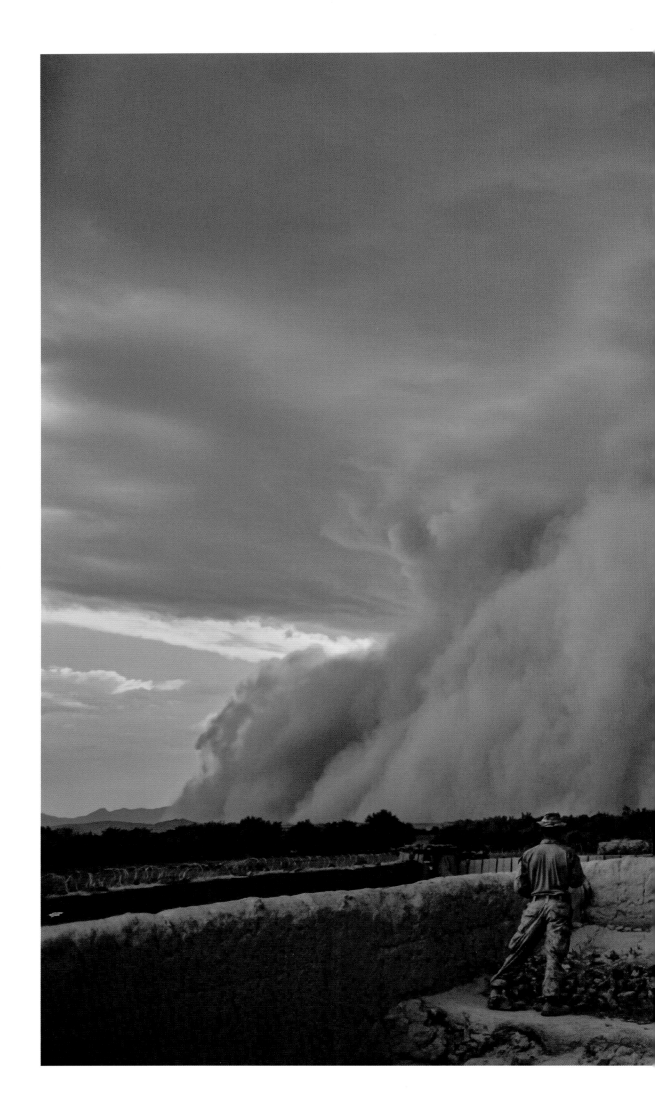

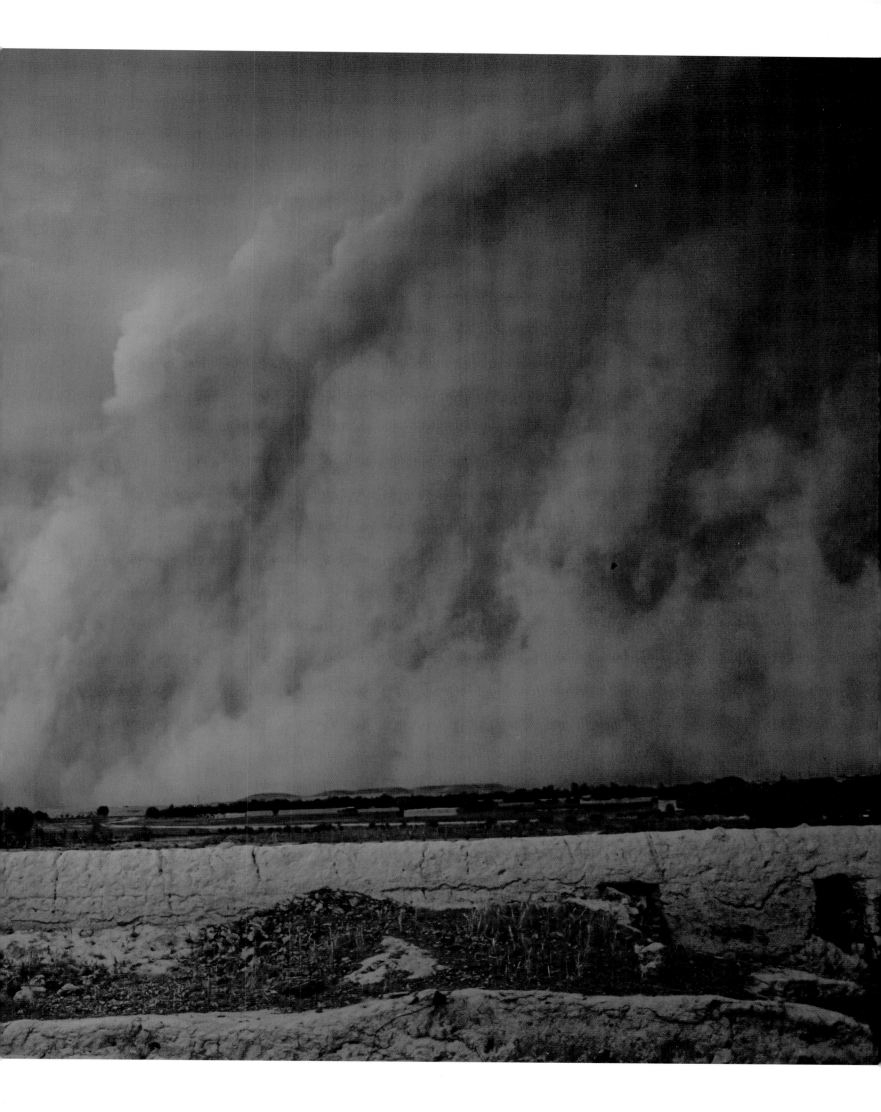

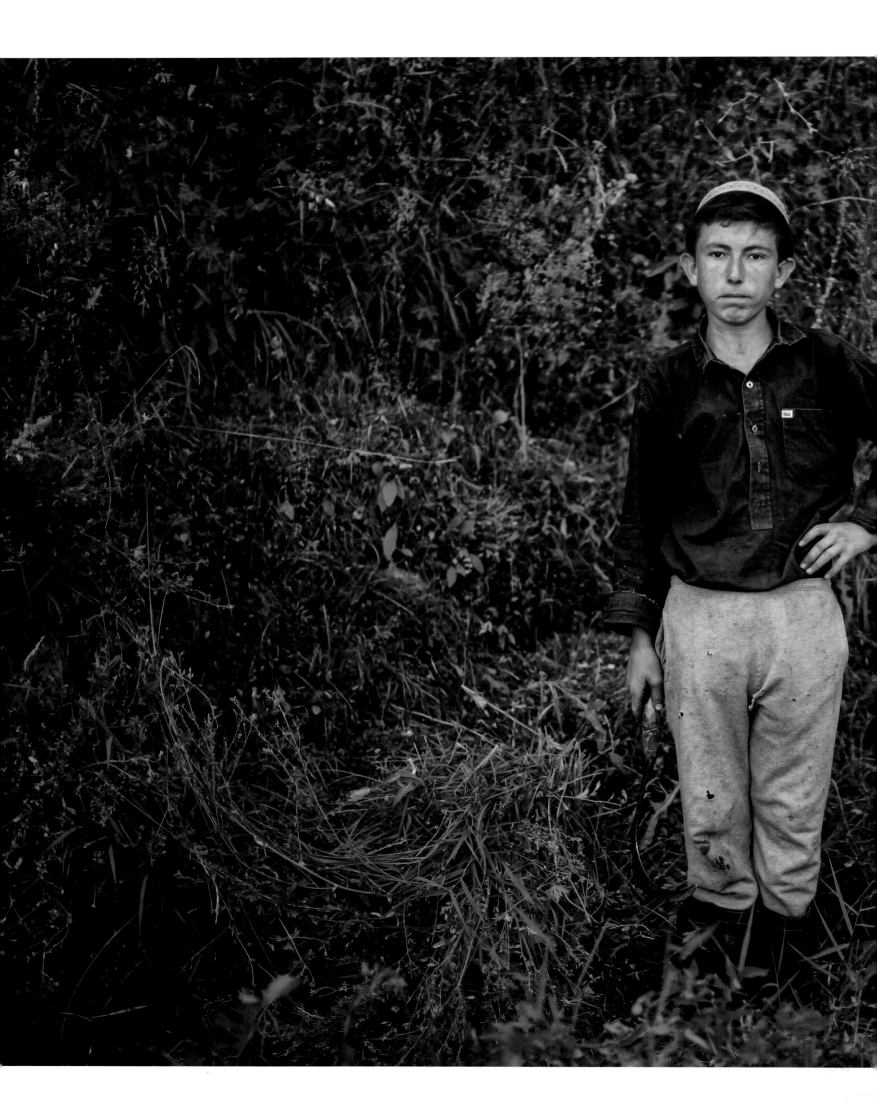

PICTURES ON THE RADIO

The Work of NPR Photojournalist

David P. Gilkey

n p r

pH powerHouse Books
Brooklyn, NY

TABLE OF CONTENTS

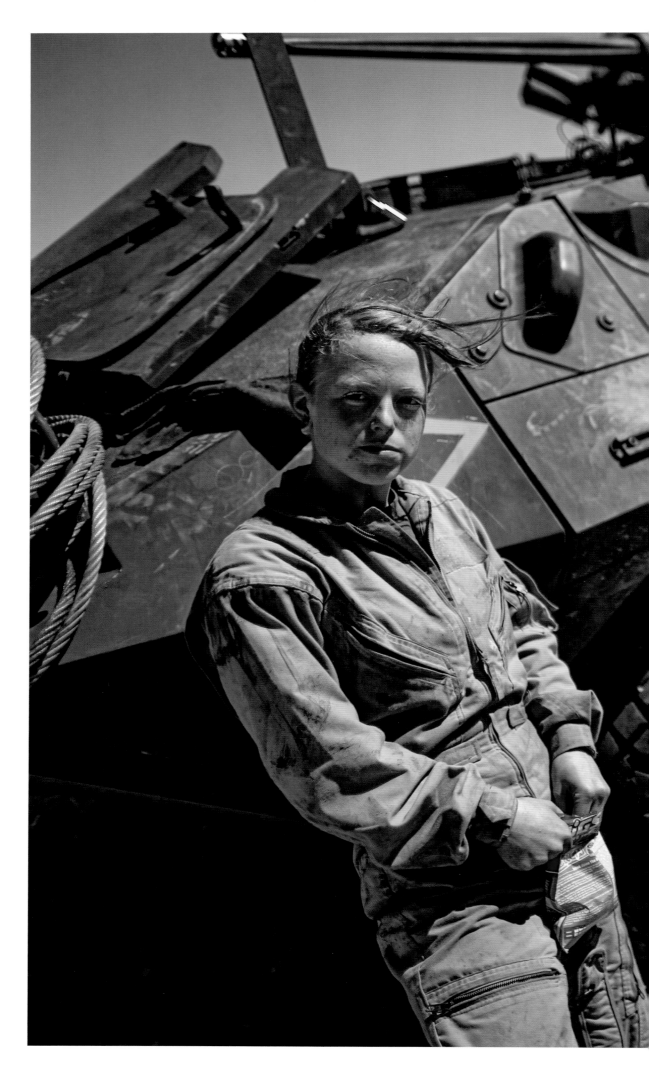

Marine Lance Cpls. Brittany Holloway and Brittany Dunklee prepare for an exercise in the Mojave Desert. California, March 2015.

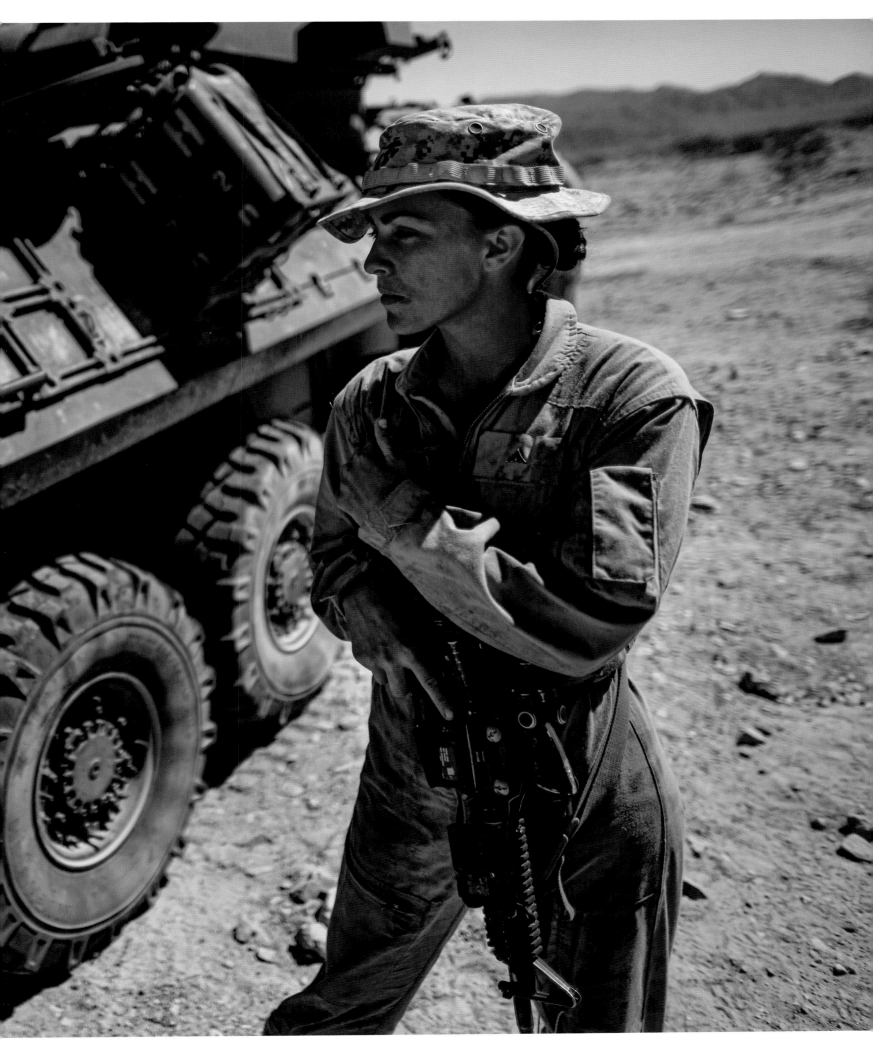

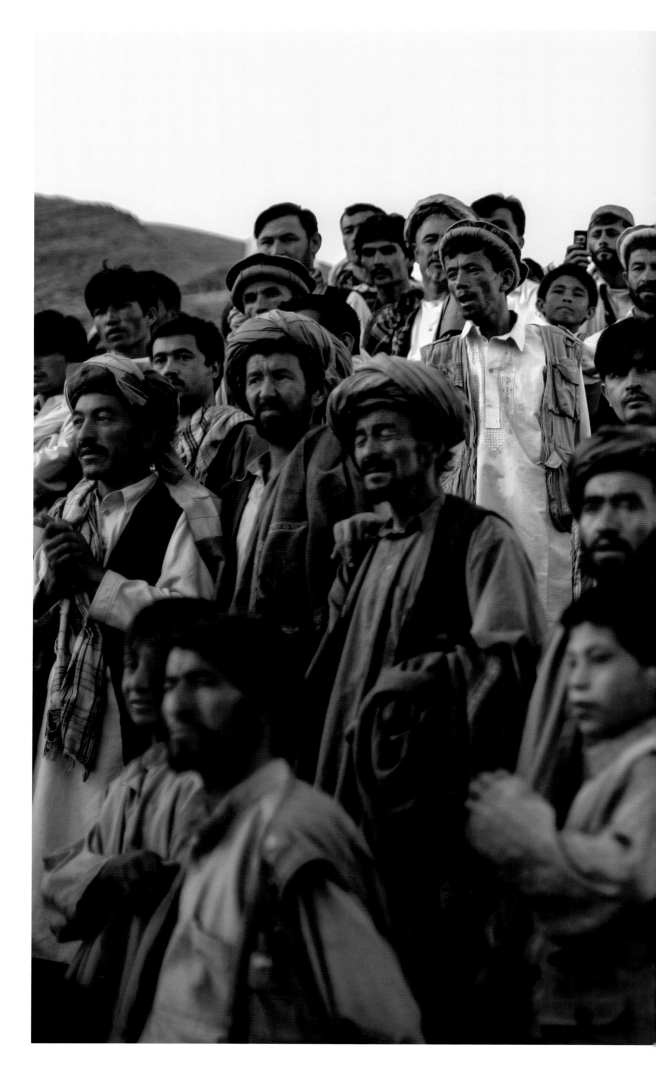

Afghan Ismailis, a minority sect of Shiite Islam, attend a presidential campaign rally for Hamid Karzai in Dar-e-Kayan. Baghlan, Afghanistan, July 2009.

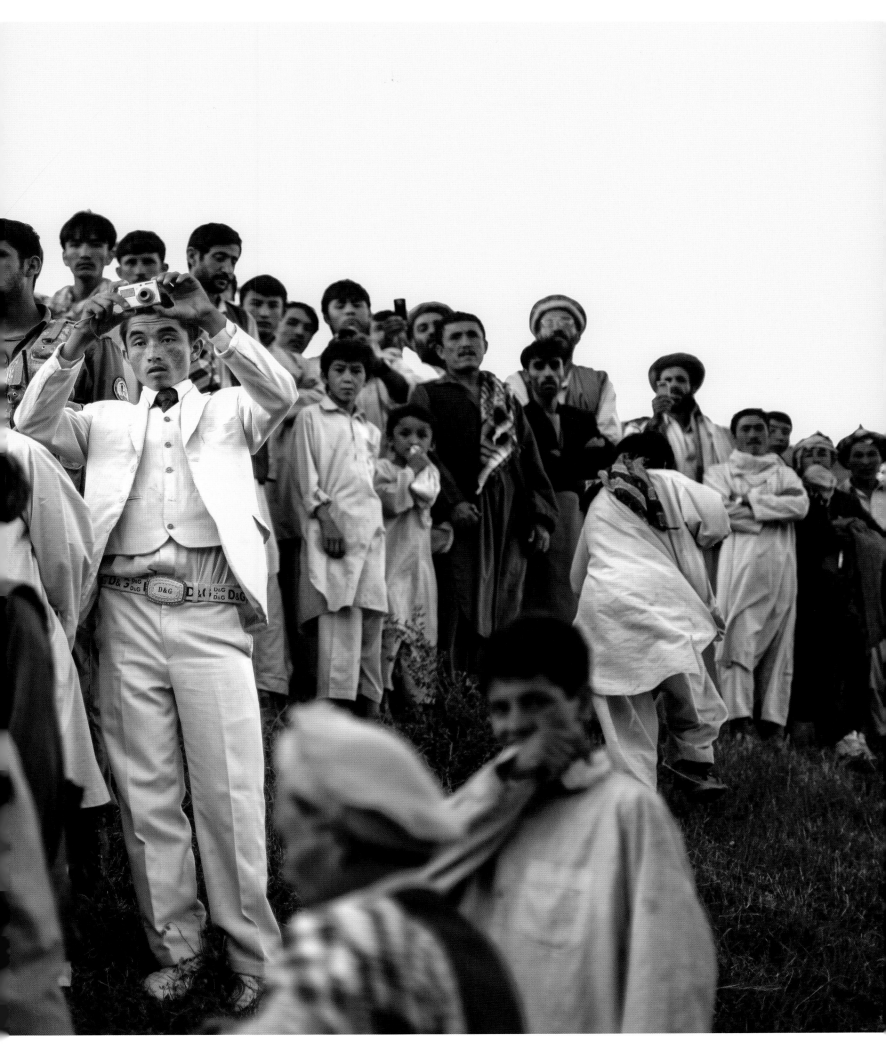

DAVID P. GILKEY

Two decades into David's career, newspapers were in free fall, and he went to work for a radio network. The wisecracks got so common that David had a ready response.

"How do you see pictures on the radio?"

David would lean in like he was going to tell you a secret.

"If you listen really hard, you can see the pictures."

Up in the mountains that border Pakistan, in the autumn of 2010, David Gilkey and I piled into a Black Hawk helicopter with some soldiers from the 101st Airborne. The first sergeant had just told everyone to expect a hot landing zone, full of Taliban. Insurgents had hit a giant twin-rotor Chinook helicopter with a rocket-propelled grenade, and the dead bird was taking up most of the dirt helipad. Only one of our helicopter's skids would hit the ground; the other one was going to wobble in midair off the cliff, in pitch darkness.

"Make sure to go out the right door," he said.

When we stumbled out of the chopper, it was so dark I couldn't see my feet as they did touch ground; no moonlight or even stars shining above. But David reached into his backpack and carefully pulled out the military-grade night vision goggles he'd been lugging around since his time in Iraq.

Then he led me, like a blind man, along a gravel track through the hills for about a mile, until we were safe.

The Afghans had a saying for guys like David: "He would give his head for a friend." It's not the sort of thing you expect to have to prove — whether someone will share his last bottle of water with you on the side of a mountain in a combat zone. David made a lot of friends that way over three decades in the world's most inhospitable places.

He would have hated this. Not just getting killed by the Taliban; that's a risk David had made his peace with along the way. He hated being the story, letting ego overshadow the mission. He had the photographer's trick of fading into the background of the scene (all 6 feet of him), and almost never liked pictures taken of himself. He did love to tell a good yarn among friends, though, almost as much as making a beautiful photograph. And he had a hell of a story.

David Patrick Gilkey was born in 1966 in Oregon. He was adopted, and never had an interest in meeting the pair who gave him up — at least one of whom, David deduced, was a raging alcoholic. David considered Dick and Alyda Gilkey his only real parents, and living saints for putting up with his wild childhood and later his penchant for dan-

gerous pastimes. When David did behave, Dick would let him mess around in the basement darkroom as a reward. Even from those early days, David knew he wanted to be a photojournalist, though another boyhood dream was to drive an 18-wheeler. After a summer internship with the *Daily Camera* in Boulder he came home to Portland and told his parents they were wasting their money paying for college. David quit school and flew off to South Africa to join a group of the world's most famous photojournalists covering violence in the townships.

A half-dozen wars later (Somalia, Rwanda, Kosovo, Sudan, Afghanistan, Iraq), David hit his stride working for the *Detroit Free Press*. He followed a Marine reserve unit from Michigan through its entire deployment to Iraq and home again. That coverage won prizes for the newspaper, and eventually an award from the Marine Heritage Foundation for David. He had also taken the time to get himself together. During an assignment to cover Detroit legend Kid Rock, David woke up one morning, hung over on the tour bus, to some friendly advice from one of the crew. He told David that if he didn't go to rehab he was gonna die. David got sober in 1999 and never had another drink.

Getting off the booze did nothing to dull David's love of life. Anything really highbrow or really low brow, either Michelin star or Taco Bell — he despised the mediocrity in between. On the same trip that he showed me the menu he'd saved from Minibar in Washington, he insisted we eat a dinner of microwaveable treats at a 7-Eleven in rural Virginia. David wore tattered baseball caps and double-bib canvas jeans but spent money compulsively on bespoke boots and handmade leather bags. While subletting a friend's *rented* apartment in Detroit, he renovated the place because the drop ceiling so offended his sense of design. And David's taste for adrenaline never faded, either, whether that meant pointing his skis straight down from the summit of Mount Hood or stealing an abandoned car to cruise post-invasion Baghdad.

The loyalty to his art and to his friends, the taste for adventure, and the fact that he secretly enjoyed eating MREs and sleeping on a broken cot in the supply shed: It all made

David the perfect photojournalist for the war on terrorism. He turned the grind into a sort of meditation.

"Life in a rock pile. The view of nothing," David wrote. "Hot water, not for showering, but for drinking. Dirt walls, cement walls, mud walls. Never flushing a toilet. The blue sky over a gray world below. Coming and going. The simplicity of it all can actually be charming."

David eventually stopped covering Iraq — his bald head and wrestler's physique made him look so much like a Special Forces sergeant that it was hazardous for him to do unembedded reporting. He turned the limitation of embeds into art, with a series of photographs framed through the tiny bullet-proof Humvee windows. Anyhow, David never loved Iraq. He loved Afghanistan.

Afghanistan had grabbed hold of David from the moment he trekked in through the northern mountains on assignment for Knight Ridder, two weeks after Sept. 11, 2001. He loved the fierceness of daily life there. Every ride in the car was a game of chicken with every other driver on the road. Flying a kite is a blood sport in Afghanistan, but even the warlords write poetry. All the friends David made there had at some point been stripped down to a basic struggle for survival. He knew how to treat that with the right combination of respect and profane humor. Several families took him in like a long lost son. David told them he felt more at home and more alive in Afghanistan than America.

By the time he started working for NPR in 2007, Americans were tired of bad news from Afghanistan, and Afghans had seen thousands of American visitors come and leave, long on promises and short on time. The networks were pulling out as the conflict lost its TV ratings. David felt honor-bound not to let Americans forget there was a war on and that young soldiers were still going through hell. Afghanistan also gave David a chance to be the best war photographer in the world, living on the edge of survival. Mostly though, I think he went back because he had promised his friends. David's return year after year proved something to them. He met their high Afghan standard of loyalty. American troops he traveled with gave him the same recognition.

Not that he wasn't scared. David would show up at the NPR bureau in Kabul where I lived with my wife. We'd hug him and then watch as he obsessively unpacked and repacked his bags for an embed — the gadgets, first-aid kit and tourniquets, and lanyards to hang his two heavy Canons off the straps of his bulletproof vest. David had insisted NPR replace all its old flak jackets with new "plate carriers" like the Special Forces were using. The gear was not just an extension of his shoe-and-bag-fetish, and David wasn't a military wannabe. He picked it out carefully because he wanted to come home from these trips. When the job was done, he'd get the

hell out. David wasn't reckless. He told colleagues he was pushing through the fear, and they could too. That's what David was doing when he died.

Proud as we were, his friends and family wanted David to quit covering war — he'd done more than his share. The job at NPR was letting him branch out to cover domestic stories, to show that he didn't need the drama of bullets flying to make compelling photographs. He was still the network's best smoke-jumper, covering earthquakes in Haiti and Japan, a typhoon in the Philippines, Ebola in Sierra Leone. But he was also reporting stories on wolves in Montana and documenting a journey on the Trans-Siberian Railway. He went to India to report on climate change and pollution along the Yamuna River. In San Diego, he used a pop-up tent studio to make dignified portraits of homeless veterans and their families. His photographs were the flagships of NPR's growing multimedia presence. David realized his goal of putting pictures on the radio and making NPR's stories into visual art. A big stack of awards shut up the skeptics.

He wouldn't stop going to Afghanistan, though. David complained it had become a black box, a perpetual war with special operations forces doing night raids and no way for the American people to get the ground truth. When U.S. officials said in 2014 that bases were being shut down and handed over, David went to document it. When they said in 2015 that American troops were no longer going out on combat missions, David went to make sure. And when they said the Afghan forces had taken control of Helmand — a province where David had seen combat with U.S. Marines — he knew what he needed to do.

"We're staying with them, we're sleeping with them, we're eating with them, and we're going on patrol with them. Every day," he said just before he left for Afghanistan. "It's a look you only get by going there."

David was embedded with Afghan commandos when the Taliban ambushed his convoy on June 5, 2016. He died alongside an Afghan friend and colleague, Zabihullah Tamanna.

David used to say his zoom lens was his feet. He knew he needed to get close enough to see the fear or the rage or the love or the quiet dignity on the faces of people far away. If he got close enough, he could bring us with him for a moment. And if you went there with him, he thought, you would come back different.

"It's not just reporting. It's not just taking pictures. It's 'Do the visuals, do the stories — do they change somebody's mind enough to take action?' " David said. "If we're doing our part, it gets people to do their part. Hopefully."

— Quil Lawrence

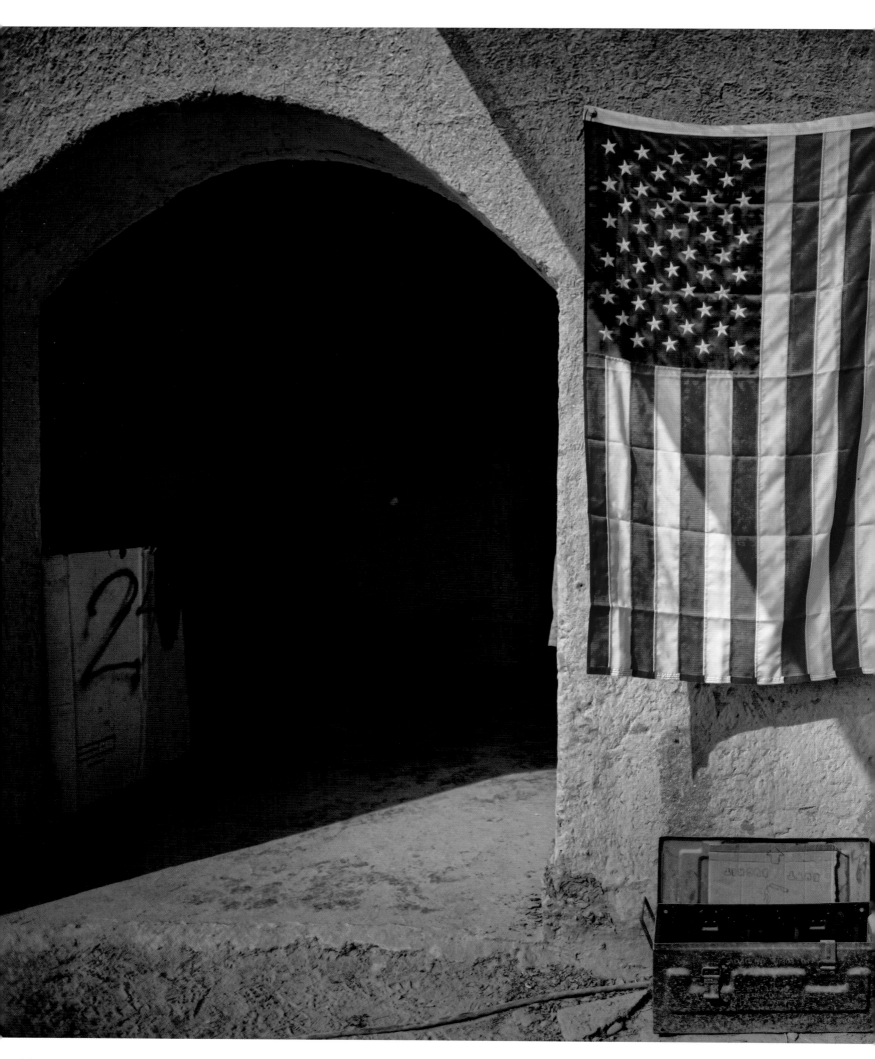

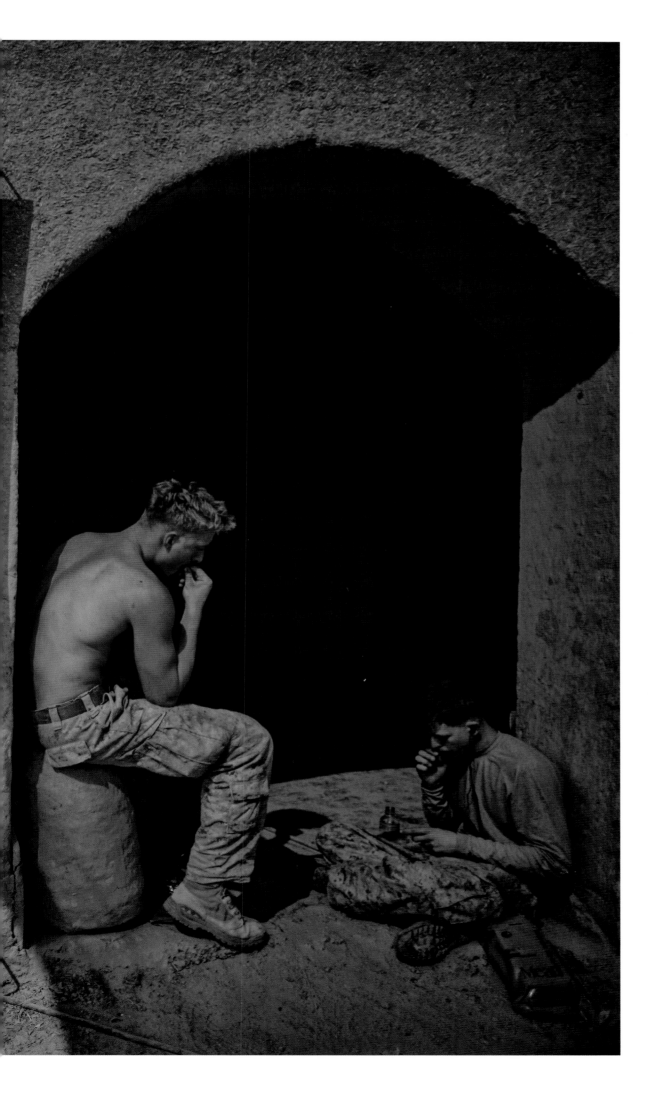

Marines from the 2nd Battalion,
8th Marine Regiment (2/8) take a
break between patrols
at their outpost in Helmand.
Afghanistan, October 2009.

PICTURES ON THE RADIO

Our son, David Gilkey, and his Afghan interpreter and fellow photojournalist, Zabihullah Tamanna, were armed with only their cameras when they were killed by a Taliban ambush in June 2016.

As David's parents we not only miss his presence, which was all encompassing, but also soon realized that because he was gone we would no longer see the kind of images he created.

We want this book to remind everyone of David's ability to use his camera to draw us into events and parts of the world that we would probably never see. His ability to capture the humanity in stories from the earthquake in Haiti, the tsunami in Japan or the Ebola epidemic in Africa and hold the viewer's attention was his unique talent.

David learned about photography before he learned to walk. Since photography was his dad Dick's first love, we had a darkroom in our basement. It would have been Dick's profession, but in those times it was very difficult to make a living with photography. Instead he used his talents to teach and later as a school administrator.

It was a special reward for the young David to be allowed to see the magic his dad did in that little windowless room in the basement. He and his sister knew they were not to go in there by themselves and not to open that door without permission.

We learned later that when David was sent to the basement to play with all the toys down there, he would sometimes look through the prints his dad had stored in a cabinet next to the darkroom. It was during those years that David decided he wanted to be the best photographer in the world.

Dick always listened to National Public Radio when he drove David to school. Listening from the back seat, David decided he would like to work at NPR someday.

David was only 50 years old when he was killed, but he had already achieved both of those goals. He had succeeded in creating the visual equivalent of NPR's famous "driveway moments," when the listener hears a story that is so compelling that if you drove home before the story ended you would stay in your car to hear the end. Judging by the awards he received for his work (listed in the back of this book), he was recognized as one of the best photographers in the world.

Awards and honors were important to David's friends and family, but not to David. That isn't why he did what he did. Once when David was home he received a phone call. When he hung up, I asked him what that was all about. He said, "I got another award. A Murrow something." I said, "An Edward R. Murrow Award?" "Yeah, I think that was it." I said, "David — that is a BIG deal!" He shrugged his shoulders and went on his way.

I think the award he was most proud of was the Sgt. Maj. Dan Daly Award, from the Marine Corps Heritage Founda-

tion for photographing the lives of Marines in a combat zone. David was the first civilian to receive it.

What drove David was his desire to remind us that the war was still going on and help us understand its effects. The Taliban attacked him as an enemy, but we know they took the life of someone who returned to Afghanistan because he loved their beautiful country and wanted to use his camera to tell the world what was going on there. His highest hope was that when his images showed tragic events and conditions, people would look and want to do something.

David always did things wholeheartedly — he skied fast, skated fast, rode his bike fast, took risks that were foreign to me. When he was a teenager I remember telling a friend, "I don't think this kid will live beyond 25." When his career as a photojournalist expanded, as his mom I would look at his work and think, "Now where would David have to be to take that photo?" The answer would be things like

climbing Half Dome, or in the middle of a combat zone, or with people who have Ebola. As we put the clues together and think of the boy we knew and the man he became, we marvel. The miracle of David the man is that he lived as long as he did.

As we read how he has affected people with his incredible photos and the wonderful friends he made all over the world along the way, we are amazed and very proud that he was our son.

Here was a man whose work and presence affected so many, a man who went into combat zones armed only with a camera to tell the stories he felt were important for people to know. A man who lived twice as long as many thought he would. We celebrate his life and we are grateful that he was in our lives for 50 years, but we are grieving for ourselves because we loved him and wanted him longer.

— Alyda Gilkey

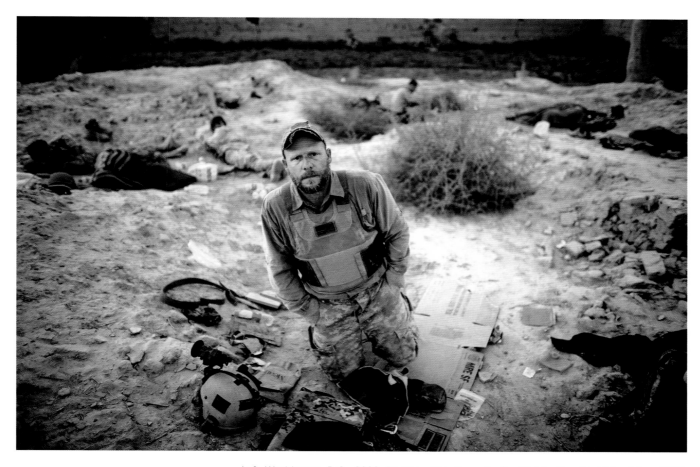

Left: Washington, D.C., 2008. Photo by Chip Somodevilla. Middle: Surobi, Afghanistan, 2008. Photo by Ivan Watson. Above: Helmand, Afghanistan, 2009. Photo by Carlos Boettcher.

A Marine with the 1st Battalion, 5th Marine Regiment (1/5) crouches in waist-high wheat while on patrol in Sangin District. Helmand province, Afghanistan, May 2011.

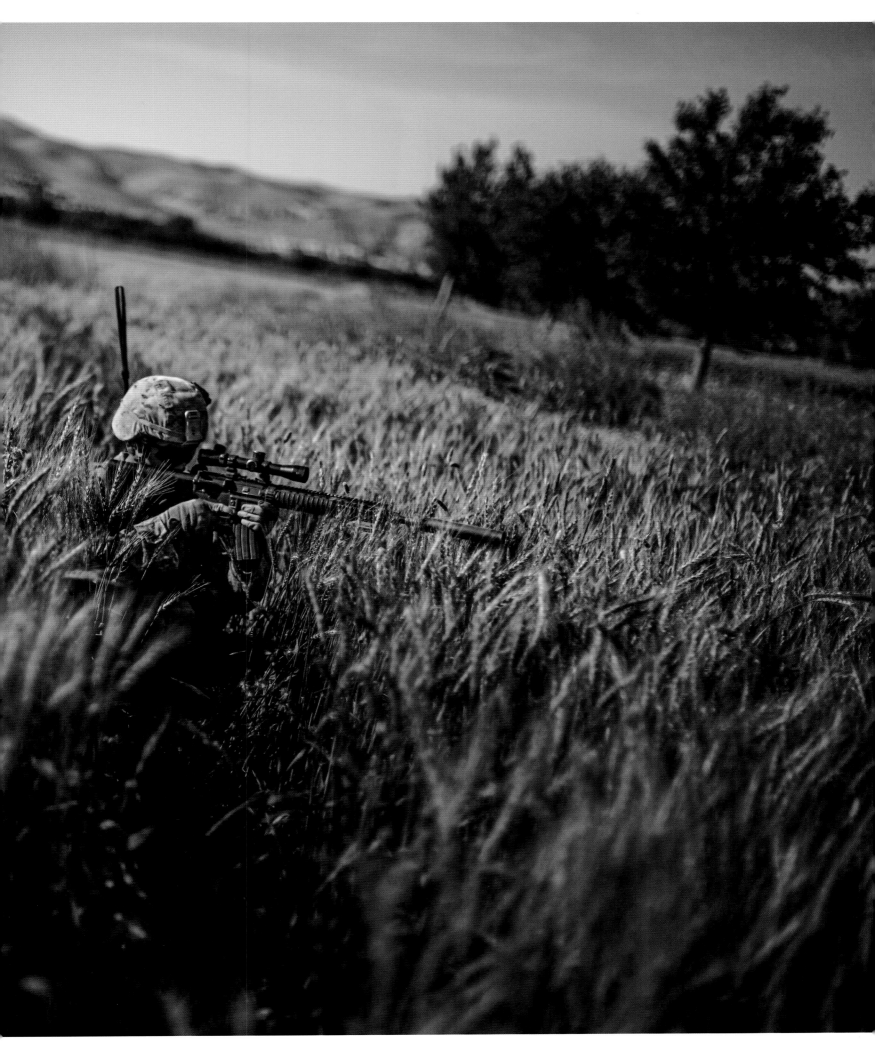

DEPLOYED. David Gilkey crossed into the northern mountains of Afghanistan two weeks after Sept. 11, 2001, and he never stopped covering the country and the conflict.

He made lifelong friends with Afghan fixers and journalists, who treated him like a brother (the beautiful photos he made of life in Afghanistan are in the last chapter of this book). The other side of his work was the front line. Over 15 years embedding with U.S. Marines and soldiers and Special Forces, with Brits and with Afghan commandos, David captured the arc of the war — from the quick collapse of the Taliban and the jubilant liberation of the country to the hardening of the resistance and full-scale guerrilla war.

In 2009, by then working for NPR, David flew into Helmand province on the largest American helicopter assault since Vietnam. He caught the fighting close up as Marines secured major towns and then small villages. After losing lives and limbs to IEDs, the troops learned to avoid roads and march straight across hard-baked fields, over stone vineyard walls and through canals.

Remote and barely populated, Helmand became the focal point of the U.S. troop surge in Afghanistan. David watched the Marines' Camp Leatherneck transformed from a dusty outpost into a city-size base with paved roads and stone buildings, as Americans pumped out into the desert.

David loved the company of soldiers and Marines. Partly because many were just like him: smartasses who were real, earthy and profane. He would often tell us — laughing until he could barely speak — their stories, none of which could be repeated on the radio.

He also respected their courage, their dedication to one another, and how they survived grueling deployments in miserable conditions. David's lens would connect folks back home, if only for a moment, to their months of hardship and moments of horror.

That all comes through in his pictures. The bravado and the exhaustion, and the fear.

The respect was mutual — one Marine told us David was among the first adult men he'd ever experienced outside of the military: "Y'all voluntarily went with us into every man's worst nightmare. No training, no brotherhood. Just to share a story. I was shocked, and perplexed. It taught me that civilians can be warriors too."

On his last trip to Afghanistan, David documented the ebbing footprint, as the U.S. pulled back out — turning tamed areas over to the Afghans, who then ceded them again to the Taliban.

A few days before David was killed, soldiers asked him if he wanted to go back to Camp Leatherneck in Helmand. Now it was a ghost town nicknamed "Chernobyl," and the soldiers would go on "Zombie Runs" to find abandoned supplies, everything from paper cups to air conditioners. Abandoned laundry fluttering on shock-cord clotheslines, chow halls open to the elements, dust blowing through empty barracks.

Chernobyl. Zombie Run. David kept repeating those words. He hopped in the truck and he was off, capturing his last, haunting pictures.

— Tom Bowman and Graham Smith

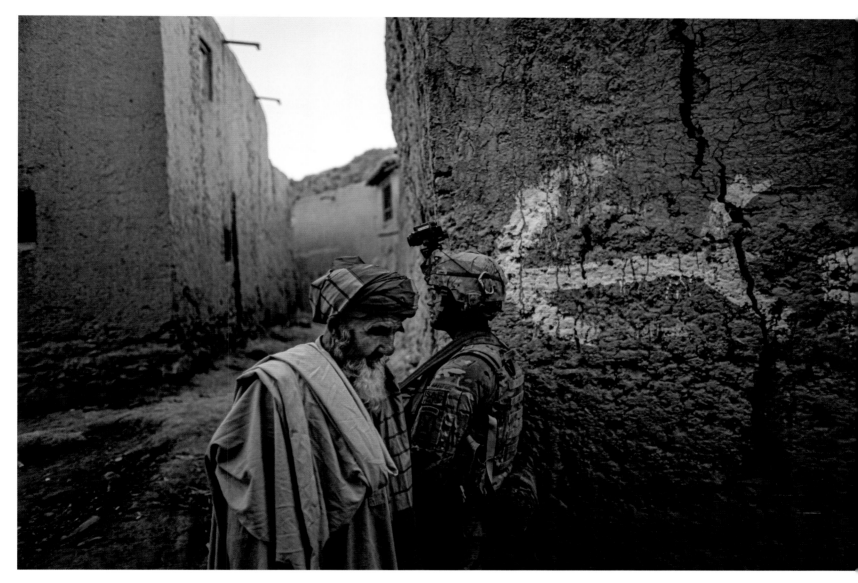

A local man crosses paths with a Army soldier from the
10th Mountain Division as they move through the central bazaar
in Charkh District. Logar province, Afghanistan, April 2011.

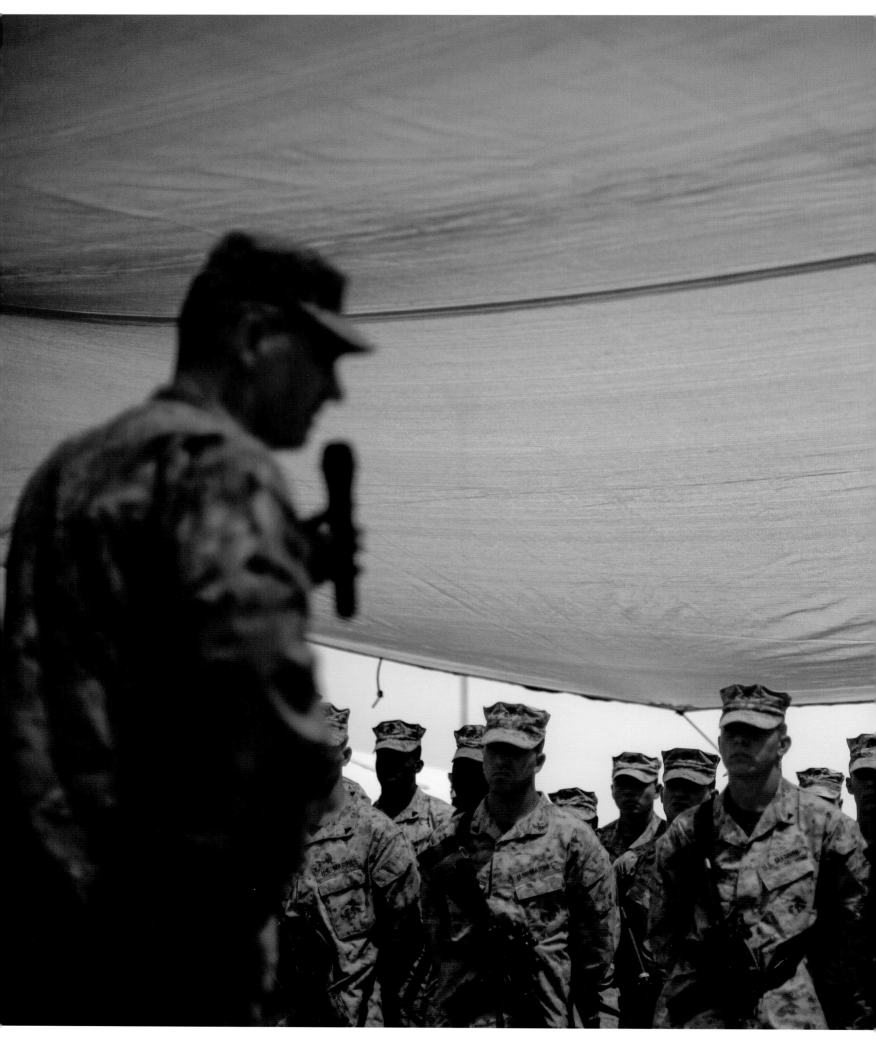

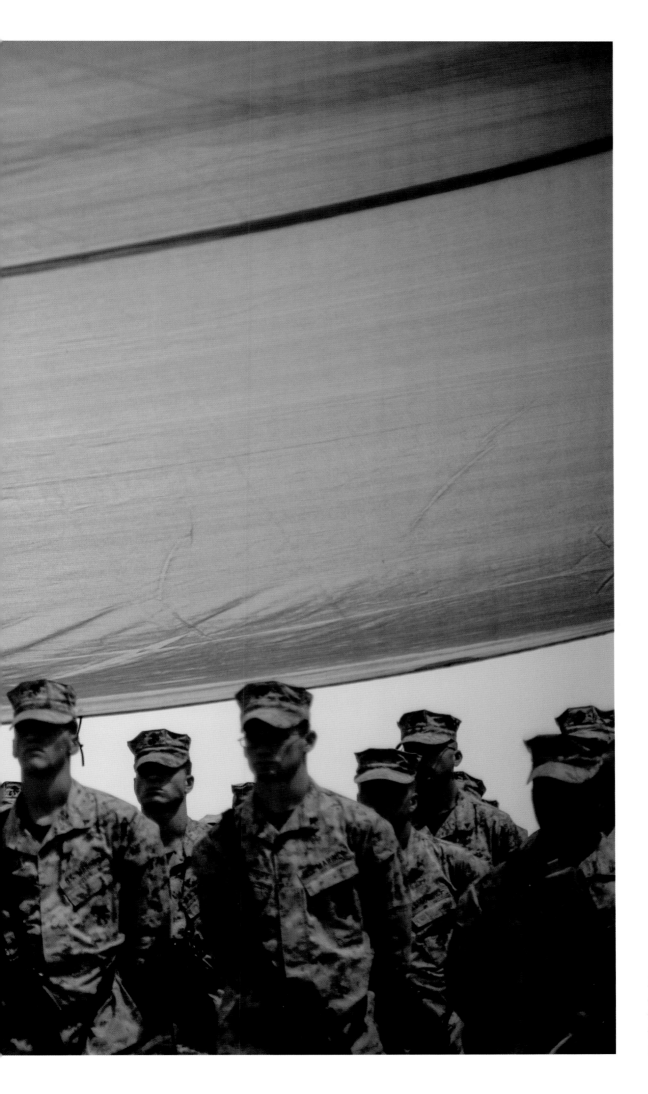

Army Lt. Gen. David M. Rodriguez, deputy commander of U.S. forces in Afghanistan, talks to troops at an air base in southern Afghanistan. June 2011.

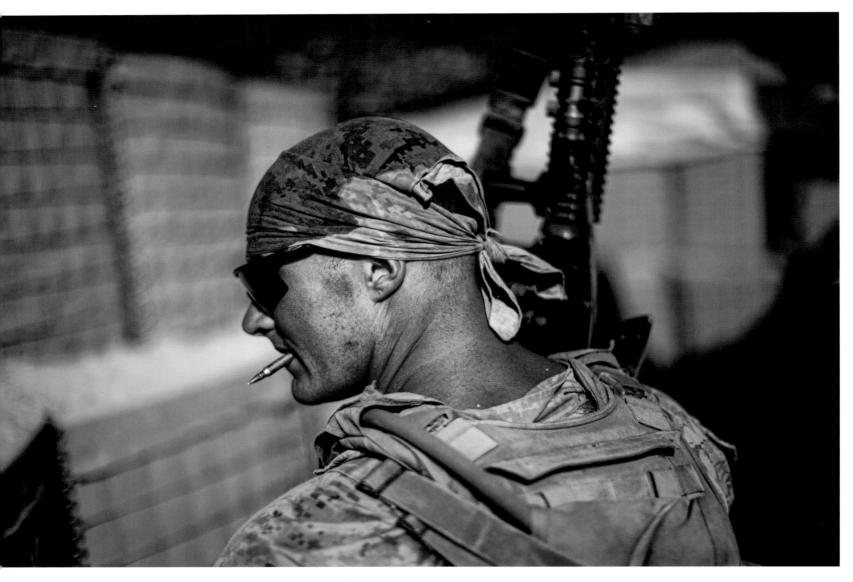

Marine Lance Cpl. Zachary Rash from the 2/8 holds a round in his
mouth after clearing it from his rifle at a patrol base in Hassanabad.
Helmand province, Afghanistan, October 2009.

Well, these things start with a crack. It's someone shooting at you.
It sounds very different. I'm sure most people have been around a weapon when it's fired.
It's a very, very different noise when it's being fired at you.
 The first thing is that everybody is in a ditch or on the ground and trying to get as low as possible.

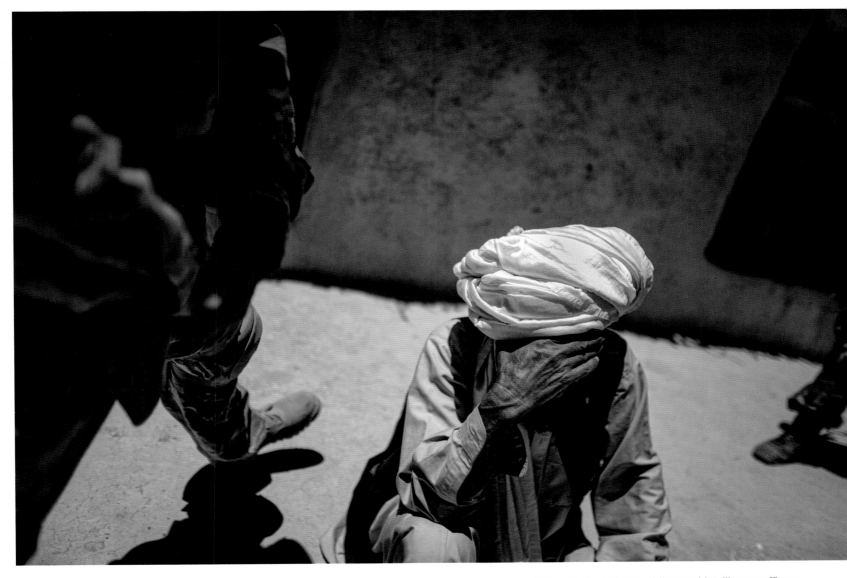

Afghan National Army soldiers and intelligence officers question the father of a suspected Taliban collaborator wanted for his involvement in building and placing bombs. Ghazni province, Afghanistan, May 2012.

But once the Marines establish which direction the fire is coming from, I mean, it's a very well-choreographed response to it.

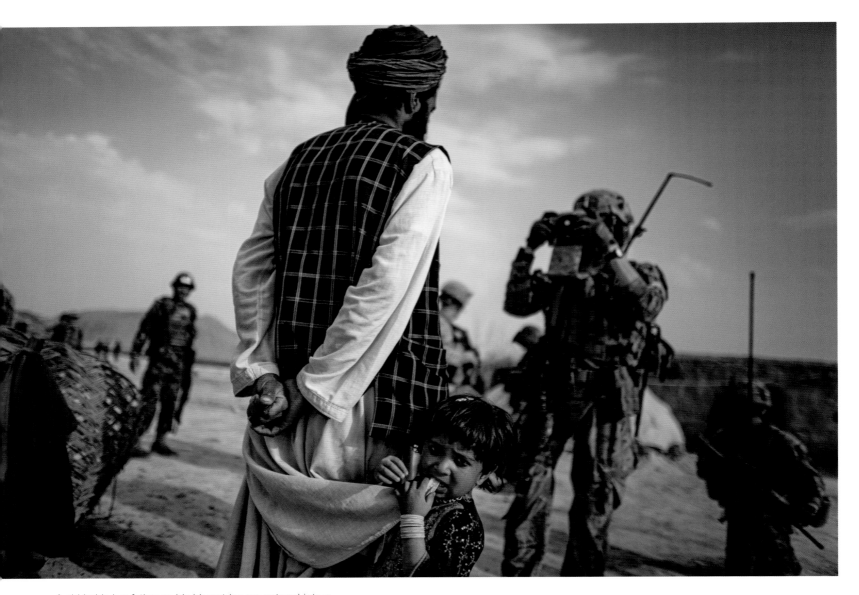

A girl holds her father as his biometrics are entered into a
database of fighting-age males that soldiers encounter,
on joint patrol with U.S. and Afghan National Army (ANA)
troops. Kandahar province, Afghanistan, May 2012.

And I just sort of move with them and almost copy their actions, short of shooting a weapon. I'm shooting a camera instead.

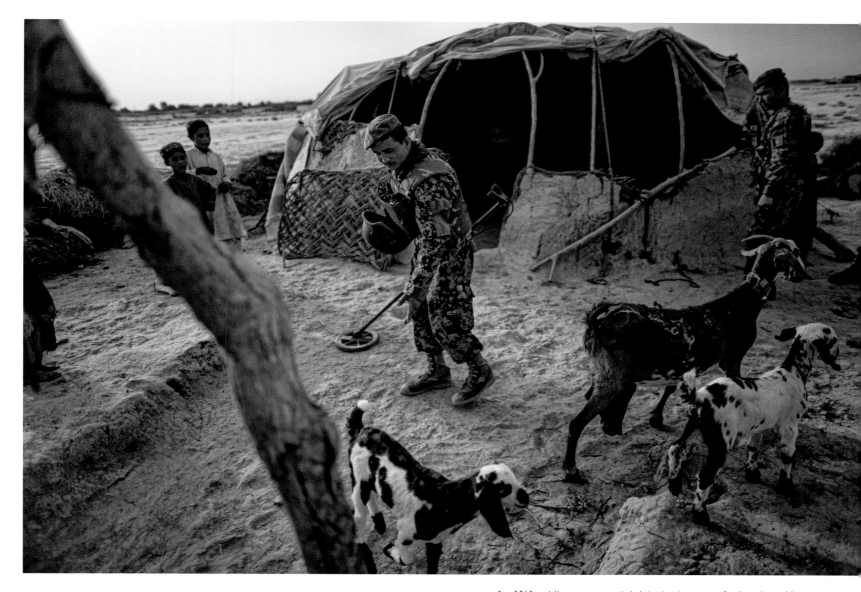

An ANA soldier uses a metal detector to sweep for bomb-making materials near Zangabad during a joint patrol with soldiers from the 2nd Infantry Division. Kandahar province, Afghanistan, May 2012.

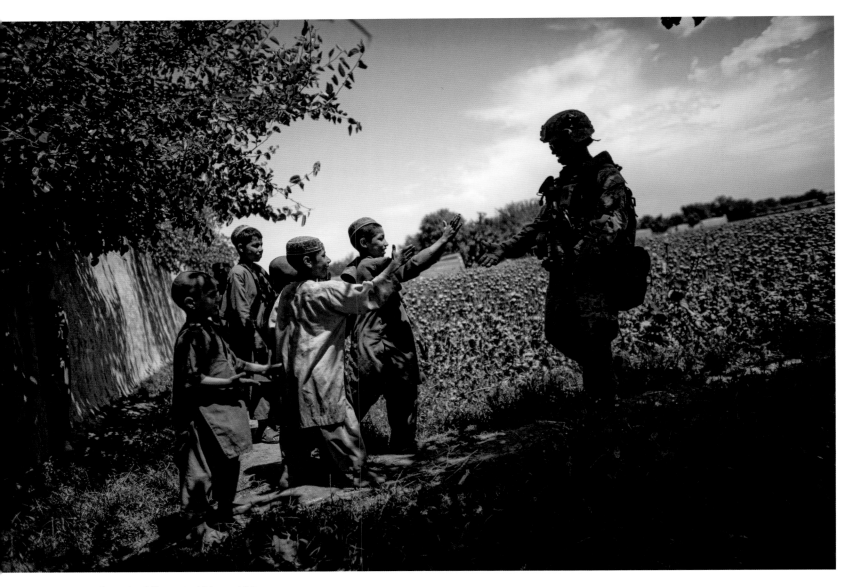

A Marine from the 1/5 greets Afghan children
while patrolling irrigated poppy fields in Sangin District.
Helmand province, Afghanistan, May 2011.

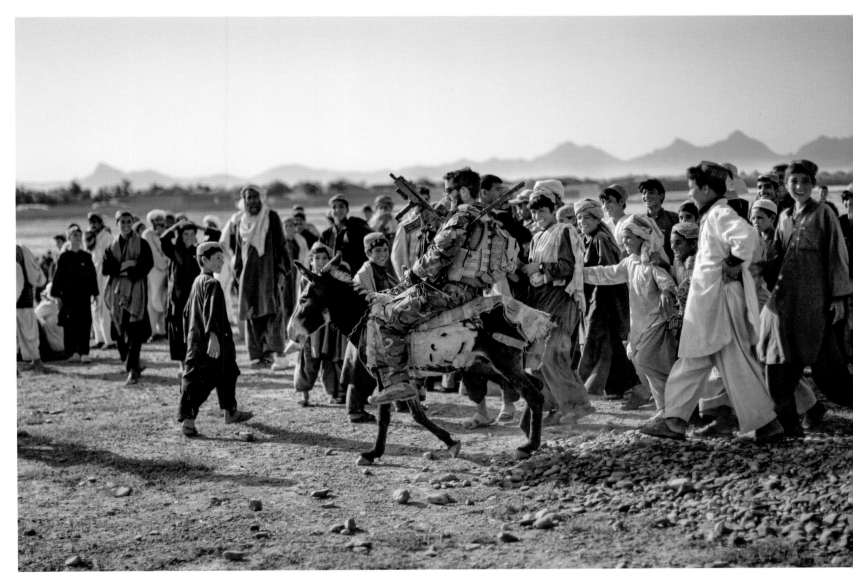

Army Special Forces Master Sgt. Geoff Dardia rides a donkey and jokes with villagers in Kuhak. The Green Berets are fighting the Taliban and working with locals to rebuild schools, expand health clinics and strengthen local police. Herat province, Afghanistan, May 2009.

Soldiers from the 82nd Airborne Division take cover by a mud-brick building in Giro District as they try to spot the location of insurgents firing at them. Ghazni province, Afghanistan, May 2012.

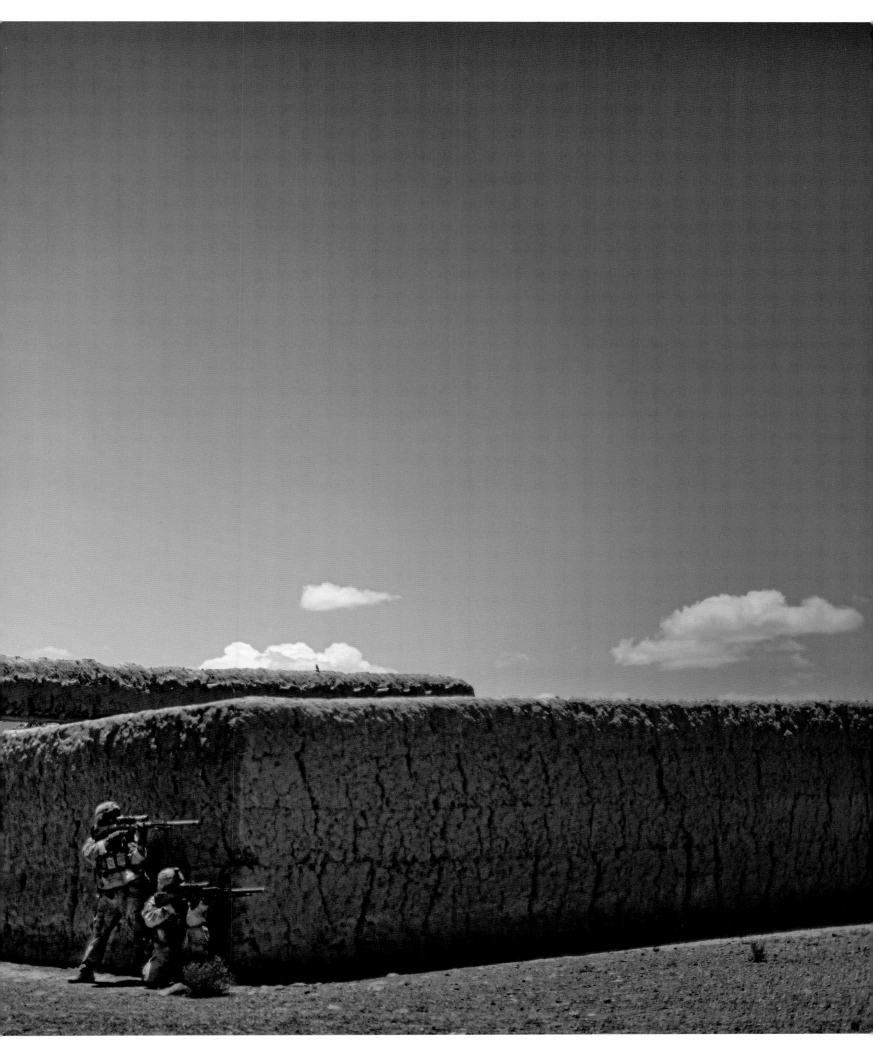

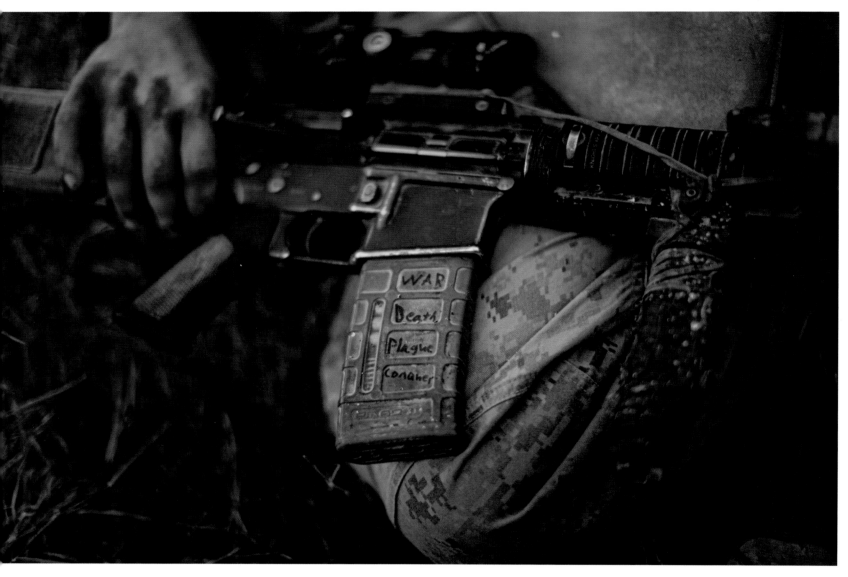

During a patrol near Koshtay, a Marine with the 2/8 holds his
M16 rifle. The Four Horsemen of the Apocalypse are written on
the magazine. Garmsir District, Afghanistan, October 2009.

Every time we left the wire, every time we went out, you were going to get in a fight.
Or somebody was going to step on an IED. This was very much super, super kinetic —

a lot of bullets flying through the air, a lot of things exploding.

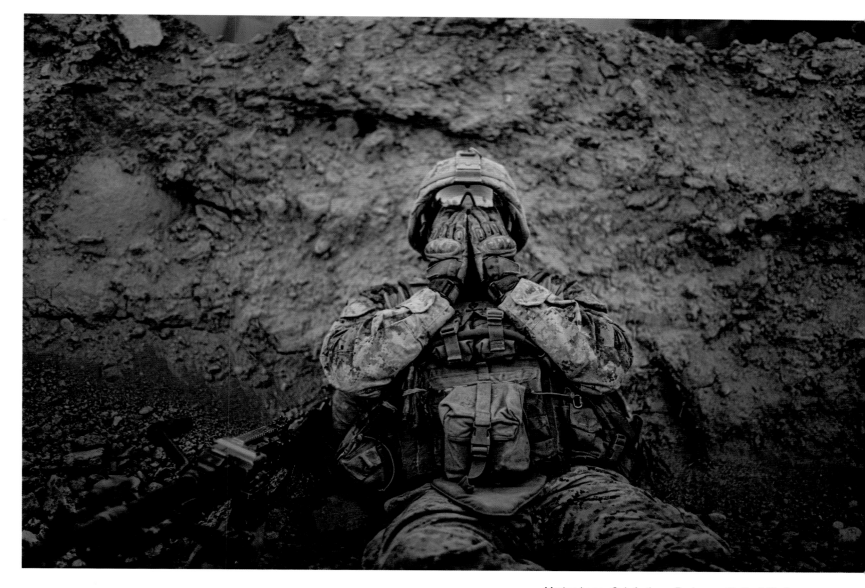

Marine Lance Cpl. Anthony Espinoza with the 1/5 wipes sweat out of his eyes at the end of a patrol on a 100-degree day in Sangin. Helmand province, Afghanistan, May 2011.

Living like that sucks. Eating MREs day after day, sleeping— on a good night, when it's 110 degrees, in a steel can because they're shooting mortars at the base every night— that's a hard, hard way to live.

I think one of the things that, as this war has gone on, is people have started to tune it out. I think people at home need to see that, you know, that's not a pleasant experience.

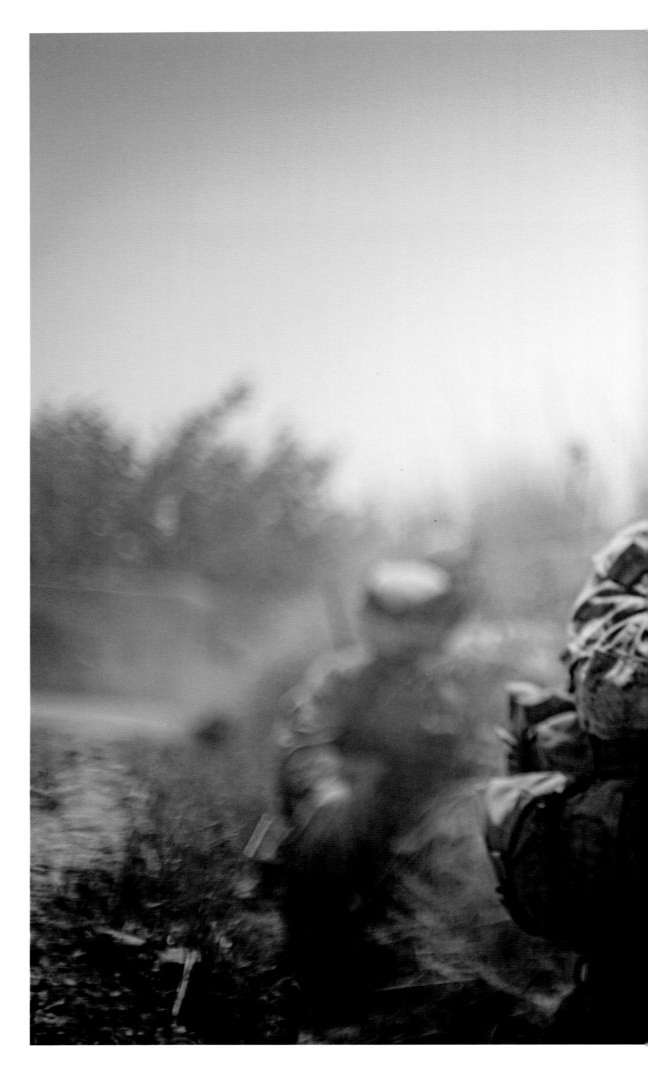

A Marine with the 2/8 engages in a firefight with the Taliban in Mian Poshteh, Garmsir District. Helmand province, Afghanistan, 2009.

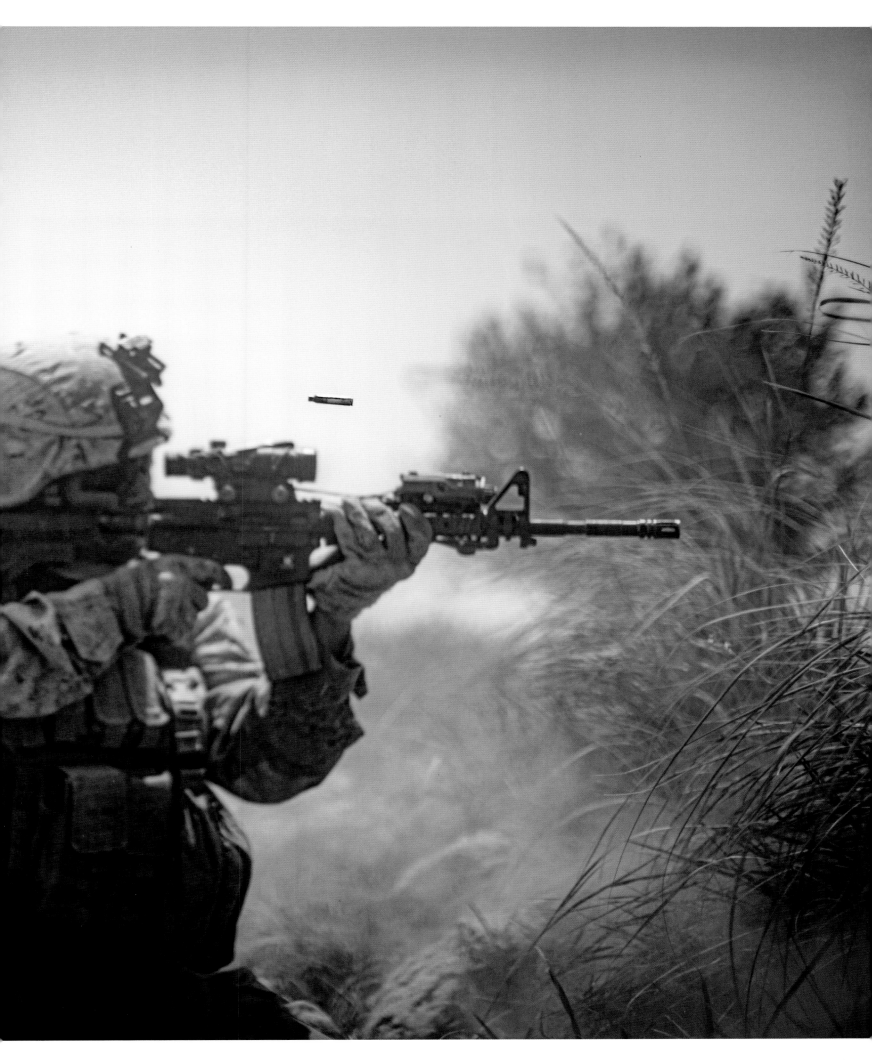

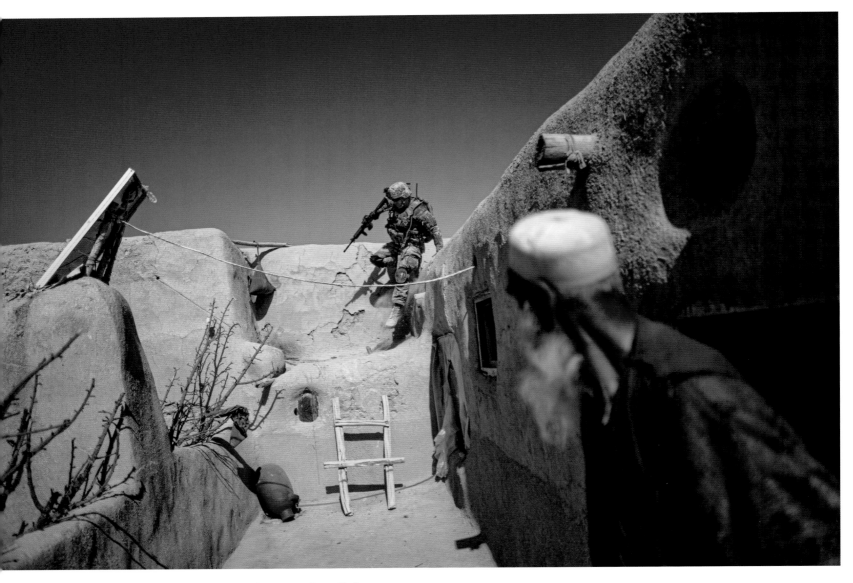

A soldier with the 82nd Airborne Division leaps over the wall of
a mud-brick building while searching for Taliban insurgent fighters.
Ghazni province, Afghanistan, May 2012.

One of the nights we were finishing up — again, it was just before dusk, it was late, late evening, almost night — I went over a wall and one of the Afghans who was with us was climbing over the wall, I think the other guys were going around the wall, walking around it. And I heard that snap, and then a couple more from the other side of me. But I just heard this sort of unmistakable noise that it had — I can't even describe it — that it, it hit someone.

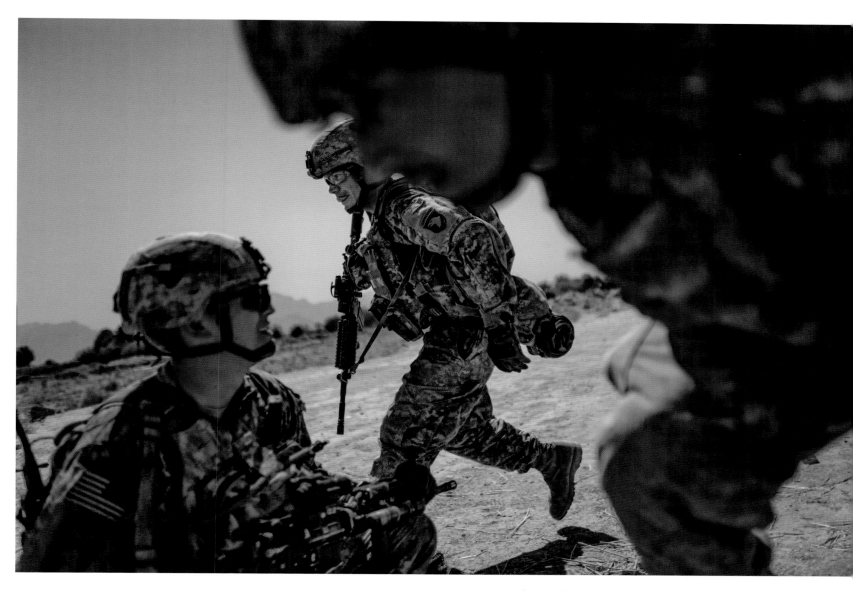

Army soldiers with the 101st Airborne maneuver for better fighting positions against heavy enemy fire near Pashmul. Kandahar province, Afghanistan, July 2010.

I came around the wall — it was the Afghan that was right on the wall next to me. He had taken it right in the side of the face and it had bounced sort of off the back of his mouth somewhere and shot out the other side.

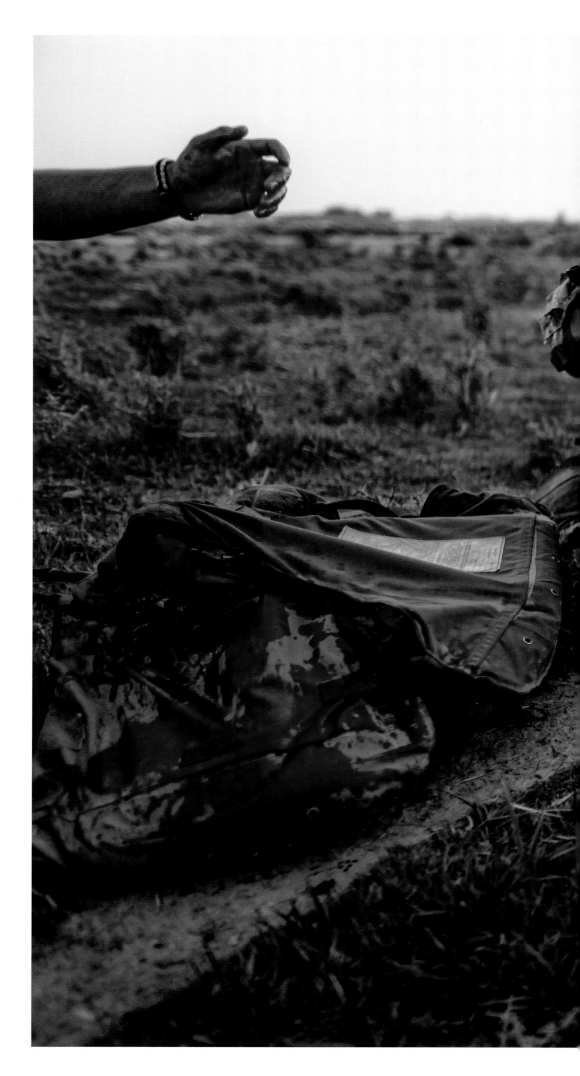

Army medic Paul Huston and Staff Sgt. Jaime Newman with 101st Airborne Division work frantically to save Afghan National Army soldier Atiqullah Obaidullah, who has been shot in the head by an insurgent sniper during a joint patrol in Pashmul. Kandahar province, Afghanistan, July 2010.

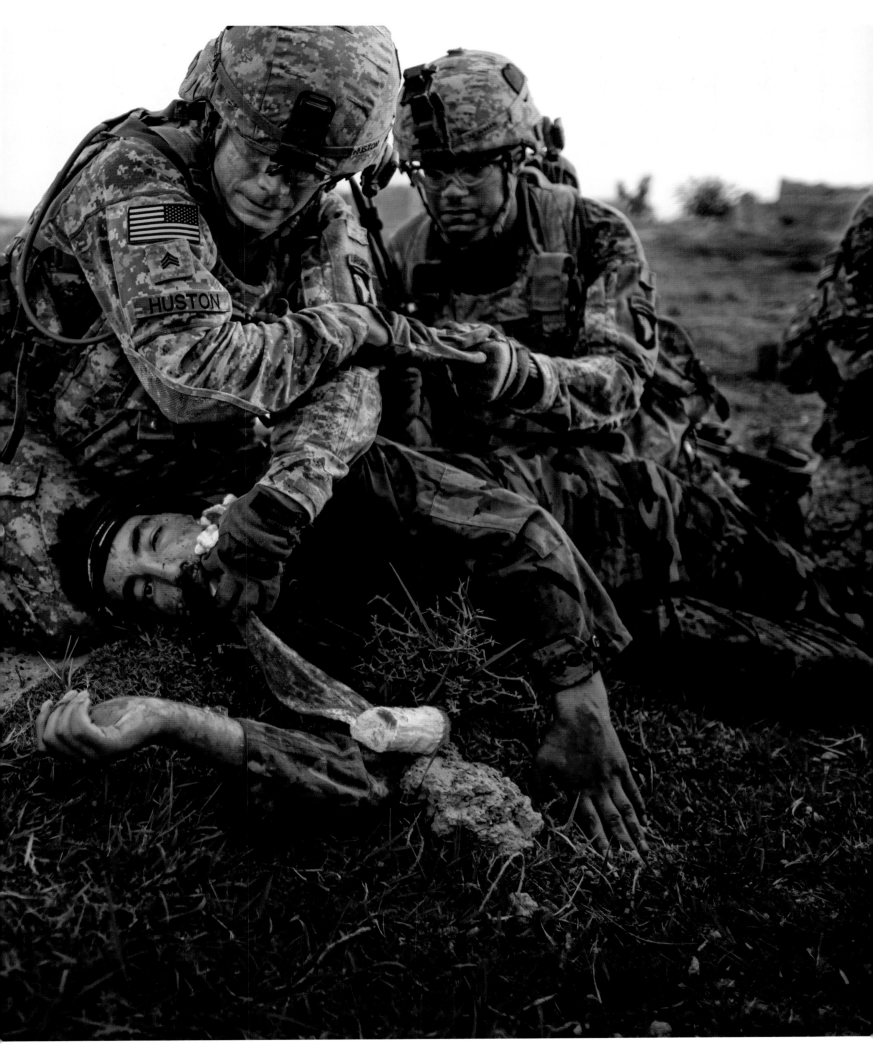

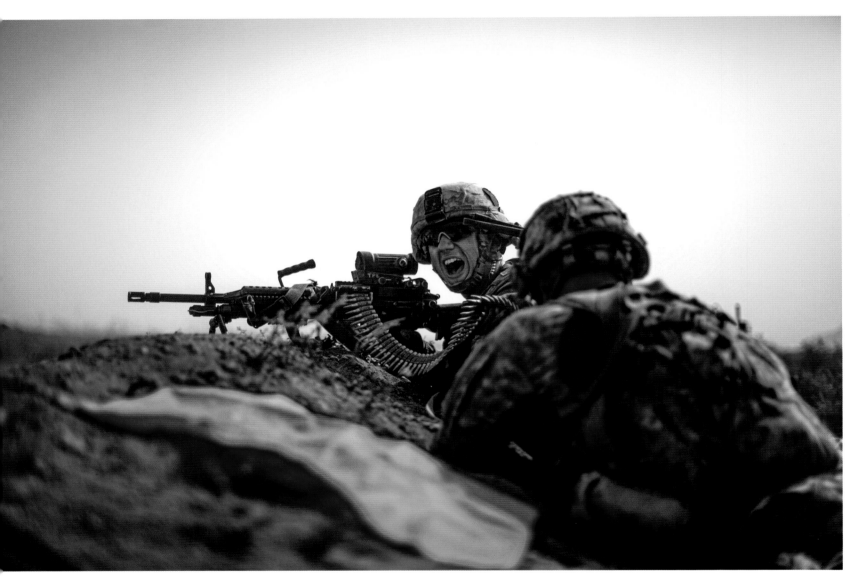

Spc. Jotiar Saaty with the 101st Airborne yells for more ammunition while trying to suppress heavy enemy fire during a four-hour running gun battle with insurgents near Pashmul. Kandahar province, Afghanistan, July 2010.

Yeah, at sort of — at the peak of this battle, I was with a young guy from California who was on one of the machine guns. And he sort of looked over as he was literally burning through these strings of ammunition, and he was yelling for people to bring him more.

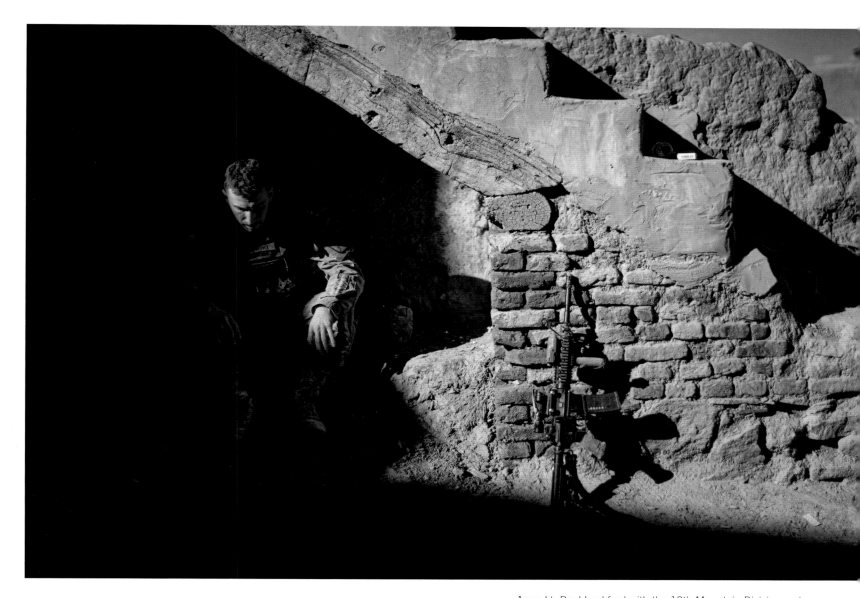

Army Lt. Paul Lankford with the 10th Mountain Division rests between patrols in the village of Charkh. With about 140 soldiers, Bravo Company had already earned 50 Purple Hearts while fighting the Taliban. Logar province, Afghanistan, April 2011.

If you think about it, when you're taking pictures, you know, you always want to be shooting someone's face. And during a gun battle, there's certainly no way you can do that. So it's really sort of a rare moment when they turn and they scream, and they're yelling at their buddies to help out with the situation that's going on. And that picture, I just thought, sort of summarized the day's events yesterday.

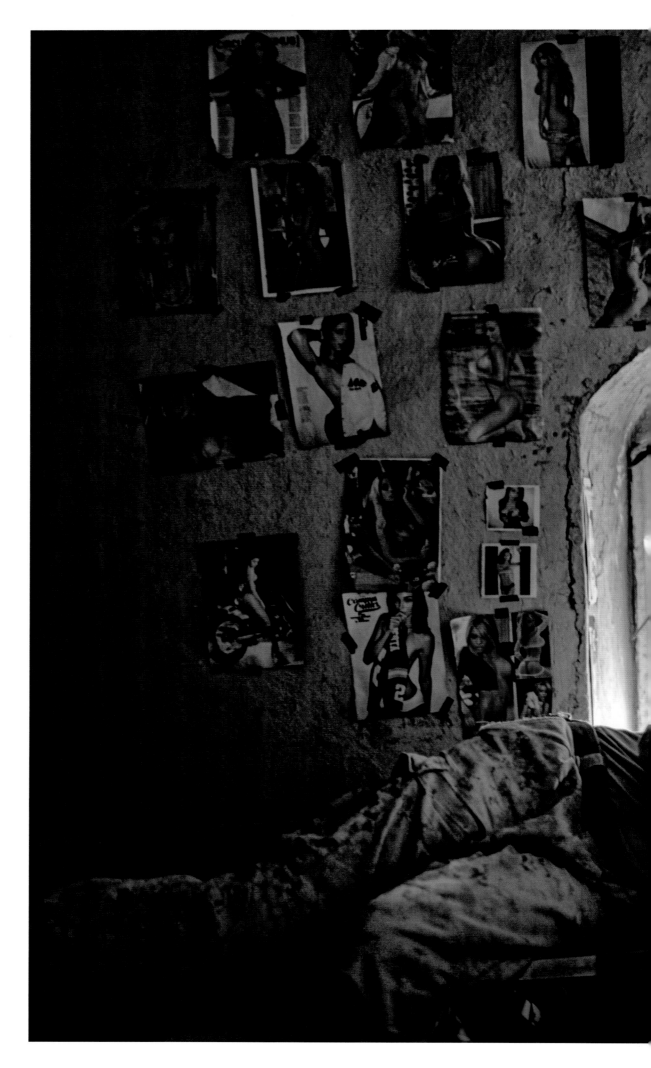

Marine Lance Cpl. Sergio
Navarette with the 2/8 sleeps
in his bunk in the village of
Koshtay, Garmsir District,
beneath a mud wall covered
with photos of girls torn
from the pages of magazines.
Helmand province,
Afghanistan, October 2009.

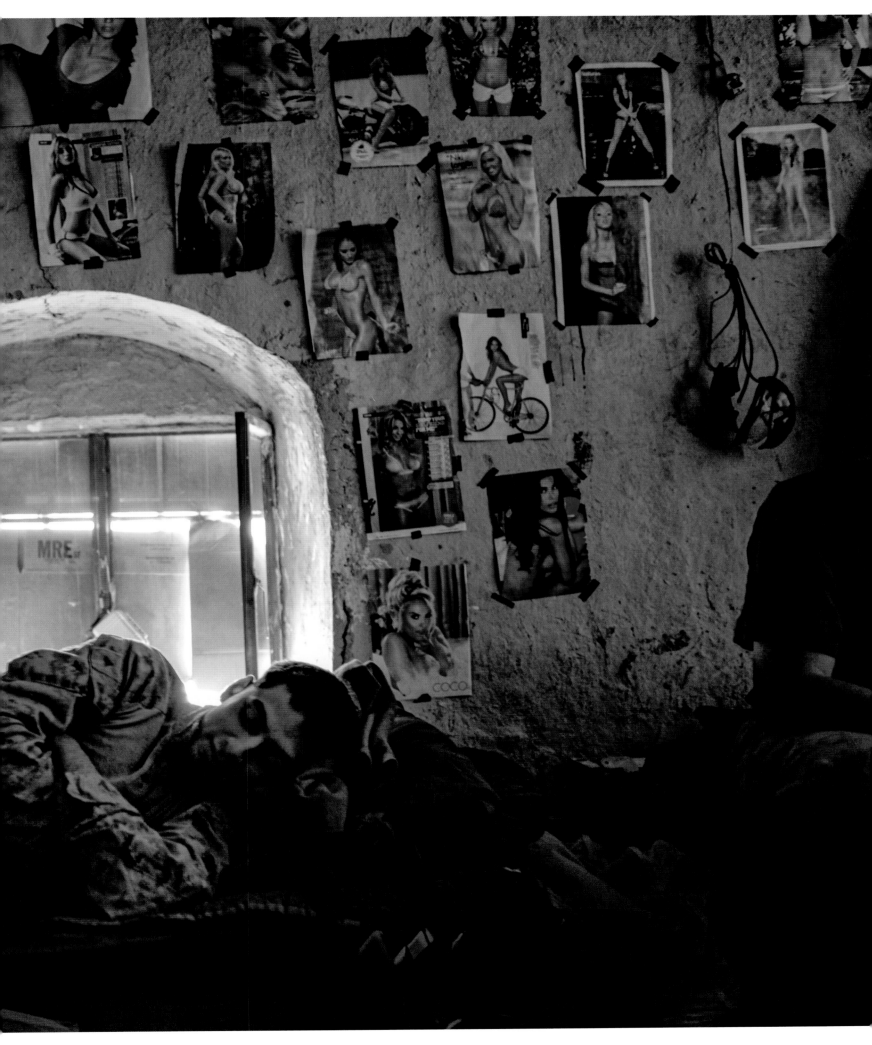

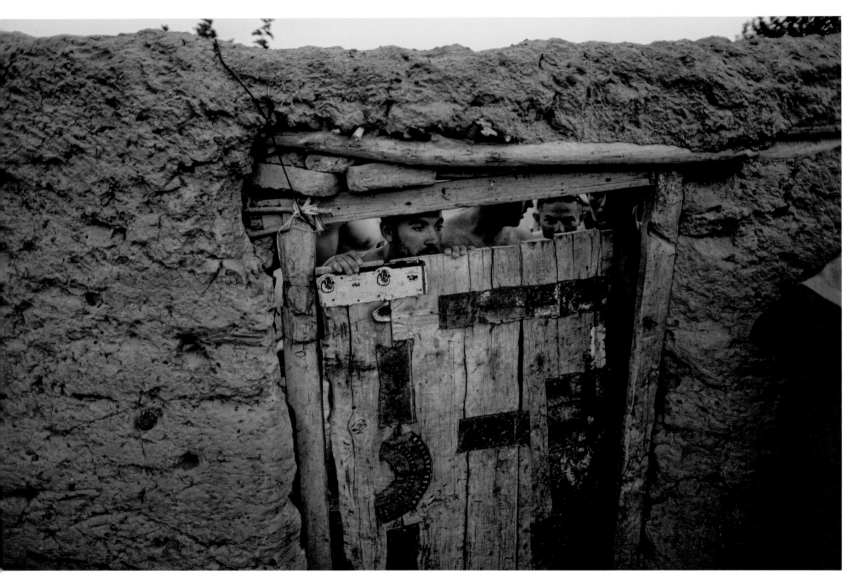

Marines peer into a chicken coop as they try to catch the rooster
that has been waking them up at dawn near their outpost in
Mian Poshteh during Operation Khanjar, or Strike of the Sword.
Helmand province, Afghanistan, July 2009.

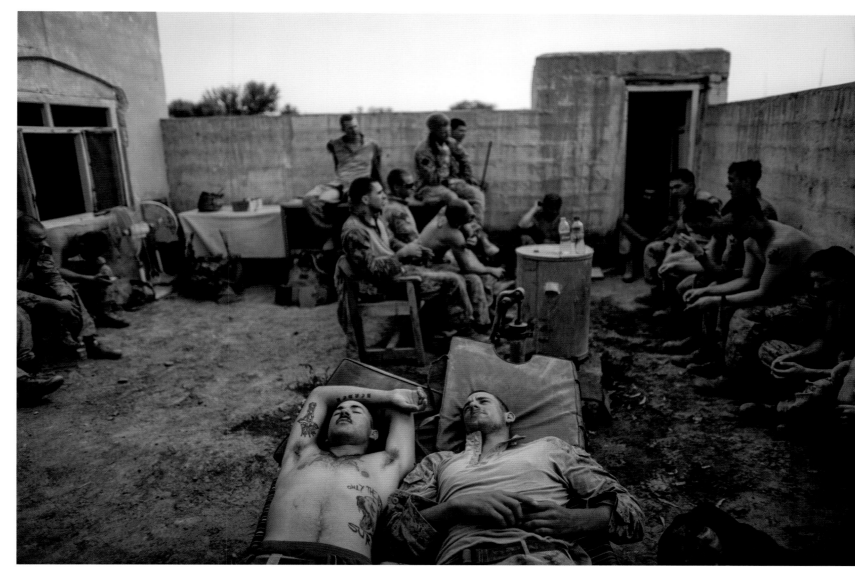

Marines rest in their temporary base after an intense gun battle with insurgents during Operation Khanjar. Helmand province, Afghanistan, July 2009.

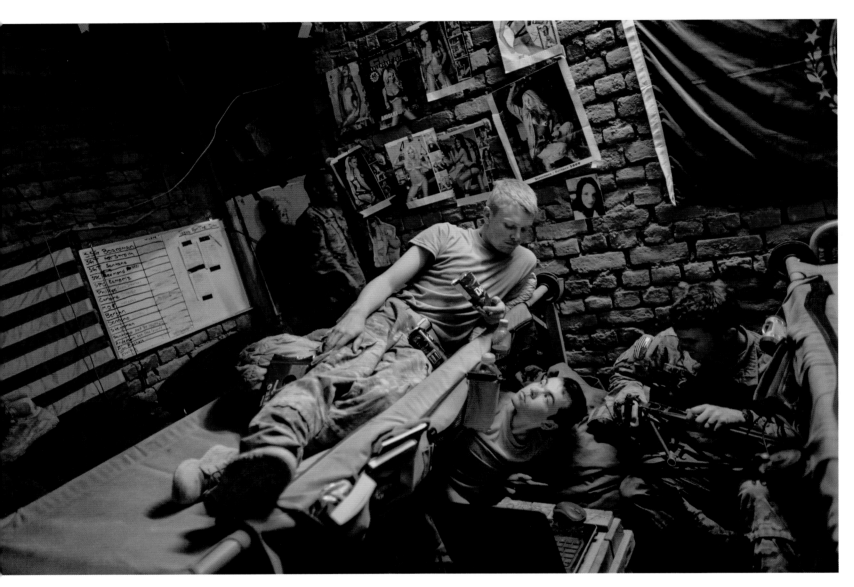

Pfc. Jesse Bergen (from left), Pfc. Derik Moe and Pvt. Alex Serrano
with the 82nd Airborne Division pass time between patrols by
watching movies and cleaning weapons in their hooch, which they
affectionately named "The Snake Pit." Ghazni province,
Afghanistan, May 2012.

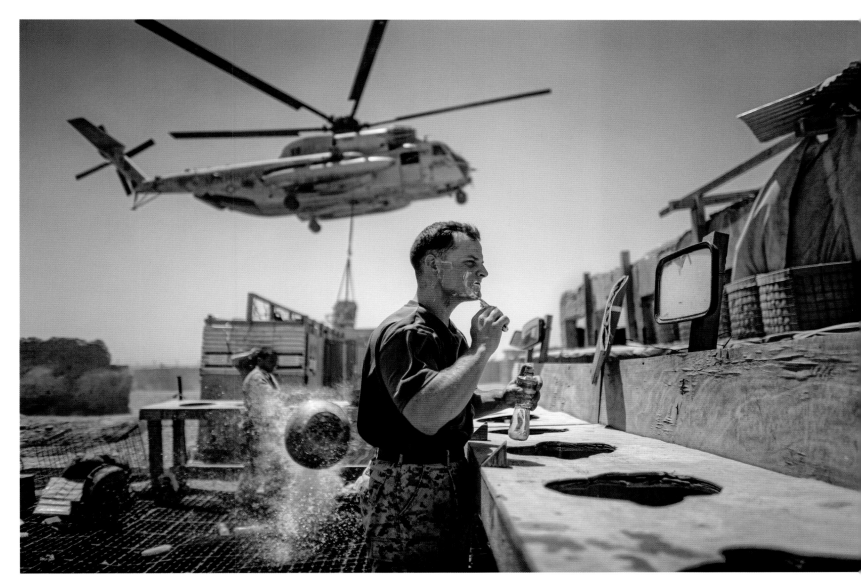

Wind from a helicopter's rotors knocks over a wash basin as
Marines with the 2/8 prepare for Operation Khanjar.
Helmand province, Afghanistan, July 2009.

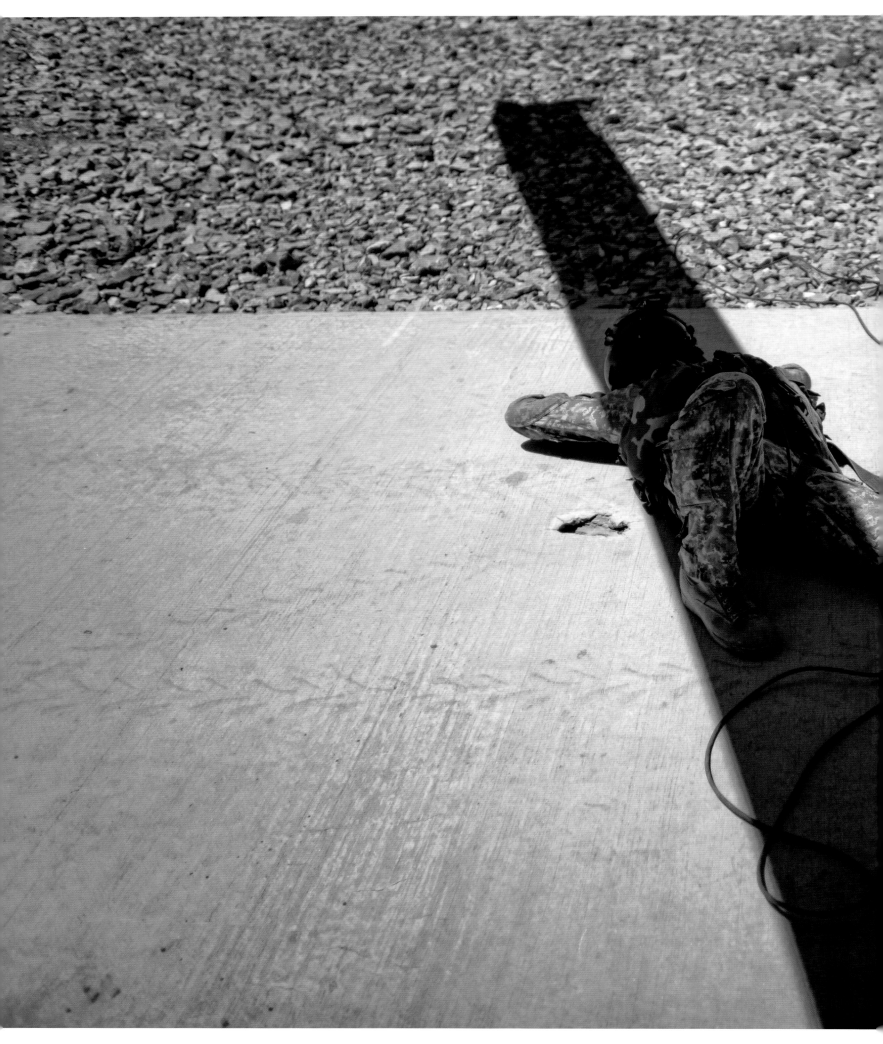

An Army helicopter crew member rests in the shadow cast by a Black Hawk helicopter blade at Kandahar Airfield. Afghanistan, May 2009.

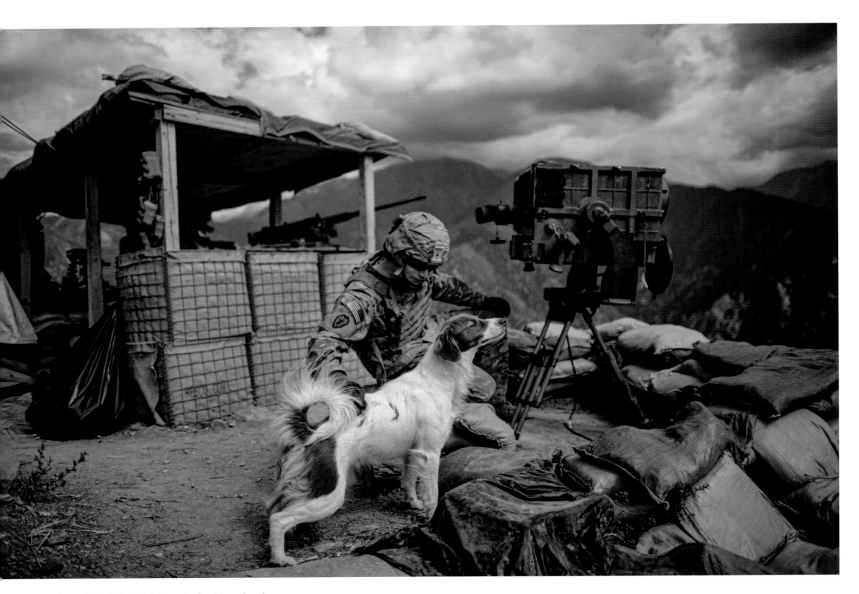

Army Pfc. Robert Hicks pets Cookie, a local
Afghan dog that adopted the soldiers who work
at Observation Post Mustang. Kunar province,
Afghanistan, September 2011.

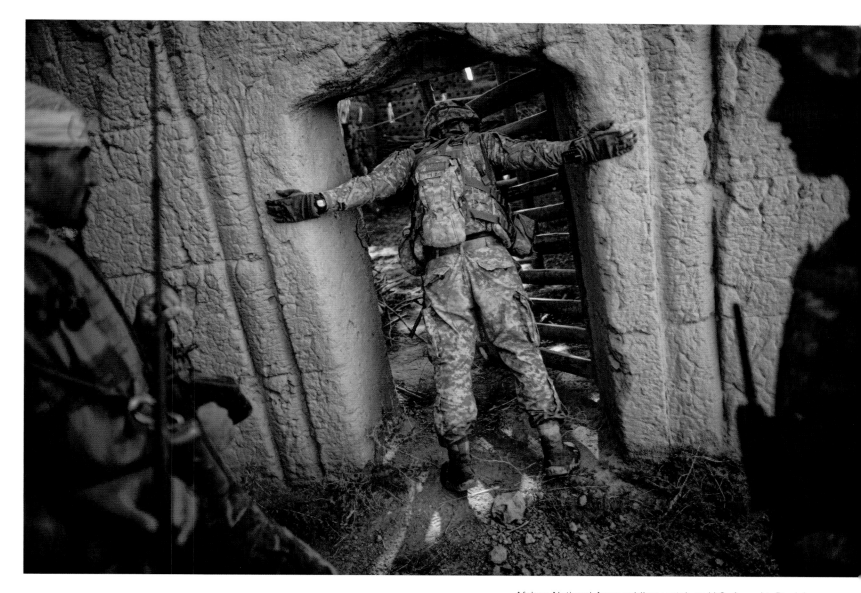

Afghan National Army soldiers watch as U.S. Army Lt. Daniel Plumb, with the 101st Airborne, looks for trigger wires to improvised explosive devices in a grape-drying barn in Zhari District. Taliban leader Mullah Omar was born in the Zhari area, and many of his first recruits came from this region. Kandahar province, Afghanistan, July 2010.

A Marine with the 2/8 rests between patrols during Operation Khanjar. Helmand province, Afghanistan, July 2009.

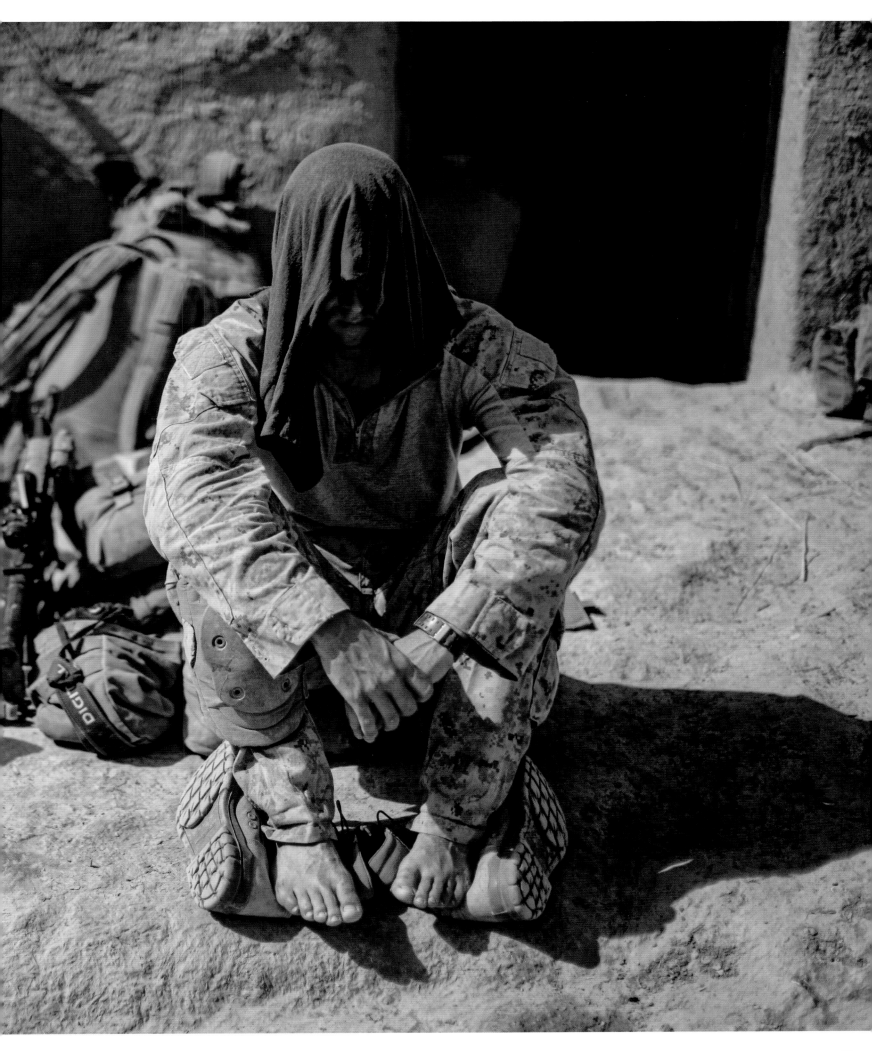

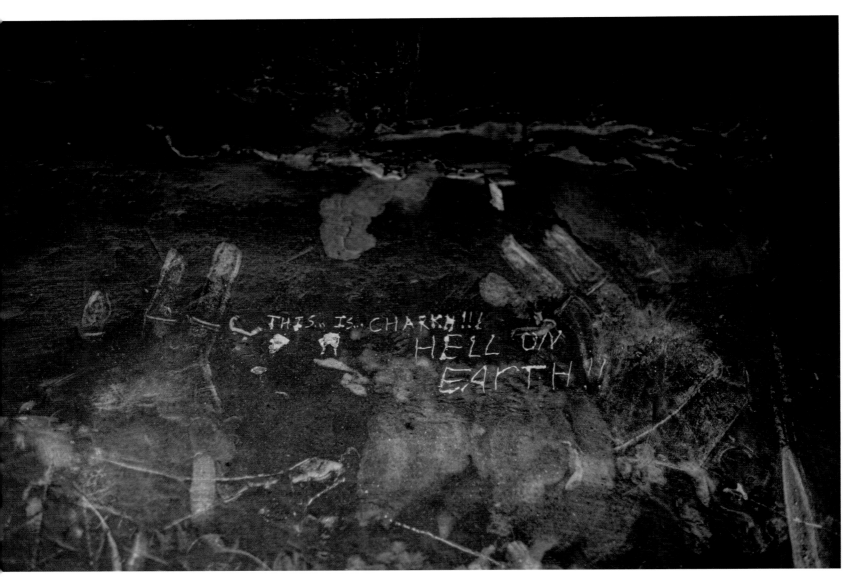

An angry scrawl in the soot-covered wall of a house in
Charkh Bazaar used as a bunker by U.S. Army soldiers
from the 10th Mountain Division. Logar province,
Afghanistan, April 2011.

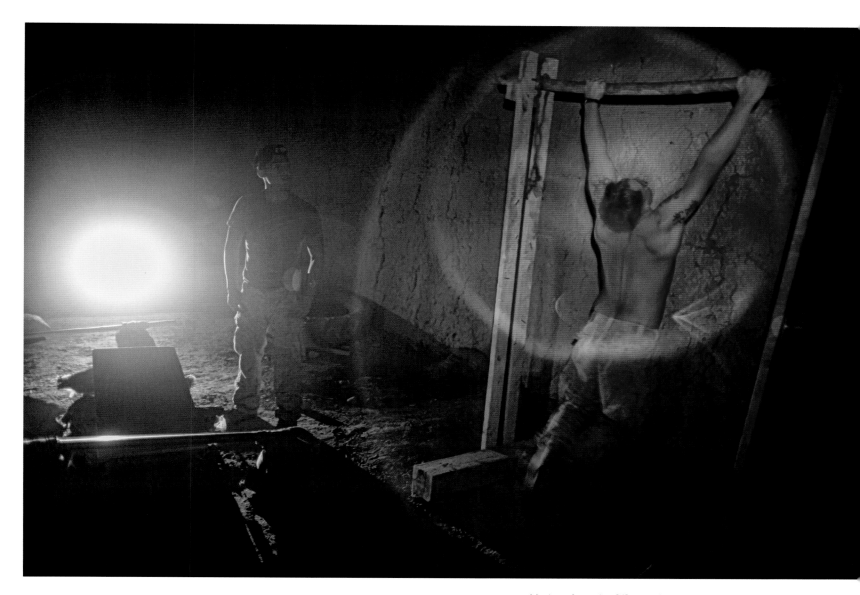

Marines from the 2/8 exercise using makeshift equipment
made from sandbags and duct tape at their base in the village
of Koshtay. Helmand province, Afghanistan, October 2009.

A Marine with the 2/8 takes a break from the heat
between patrols during Operation Khanjar.
Helmand province, Afghanistan, July 2009.

A Marine with the 1/5 takes cover as a dust storm
approaches his outpost in Sangin District.
Helmand province, Afghanistan, May 2011.

Soldiers with the 101st Airborne Division build a fire to keep warm at an abandoned CIA outpost, 8,000 feet high in the mountains of the Ghaki Pass. Kunar province, Afghanistan, October 2010.

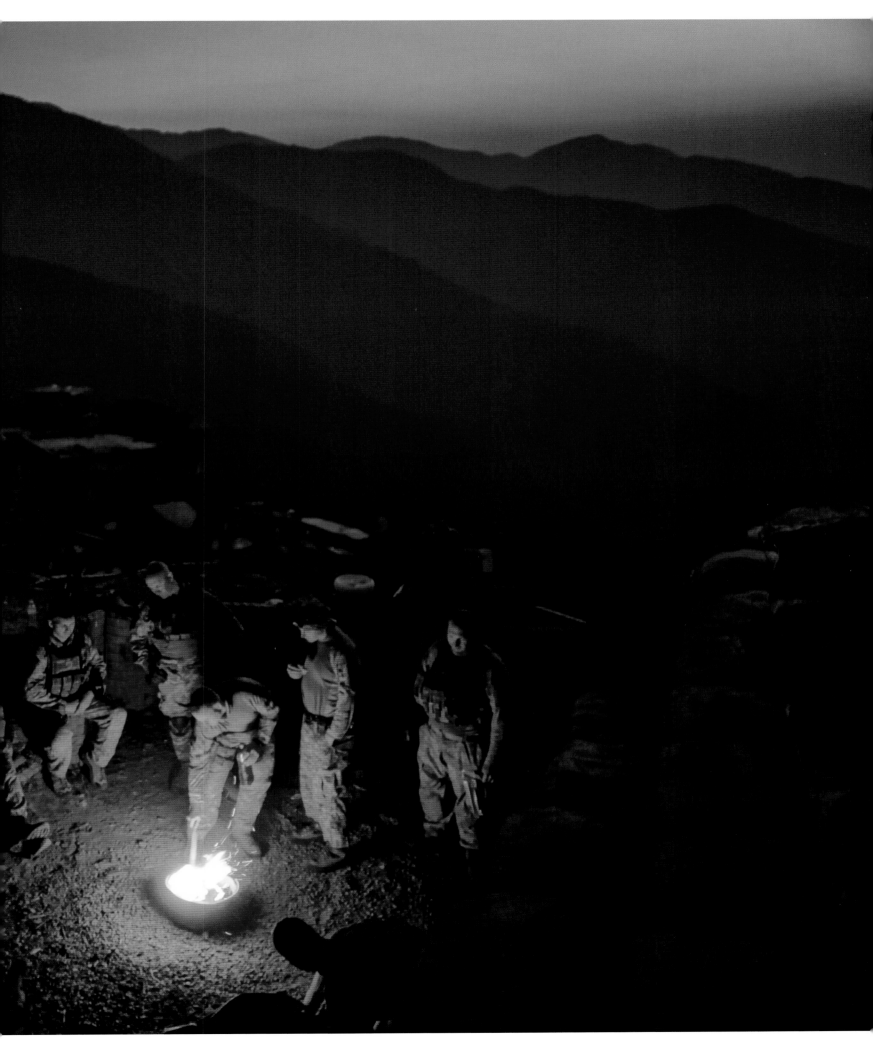

DISPATCH: THE QUAKE

Haiti
December 2010 — 2013

In the immediate aftermath of the 2010 Haitian earthquake, Port-au-Prince was in ruins. Multi-story concrete buildings had pancaked into piles of rubble. Gray dust from pulverized cinder blocks coated everything in an oddly gentle powder. Bloated human bodies oozed by the side of the road. The injured wailed outside a hotel that had been favored by Western aid workers. David Gilkey and I had just arrived in hell.

I struggled to describe the scale of the destruction, the extent of the horror — on my first live broadcast from Port-au-Prince, a bleeding young girl stepped into view, and my voice broke. David didn't seem to struggle. He snapped into action. He ducked down and moved quickly through the piles of dead bodies at the morgue. He scrambled over slabs of collapsed concrete.

Amid a chaotic, dusty landscape that to me looked visually overwhelming, David would distill images that were poignant, striking and complex. I remember at one point when we were filing from a half-collapsed hotel, one of our readers sent us a note complaining that his images of the disaster were "too artistic." He laughed. But his images were artistic. There was often a big sky, a pop of color, a thrust of human arms. Smoke. He could capture despair, drama, danger; sometimes all in one frame.

David and I returned to Haiti together and separately more than a dozen times over the next few years. We covered cockfights, presidential candidates, riots and cruise ships. We drove across much of the country in vehicles that regularly broke down. It was the beginning of a series of trips we took together to disaster zones around the world. On those journeys he helped me and our audience see those places in a way that I'm not sure anyone else could.

— Jason Beaubien

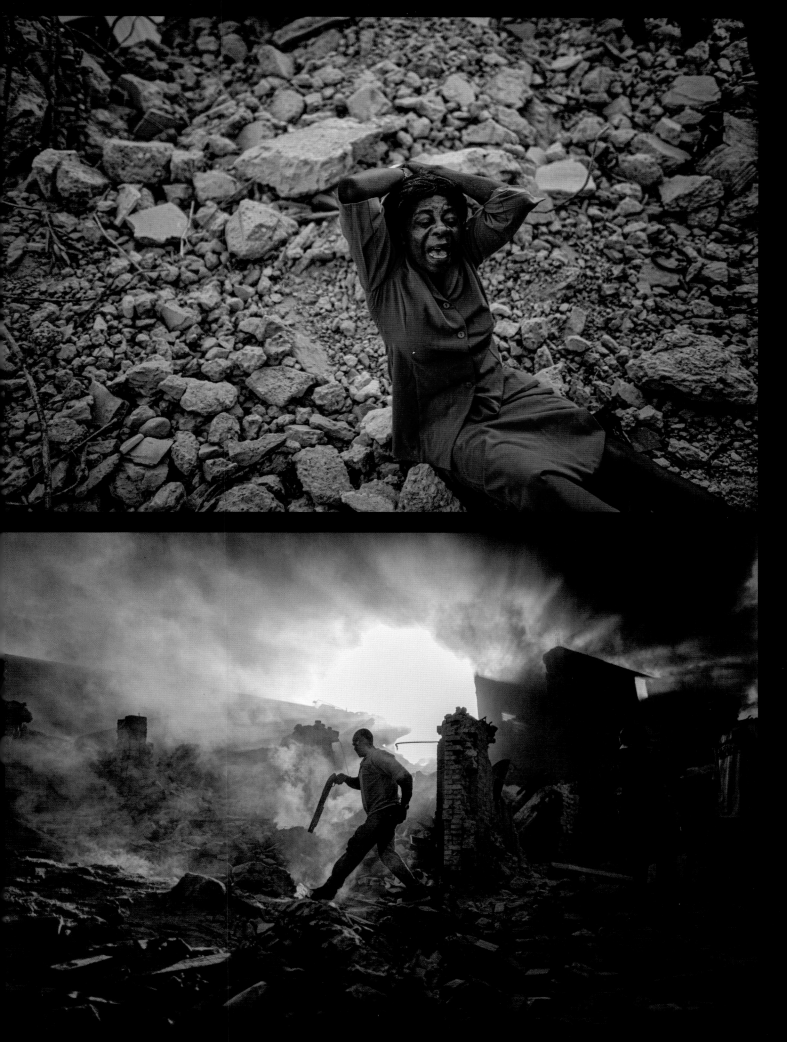

ABOVE: A woman falls in anguish in the rubble of the destroyed cathedral during the funeral of Archbishop Joseph Serge Miot. The government declared that the search for survivors was ending. Port-au-Prince, January 2010. BELOW: A man, carrying a shotgun, walks through a collapsed building while trying to keep looters at bay. Port-au-Prince, January 2010.

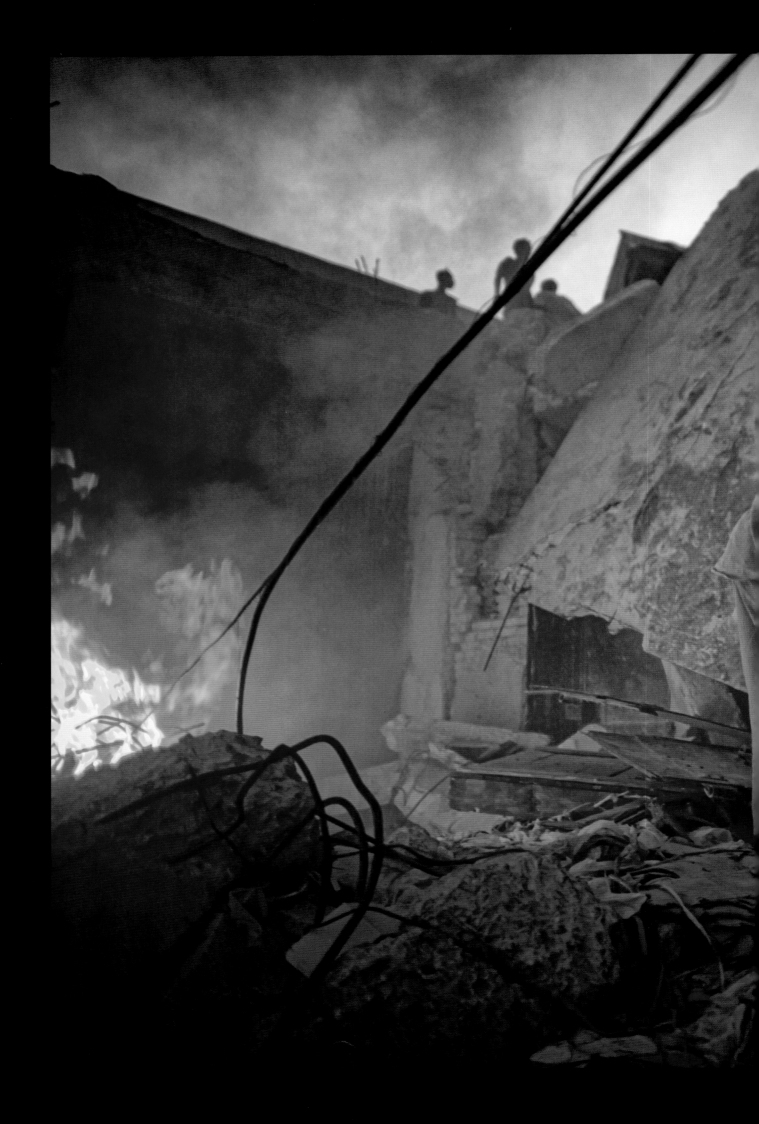

A Haitian man holds a knife as he watches for looters in a shop near downtown Port-au-Prince. January 2010.

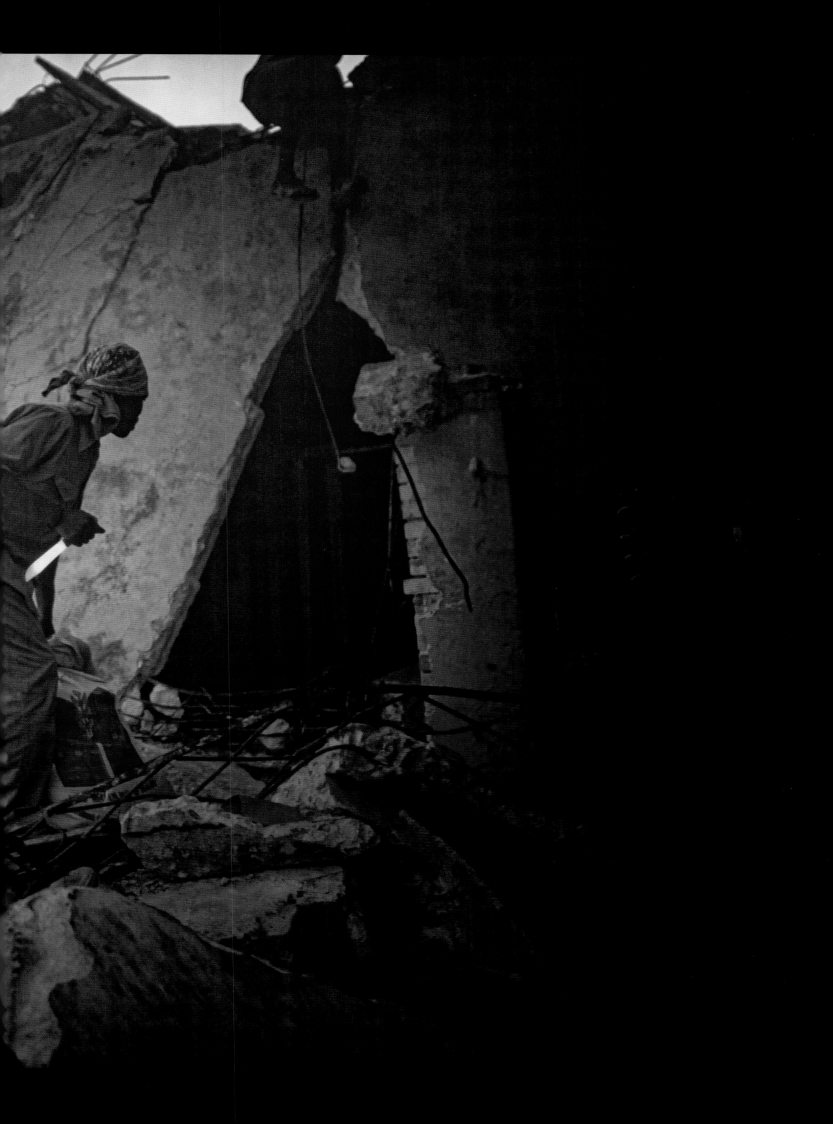

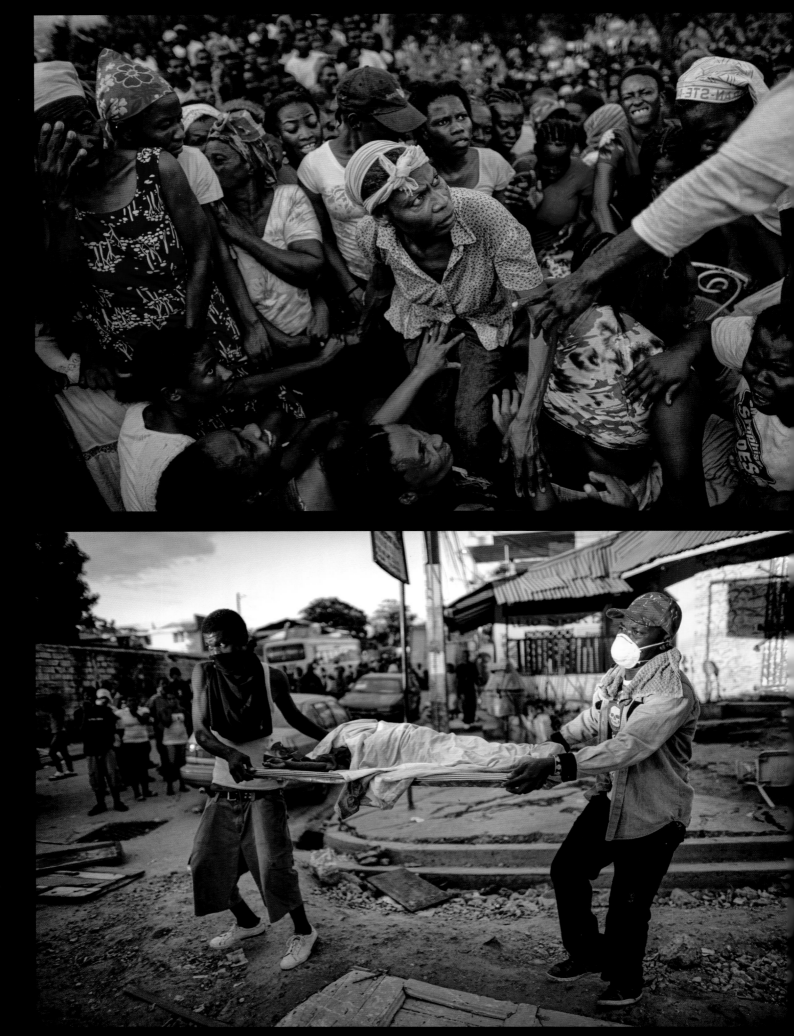

ABOVE: Women surge to get the last food rations at a distribution site run by the U.S. Army at a golf club in the hills above the capital. Port-au-Prince, January 2010. BELOW: Men carry the body of a dead child to a waiting dump truck. So many were killed that trucks and other construction vehicles were used to remove bodies from the streets. Port-au-Prince, January 2010.

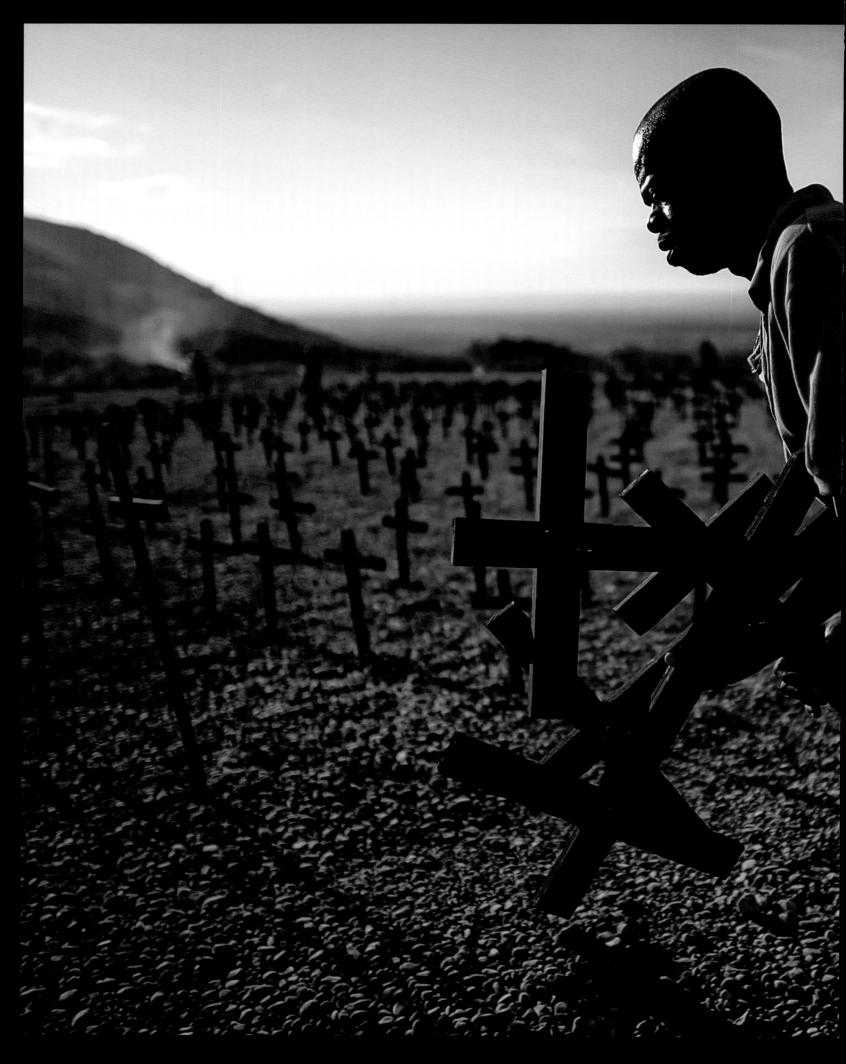

A year after the devastating earthquake that killed thousands, a man drops crosses on the ground to mark the mass graves where tens of thousands were buried. Titanyen, January 2011.

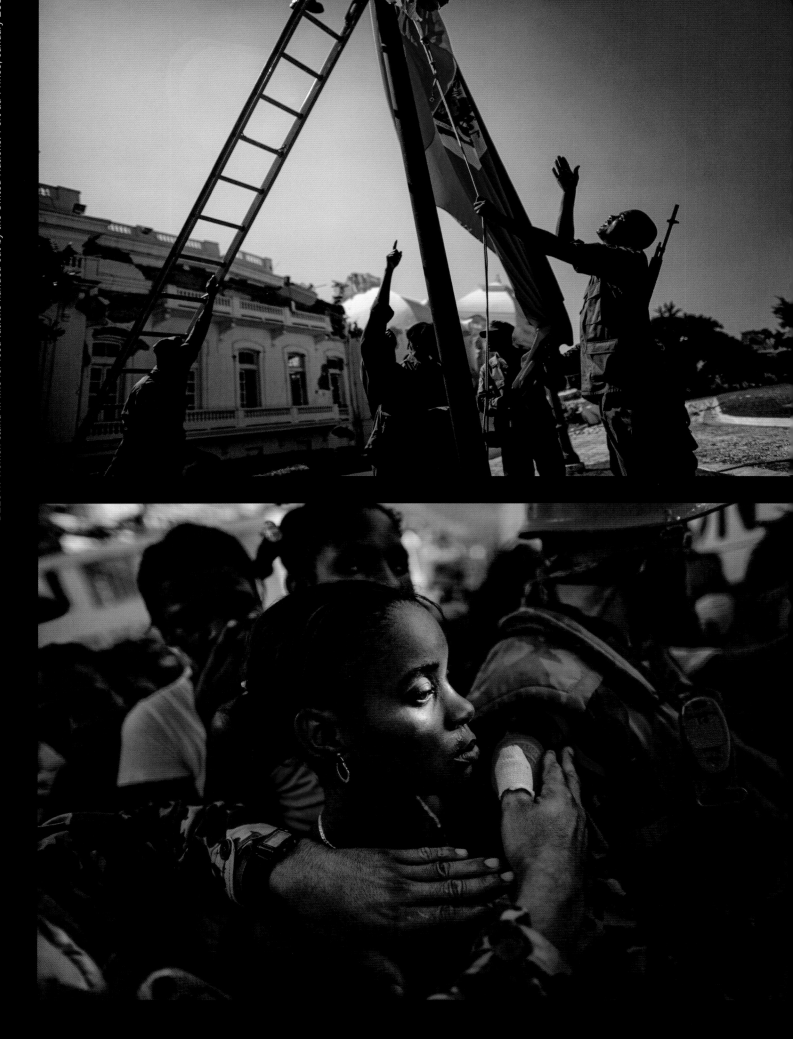

ABOVE: National Police raise the Haitian flag in front of the destroyed National Palace. Port-au-Prince, January 2010.
BELOW: Women stand in line for food rations handed out by the United Nations. Port-au-Prince, January 2010.

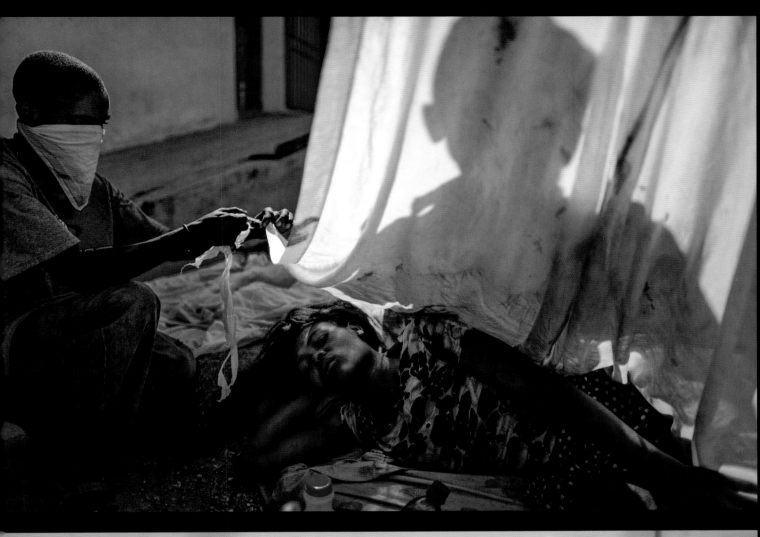

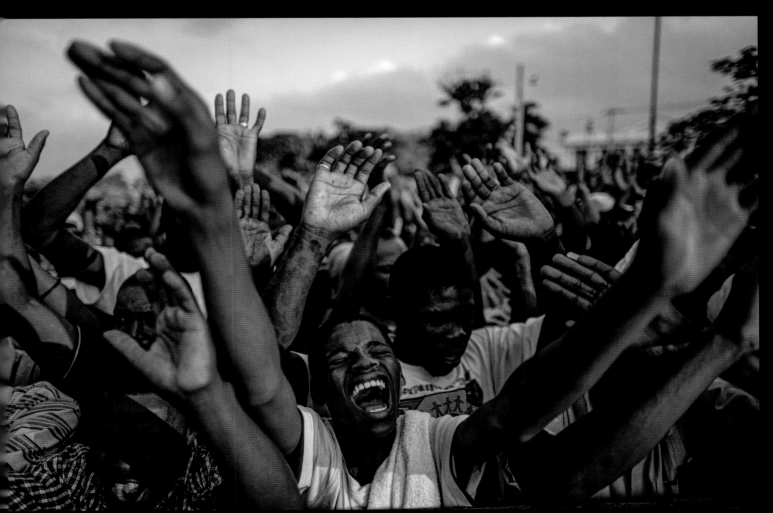

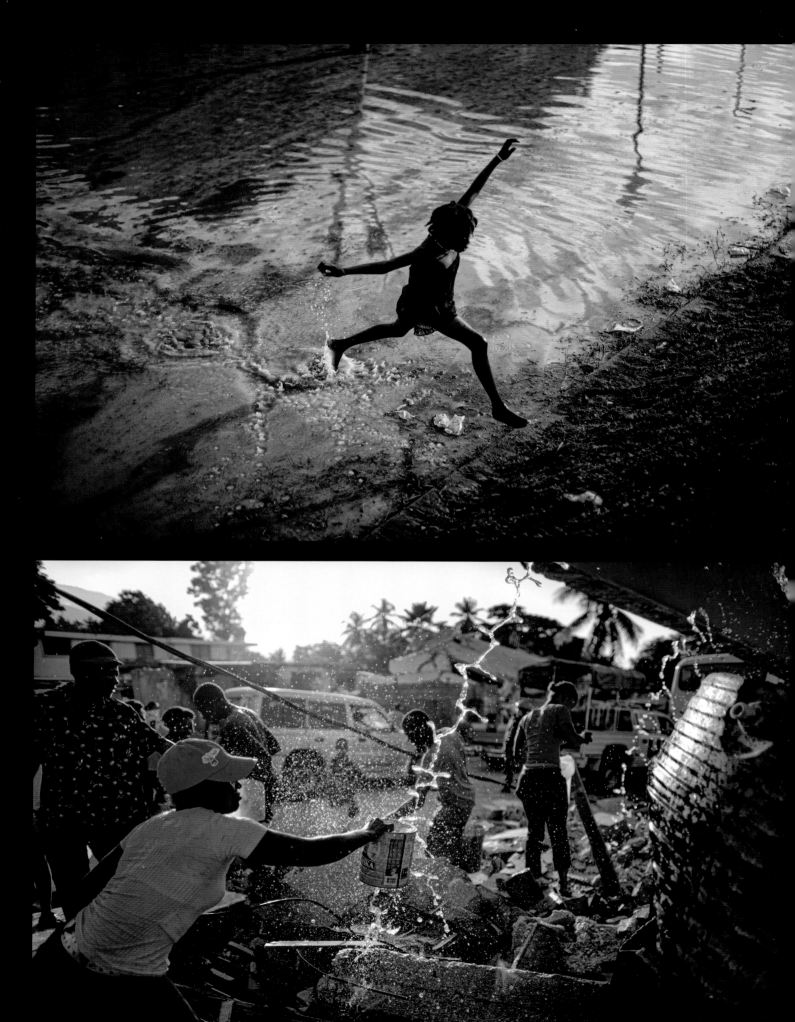

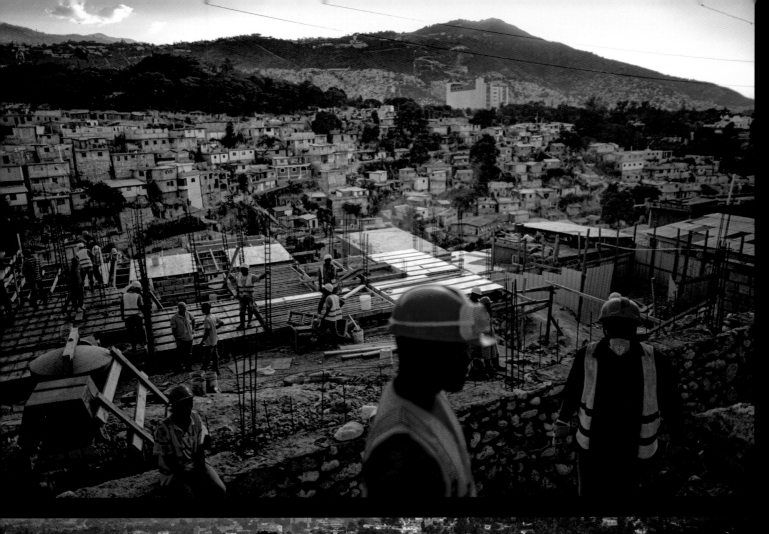

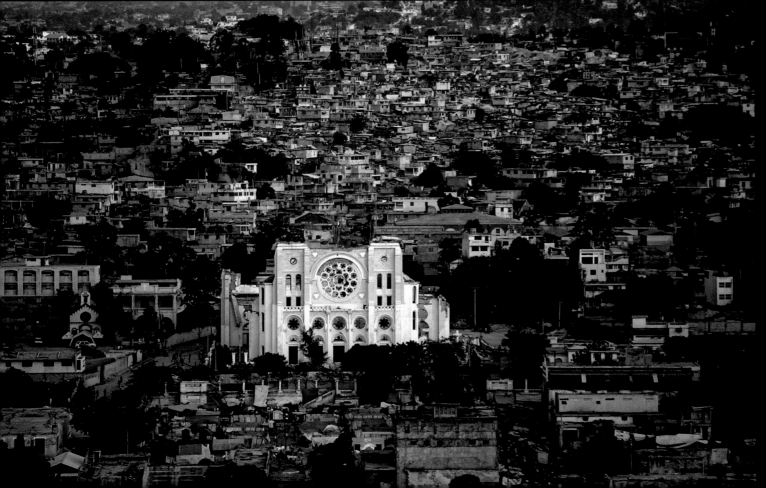

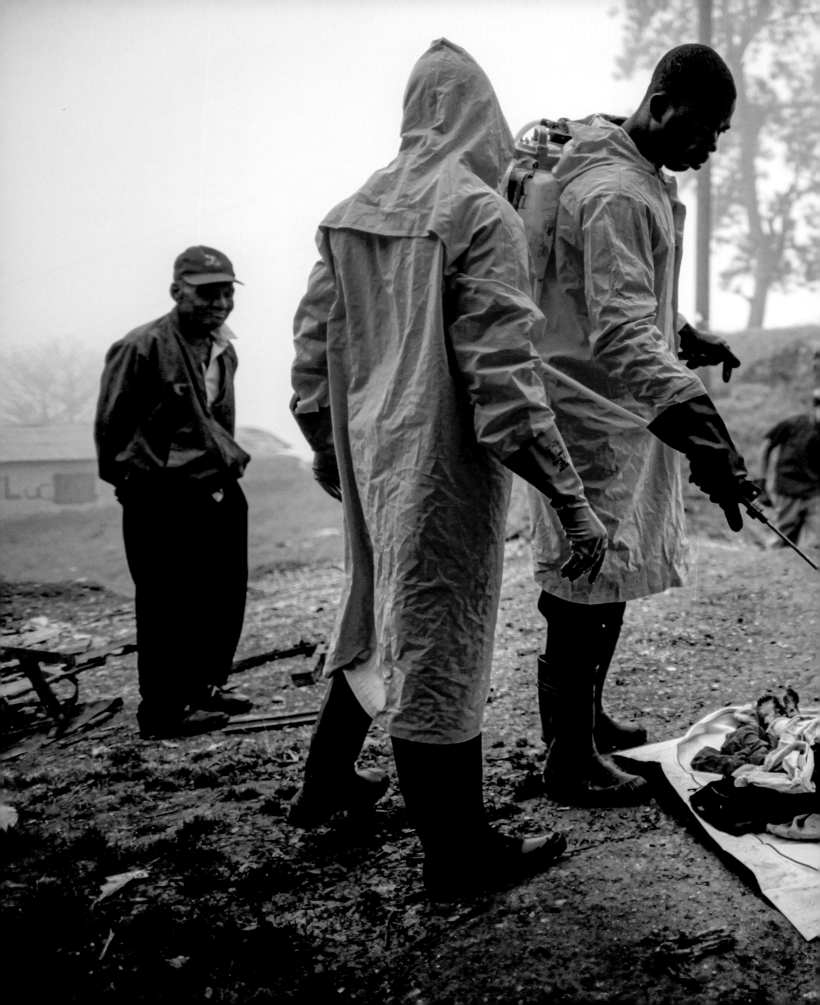

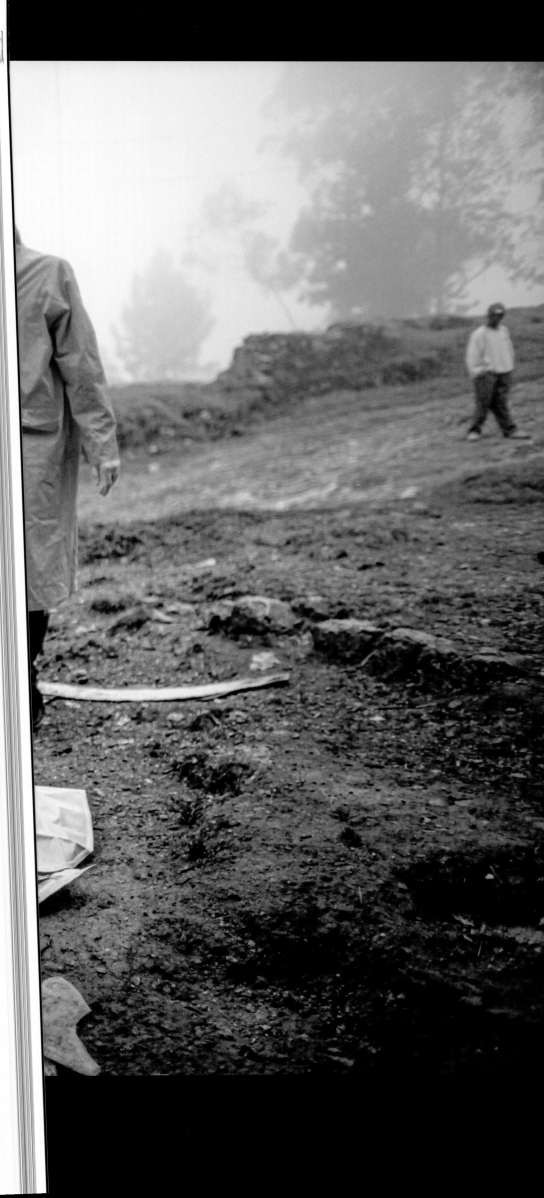

REDEPLOYED. The worst part about returning home from war is that no one seems to know there's a war on.

A tiny number of Americans — about 1 percent of the population — has gone to Iraq or Afghanistan since 2001. They're an all-volunteer force, deploying longer and more often than in past wars, when everyone's dad, brother or son spent time in uniform. Supporting the troops has somehow gotten confused with not mentioning the war but plastering your bumper with yellow ribbon stickers. Veterans returned to a lingering feeling that no one back home knew there was a world out there.

David Gilkey was not a tourist in that world. He had followed Michigan Marines to Iraq for an entire deployment and their return home. His embeds at the most famous battles of the wars — in Fallujah, Iraq, and Helmand, Afghanistan — earned him an engraved brick at the Marine Corps Heritage Foundation's memorial park.

In 2012 David helped persuade NPR to create a full-time beat covering veterans. That was the job that got me home from the wars for good. David kept going back, though. In between his other trips we had a great time covering veterans' stories.

Photographing vets was almost too easy for David. He could play the "where'd you deploy?" game with them and more often than not he'd been there. The alienation that comes with returning home to an unexpected and permanent culture shock — he'd been there too. That rapport made for unguarded, honest and revealing pictures.

David made portraits of maimed soldiers learning to walk on prostheses at Walter Reed and later training on skis or skates for the U.S. Paralympic team. Female combat-decorated vets told him about how, back home, no one believed they'd even served. He traveled to Alaska to meet Native Alaskans who fought in World War II, finally getting recognized as veterans after 70 years. He walked through the riverbed homeless camp in San Diego — and one of the homeless men he met on that trip turned out to be a soldier David knew from Kandahar.

Some vets find the best therapy is to re-create their camaraderie, closeness and sometimes the adrenaline of war back home, without so much actual danger. David followed a group of them rock-climbing up Half Dome in Yosemite National Park in 2013. One had been blinded by an explosion, and hiked with a guide. Another climbed on a prosthetic leg, which started to slip off from sweat on the way up an 800-foot cliff face. He paused, pulled his leg off and tied it to his belt.

David hung suspended on a rope next to them, shooting it all, eyes popping with real fear. And having the time of his life.

— Quil Lawrence

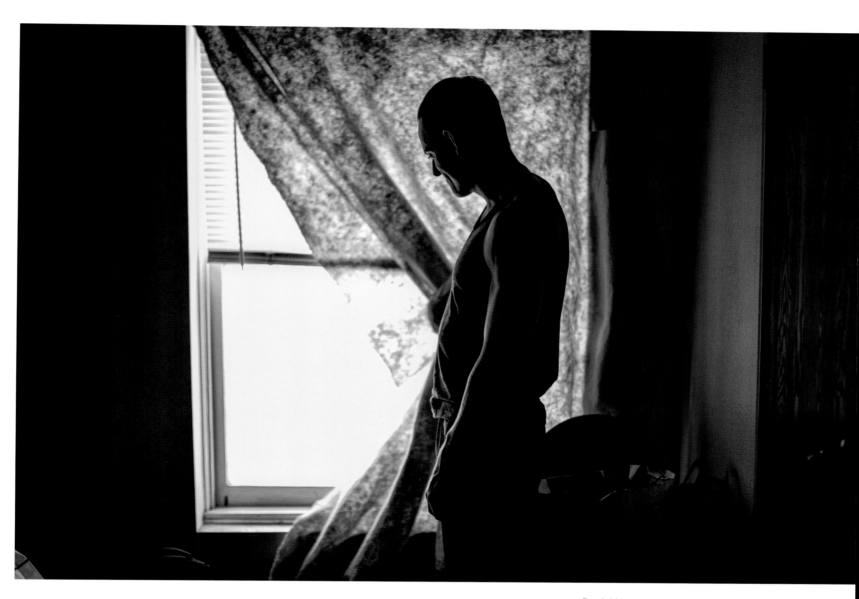

Daniel Harmon, a veteran of the wars in both Afghanistan and Iraq, looks out the window of his room at the Hollywood Veterans Center in Los Angeles, which provides housing to homeless vets. July 2015.

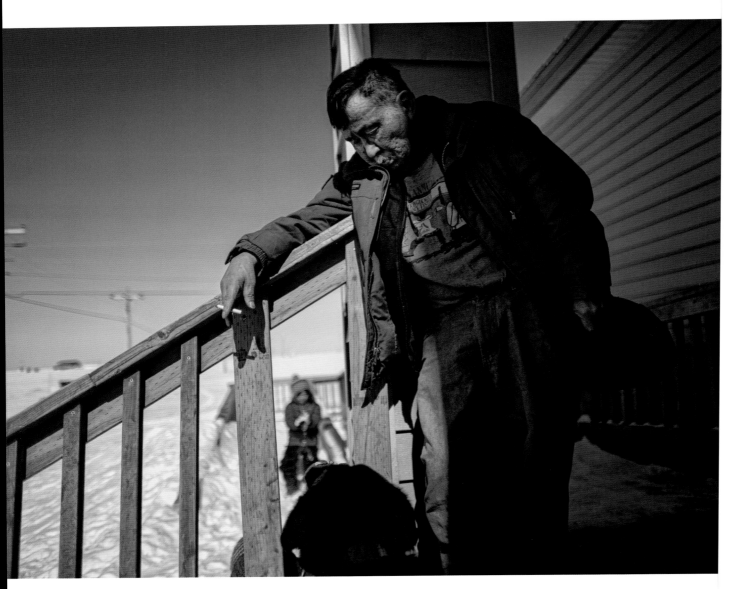

Isaac Oxereok stands outside the community center in the isolated village of Wales, Alaska, after meeting with Veterans Affairs representatives. April 2013.

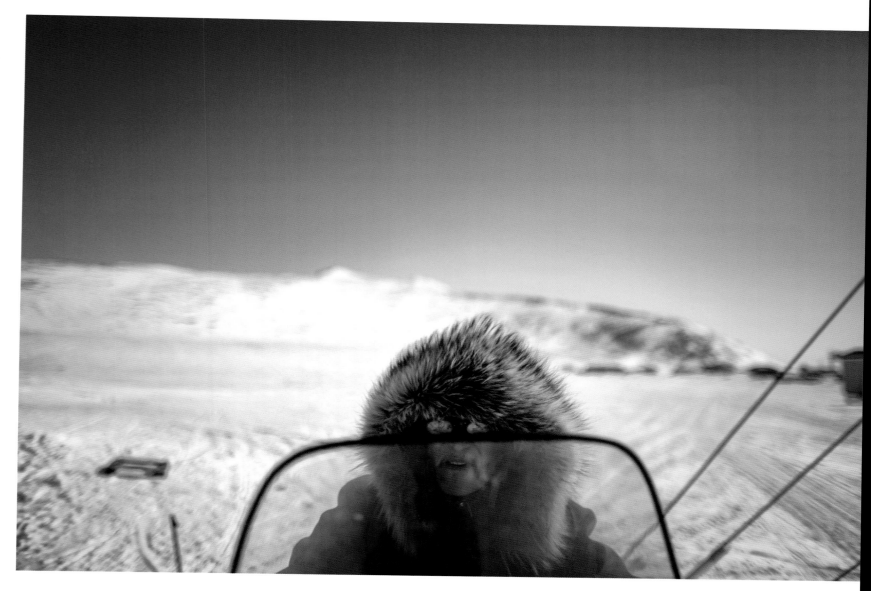

Daniel K. Omedelena rides his four-wheeler across the snow and ice in Wales, Alaska. Omedelena served as a door gunner in the Army through two tours in Vietnam. April 2013.

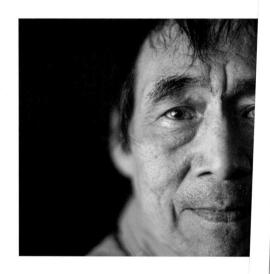

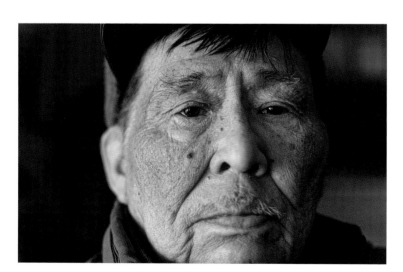

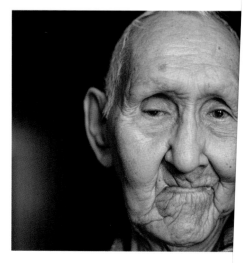

Veterans in Alaska, April 2013. TOP: Daniel K. Omedelena, 71, served in the Army in Vietnam from 1968-69. MIDDLE: Ralph Anungazuk, 64, served in the Navy from 1969-75. BOTTOM: Isaac Oxereok, 69, served in the infantry of the Army from 1966-67.

TOP: Sean C. Komonaseak, 47, served in the A He is the tribal veterans representative for Wal MIDDLE: Kelly Anungazuk, 61, served in the A BOTTOM: Howard Lincoln, 82, served in the A where he was nearly killed, and earned a Purp

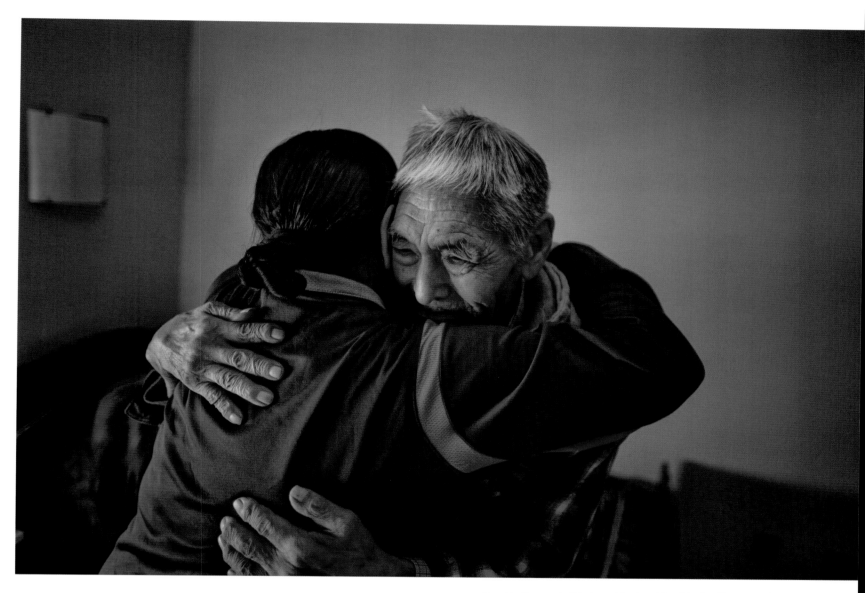

Frankie Kuzuguk, 83, hugs his daughter, Marilyn Kuzuguk. Seven decades after Kuzuguk served with the Alaska Territorial Guard in World War II, Veterans Affairs officials presented him with an honorable discharge. The Army recruited the "Eskimo Scouts" after Japan invaded the Aleutian Islands, but it took Congress until 2000 to acknowledge them as veterans. Nome, Alaska, April 2013.

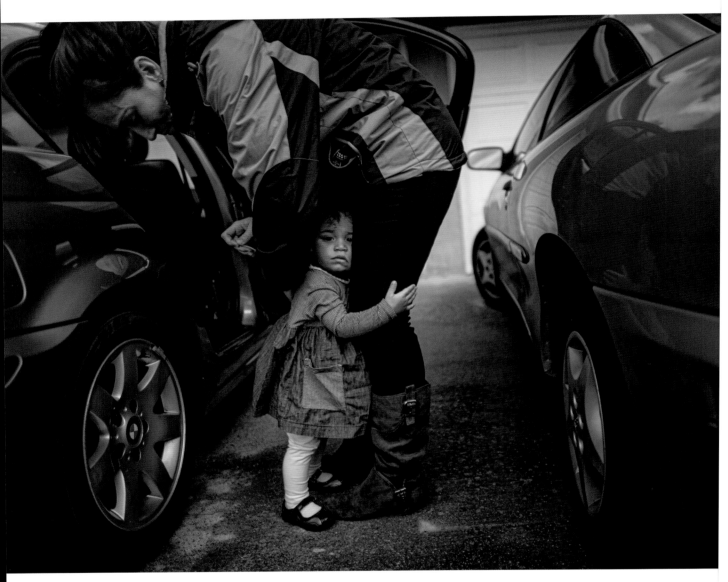

Crystal Turner, a Marine veteran attending classes at Sierra College
in Rocklin, Calif., helps her 1 1/2-year-old daughter,
Marley Rose, out of a car. Turner balances classes and working
at the Veterans Success Center on campus with being a
full-time mother. March 2012.

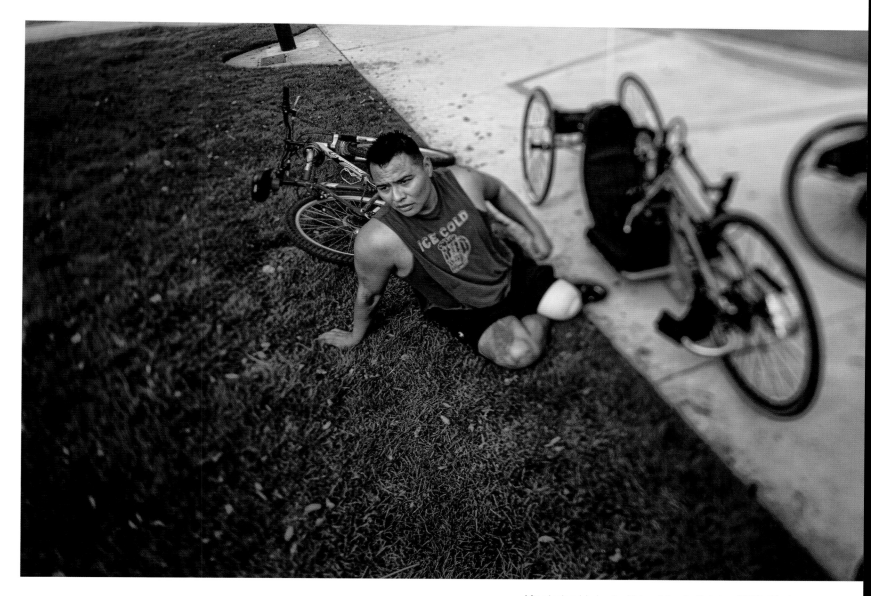

After losing his leg in Afghanistan in October 2010, Marine Cpl. Marcus Chischilly underwent rehabilitation in San Diego. He uses a recumbent bike equipped with hand pedals, and a year later he finished 16th in the wheelchair portion of the Marine Corps Marathon in Washington, D.C. October 2011.

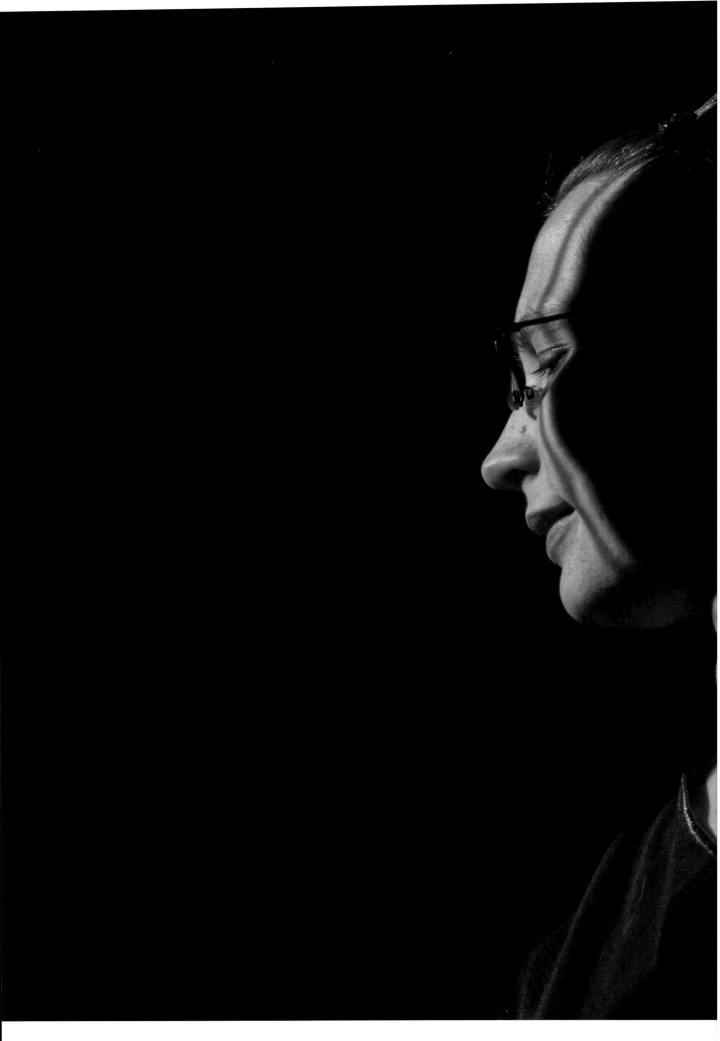

Jamie Livingston survived sexual abuse several times during her almost six-year term in the Navy. She settled in Texas with her family, where she could get assistance dealing with the trauma caused by the abuse. March 2013.

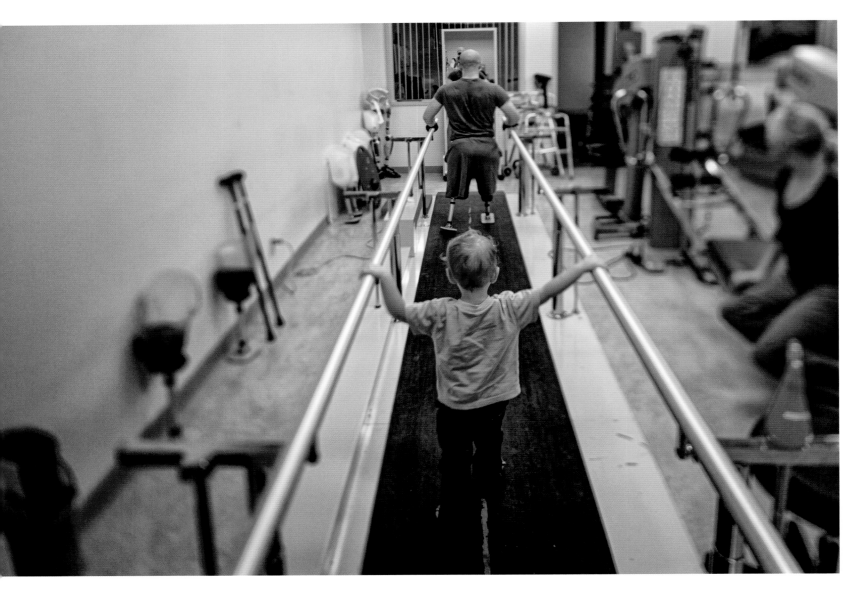

Liam, 2, accompanies his dad, Jake Romo, during rehab at
the Naval Medical Center in San Diego. Romo, 22, lost both his
legs while serving with the 3rd Battalion, 5th Marine
Regiment (3/5) in Sangin, Afghanistan. October 2011.

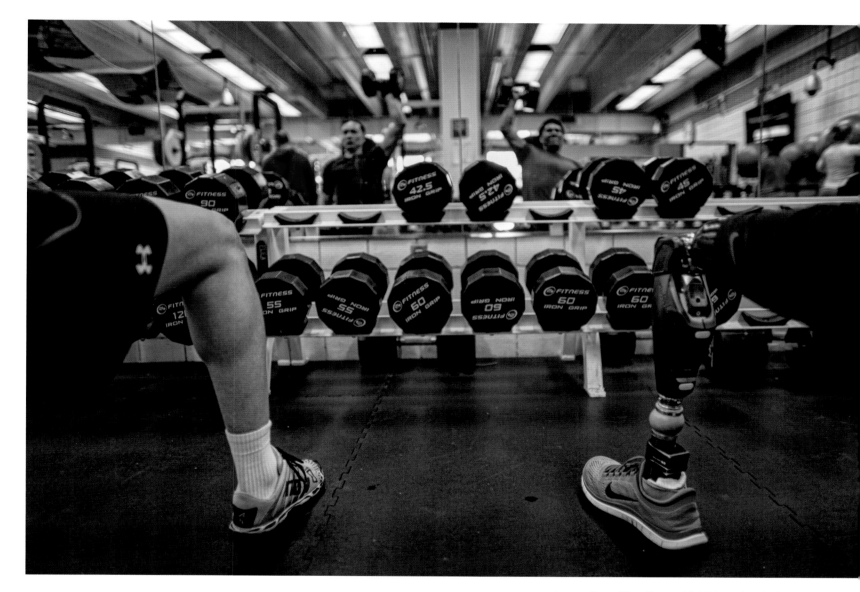

Army veteran Rico Roman (right) lost a leg during his third deployment to Iraq, in 2007. Here he trains in Colorado Springs, Colo., as a member of the men's U.S. Paralympic Sled Hockey team. February 2014.

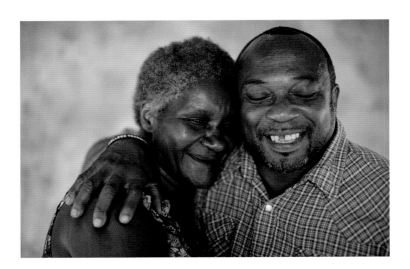 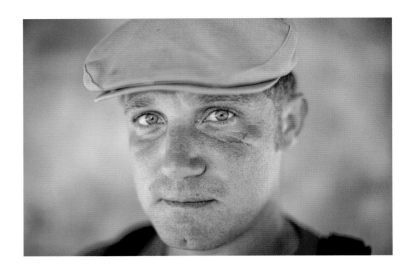

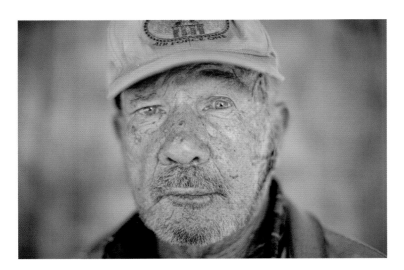 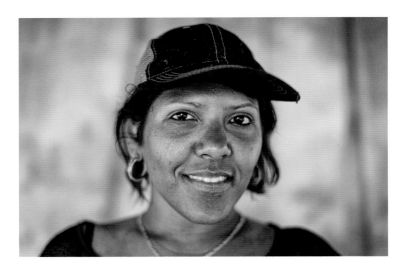

Attendees at "Stand Down," an event for homeless veterans in San Diego. July 2014. TOP: Marcus Bennett, 32, joined the Marines as a teenager and served for 10 years. MIDDLE: Fred E. Parks (photographed with his wife, Jessica) was in the Army for five years in the 1980s. BOTTOM: Henry Addington, 67, served with the Navy in Vietnam.

TOP: Melinda Baca did clerical work in the Navy in the late '80s and never deployed to a war zone. MIDDLE: Dan Martin, 29, was a Marine for four years, then in the Army for three. BOTTOM: Vanessa Messner, 40, was born in Panama and served in the Army from 1996-2001 as a medical supply specialist.

Lance Cpl. Josue Barron lost his left leg and left eye in Sangin, Afghanistan, while serving with the 3/5 from Camp Pendleton, Calif. He now has a glass eye that is emblazoned with the 3/5 insigne. October 2011.

A drawing of an M4 rifle with a grenade launcher
is taped to the door of a room at the Hollywood
Veterans Center. July 2015.

A deported veteran stands outside a screen window
at a drug and alcohol rehabilitation center on
the outskirts of Tijuana, Mexico. December 2015.

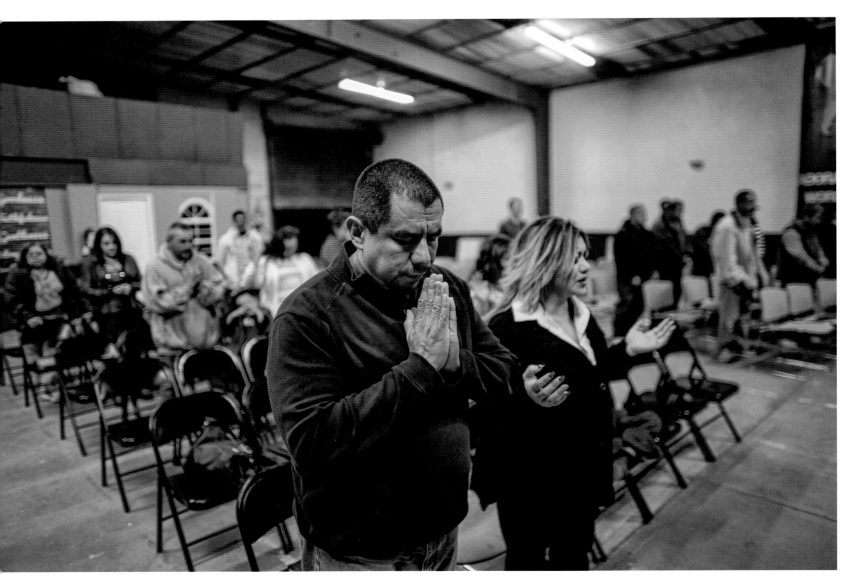

Pastor Robert Salazar (center) prays before giving his sermon at
the Cruising for Jesus mission of Tijuana. Salazar is a deported
Marine, and his church runs a men's drug rehab shelter
nearby to help other deported veterans. December 2015.

Navy veteran Jamie Livingston outside her home
near El Paso, Texas. March 2013.

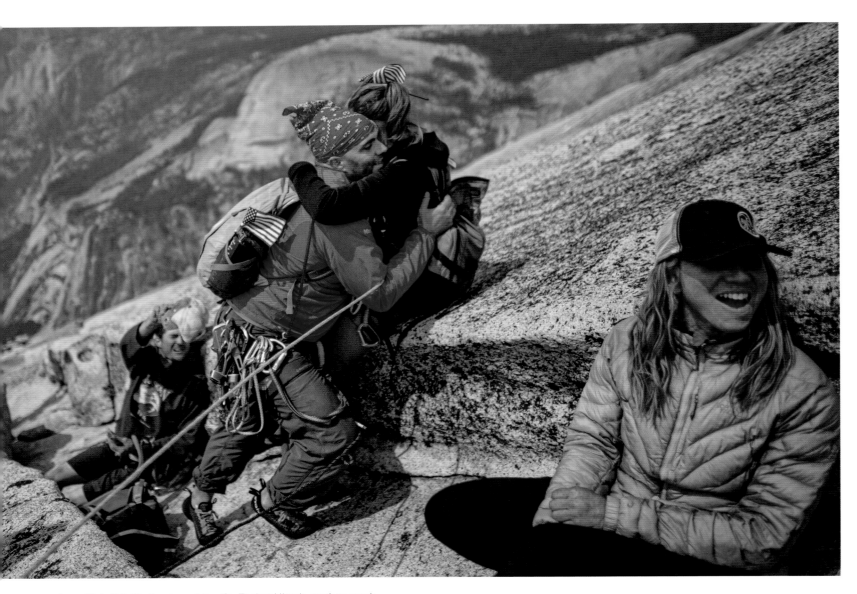

Army Maj. D.J. Skelton hugs his wife, Tucker Hirsch, as they reach
the summit of Half Dome along with fellow climbers. Skelton
lost an eye and much of his left arm in Fallujah, Iraq, in 2004 but
returned to lead troops in Afghanistan. Nineteen veterans
commemorated the anniversary of Sept. 11 by climbing two
peaks at Yosemite National Park. September 2013.

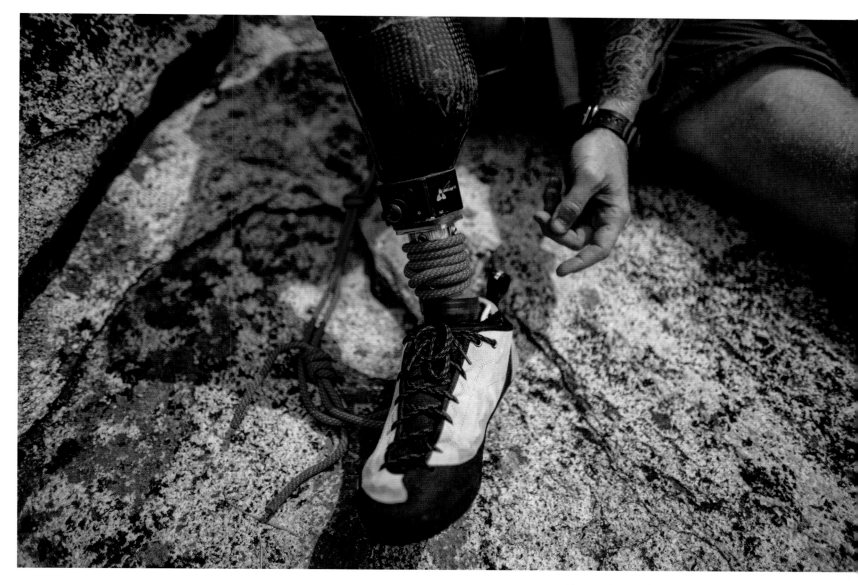

Veteran Andrew Sullens lashes his prosthetic leg
to his belt after it nearly fell off while he
was ascending the 800-foot southwestern
face of Half Dome. September 2013.

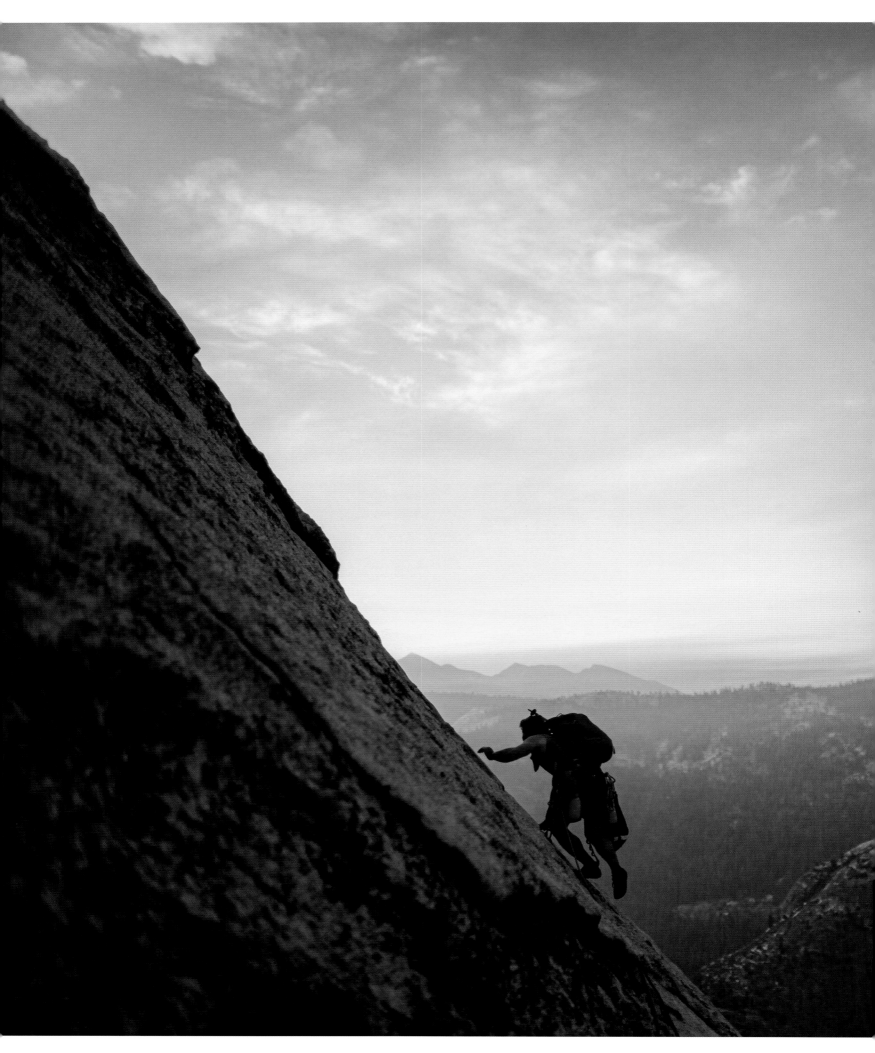

Niels Tietze leads a group of
injured vets from the wars
in Afghanistan and Iraq up the
southwestern face of Half
Dome in Yosemite National Park.
September 2013.

DISPATCH: CAST LEAD

Israel, Gaza, and the West Bank
December 2008 — January 2009

David and I were standing on a sunny hilltop overlooking the Gaza Strip a few miles away, watching smoke rise from relentless Israeli airstrikes as a handful of Hasidic Jews danced and chanted to a crackly techno soundtrack from a nearby van.

They weren't joyful at the carnage in Gaza — they were singing about a rabbi-cum-Messiah returning soon to usher in Judgment Day.

We had hastily stopped for batteries and energy drinks that morning but stupidly forgot lunch. We were hungry.

"I hope the Messiah brings back some fucking food," David quipped as he took long-lens photos of Gaza City, washing down his steady diet of snuff tobacco with Red Bull.

It was the 2008-09 war that Israel called Operation Cast Lead and Palestinians called "the massacre." The stated goal was to stop rocket fire into Israel from the militant Hamas party. Israel had blocked all journalists from entering Gaza — a hill hugging the border would have to do.

A few days before, we'd been covering a tear-gas-filled riot in the occupied West Bank when an Israeli rubber bullet had sailed a few inches past David's head and smashed apart his camera lens.

Now, standing on the hill, a squiggly line of white smoke sudd-enly shot up from inside Gaza. It was a Palestinian house-made Qassam rocket: simple, notoriously indiscriminate. But they can still kill.

In the sky the Qassam gently tilted directly toward us and the dancing End Time Hasidim.

David kept shooting as I urged him to take cover. "I'm good," he muttered, ignoring me.

Finally, he hastily joined me crouching in a fetal position in the dirt on the back side of the hill.

As it sailed directly overhead, the rocket hit a power line, making an almost cartoonish, loud TWAAANNGGGG vibrating sound. Redirected downward and off its straight path, the rocket plummeted to the ground and exploded some 50 yards away.

We looked at each other for a moment.

David broke the silence with a smile, shouting: "TWAAAN-NGGG!"

"TWAAANNNGG!" I shouted back.

We finally entered Gaza via Egypt hours before a cease-fire took hold, and we found destruction like nothing we'd seen since Iraq: Entire buildings and blocks were razed, men dug for survivors, families wailed in mourning or held stunned silence. A father dug a shallow grave in the sand to bury his baby son in a dirty blanket.

"Rockets. I mean, I get it," David said, snapping more pictures of the rubble and death. "But what the fuck?!"

That was David: a pro doing his job but never emotionally detached from the reality in front of him, however harsh. And not oblivious to the risks either.

"I go back and forth between Afghanistan every year. I went to Iraq every year," David said in an NPR interview later, "and it was always the question among the journalists, I think: 'When you leave, do the dice reload? Or are you just stacking up bad karma?' And I don't have an answer to that."

I don't either.

Maybe the dice reload. Maybe you just get lucky with a camera lens or a power line. For years after that day, when I saw David he would look at me and out of the blue, loudly or sotto voce, say, "TWAAANNNGG!"

— Eric Westervelt

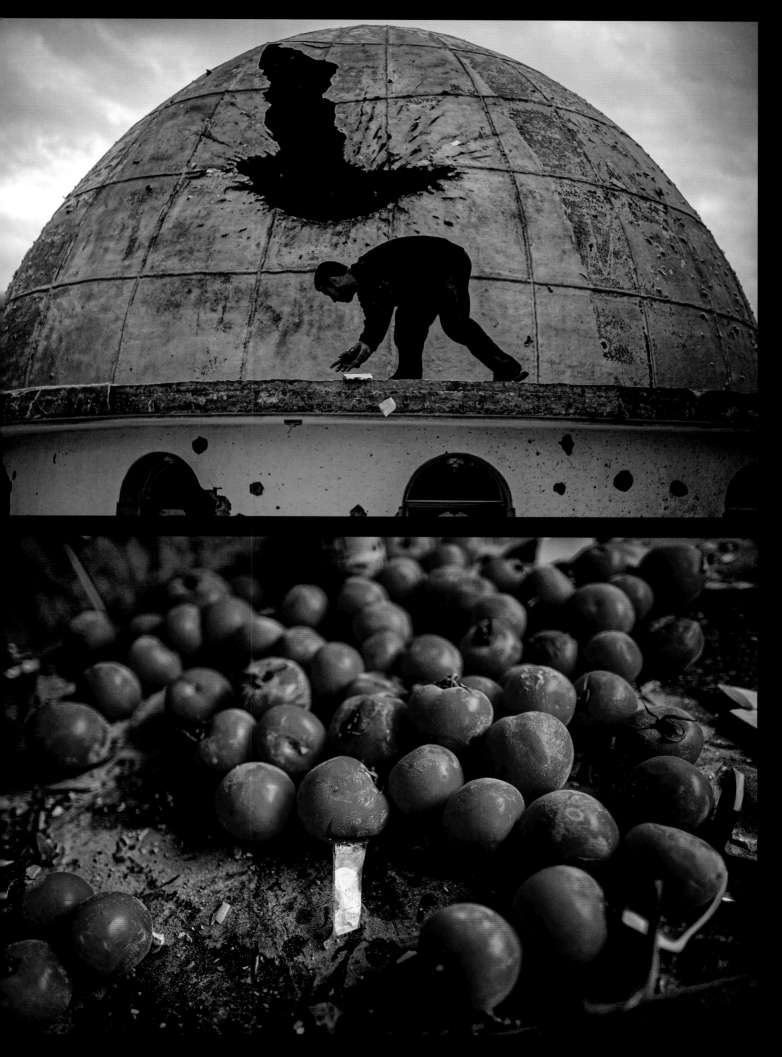

ABOVE: North of Gaza City, a Palestinian man picks up fragments of a mosque's golden dome, which was hit by a tank round during fighting between Hamas and Israeli forces. January 2009. BELOW: Tomatoes, pierced by shards of broken glass, lie rotting in a kitchen in the northern section of the Gaza Strip. January 2009.

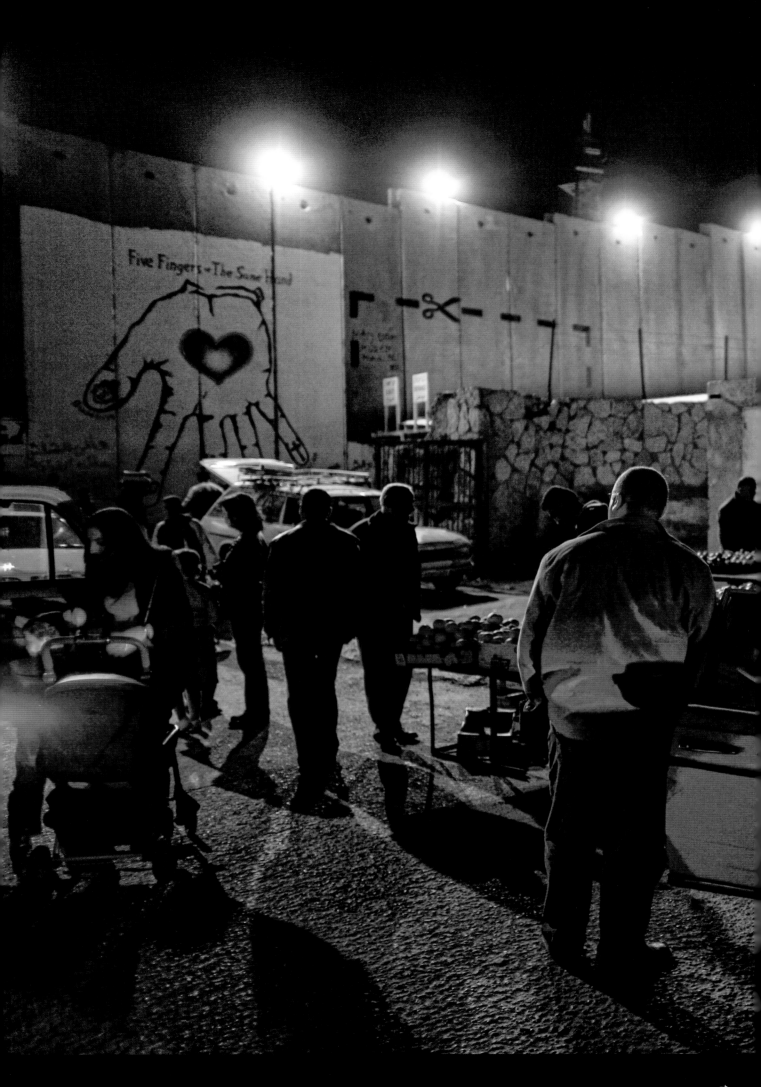

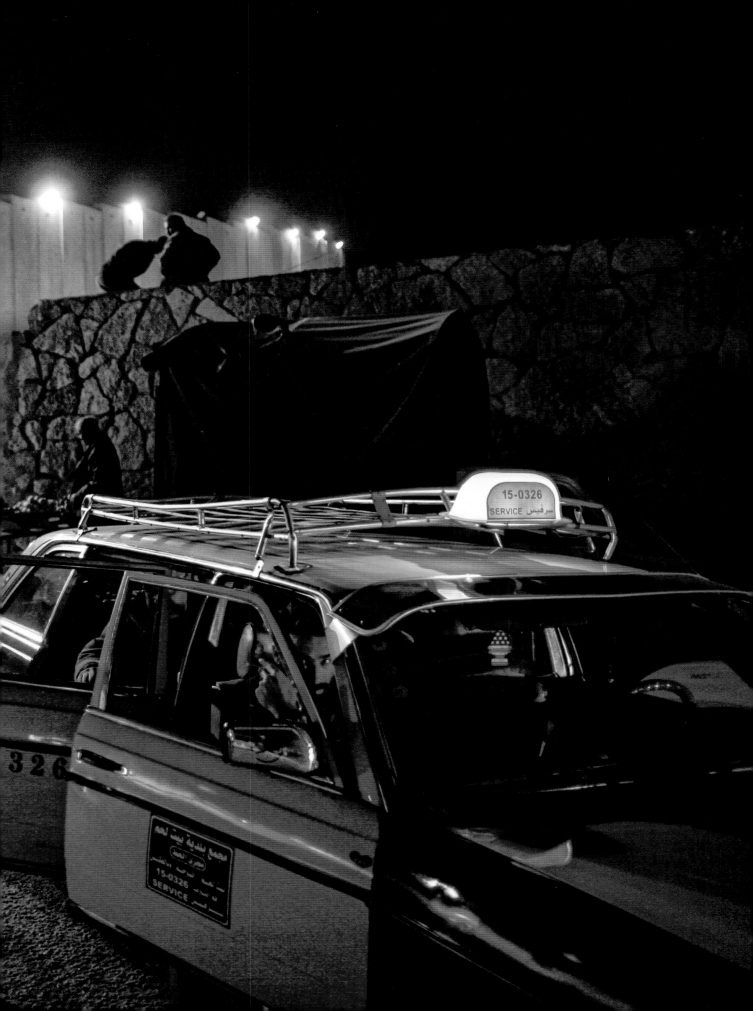

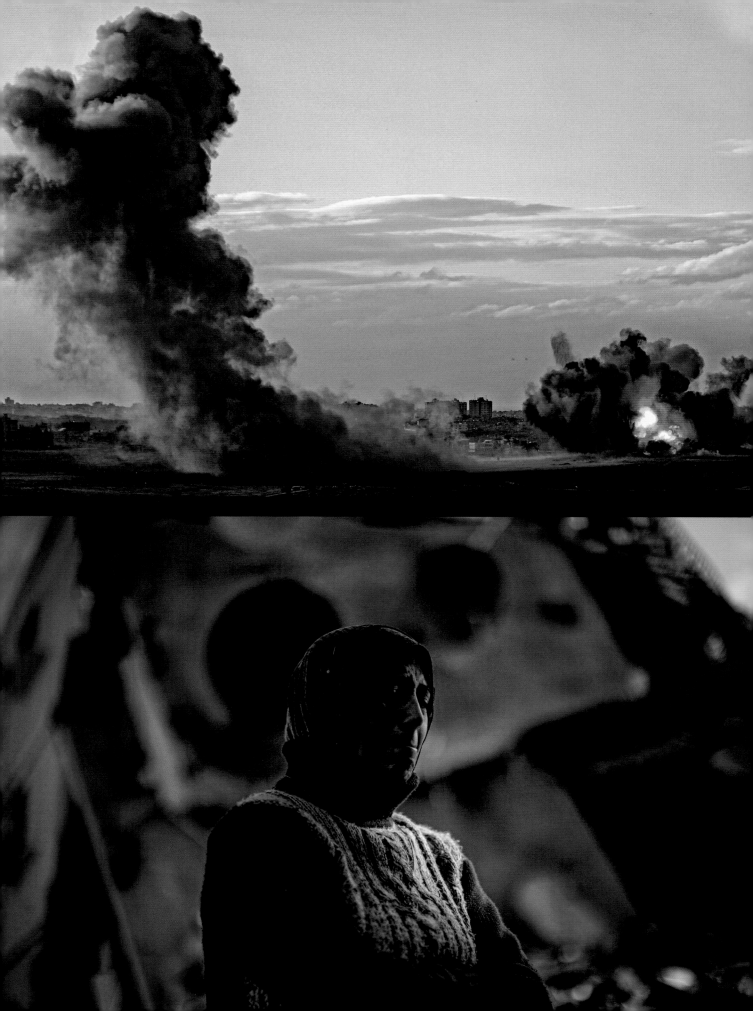

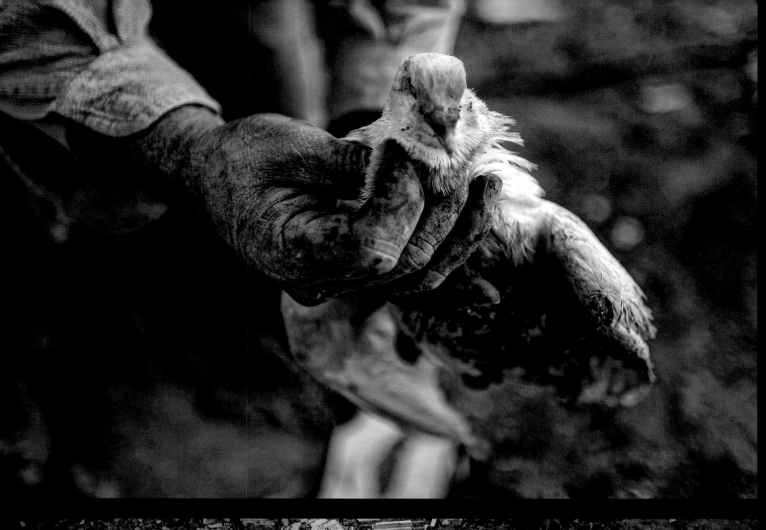

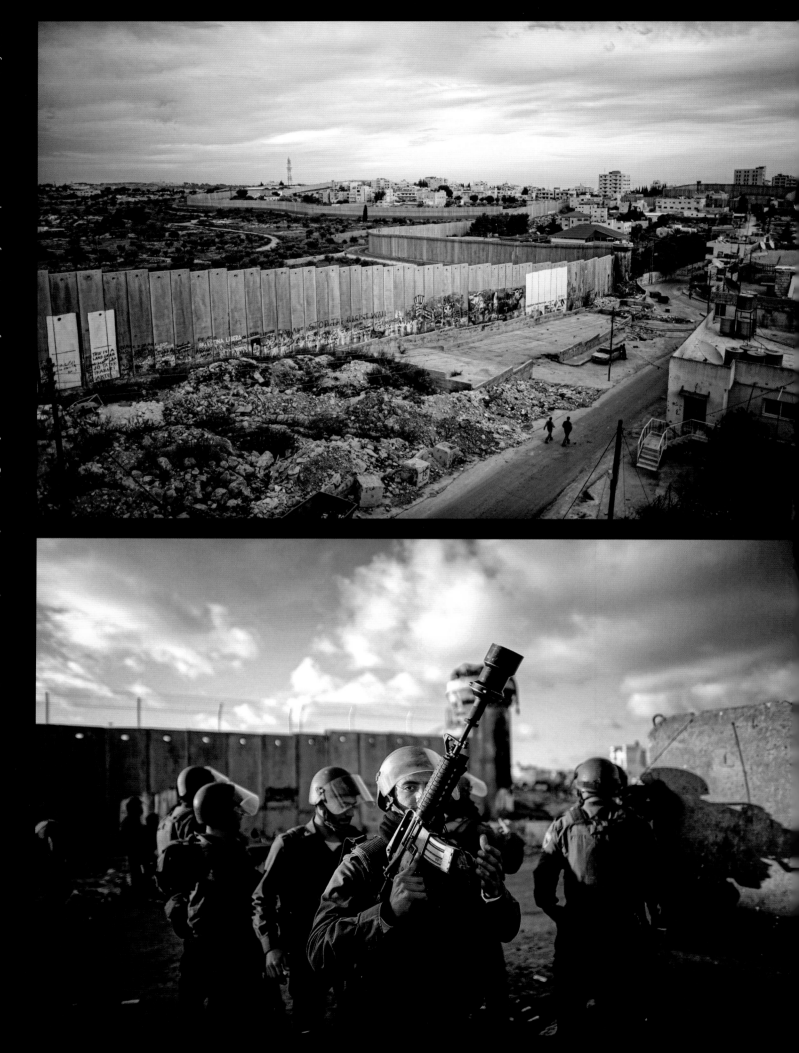

ABOVE: Israel's 125-mile wall separates much of the occupied West Bank from Jerusalem. Israel calls it a "security barrier." Palestinians call it a "segregation fence." December 2008. BELOW: Israeli soldiers fire tear gas and stun grenades in an attempt to break up a roadblock set by Palestinian youths during a rally at the Israeli military-manned Qalandiya checkpoint outside Ramallah. January 2009.

104

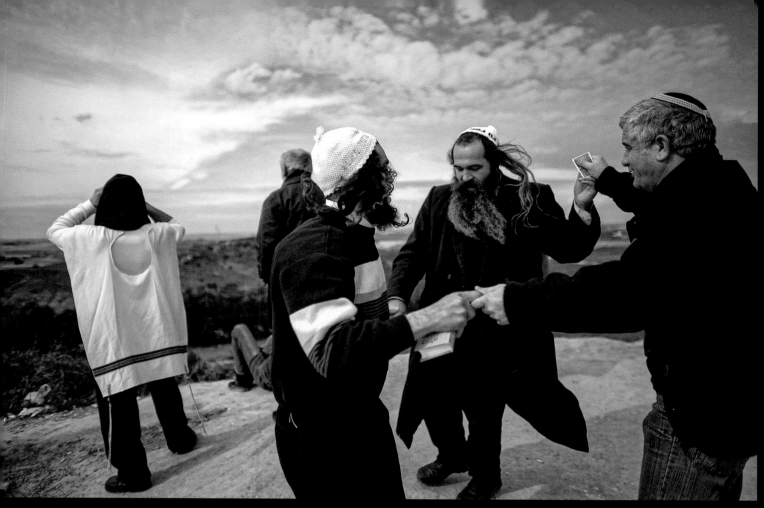

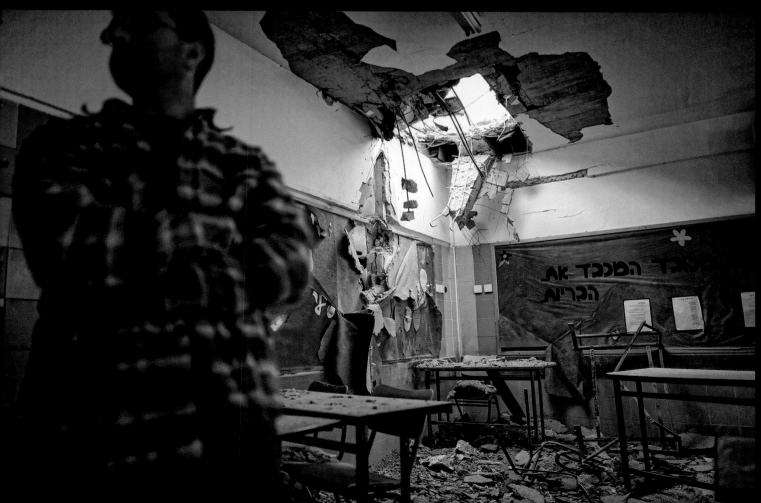

ABOVE: A displaced Palestinian boy waits in a United Nations van at a temporary shelter before moving back to his destroyed neighborhood in the Gaza Strip. January 2009. BELOW: Relatives mourn the death of Anwar Ziad Sammor, 27, who was killed by Israeli gunfire in the village of Beni Suhaila. January 2009

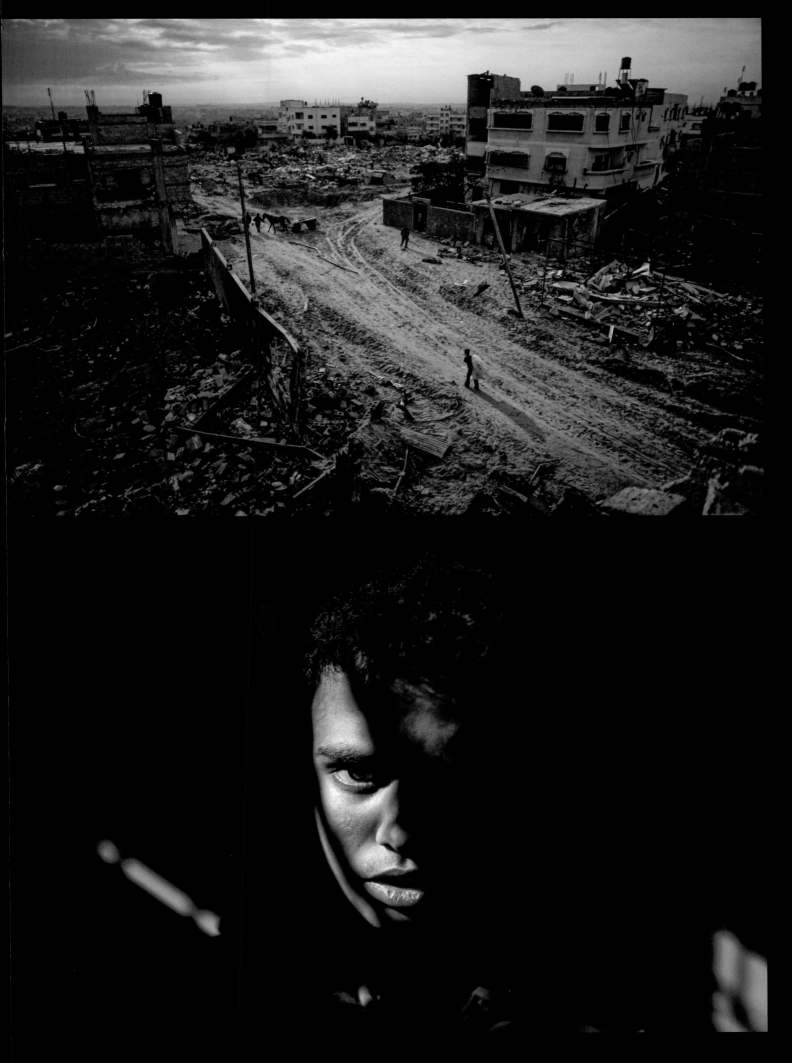

ABOVE: A neighborhood in Gaza City lies in ruins as residents try to pick up the pieces. January 2009. BELOW: Ahmed Samouni, then age 16, was hiding for days among his dead and dying relatives, terrified to seek help for fear that Israeli soldiers camped outside would kill him. January 2009.

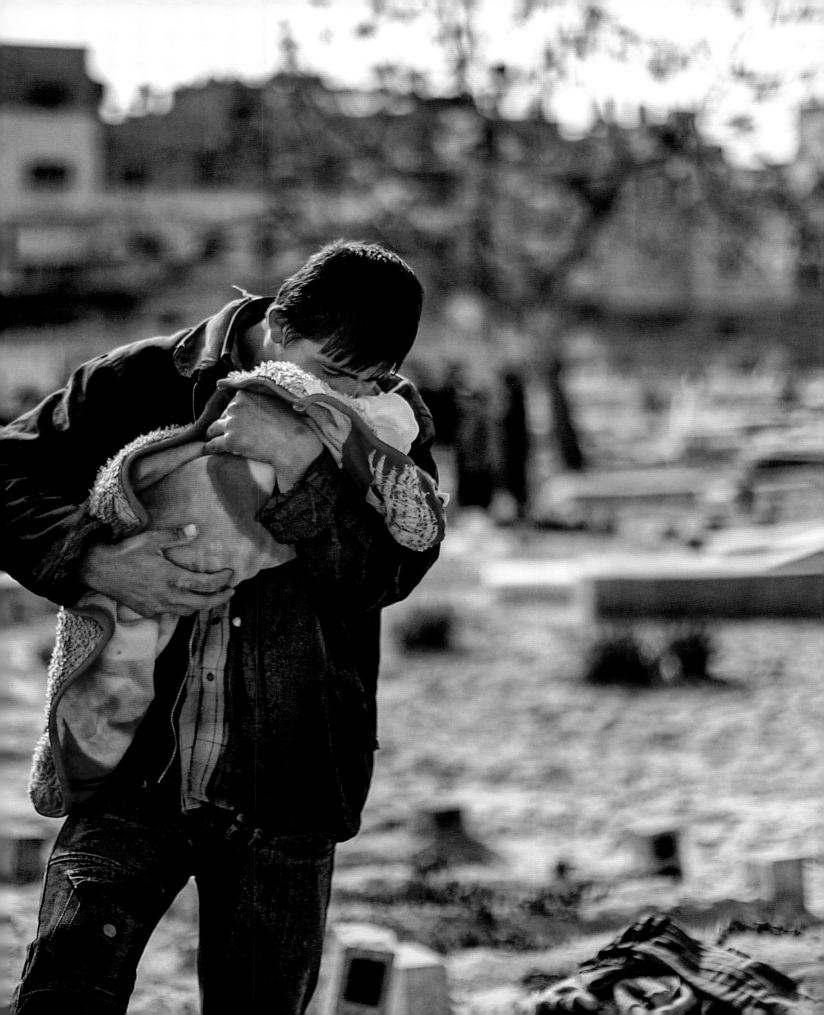

DISPATCH: GOLD AND POISON

Nigeria
September 2012

David had a smirk on his face when I picked him up at the Abuja airport.

I'd rented a slightly battered, double-cab pickup for our trip to the north of Nigeria.

"What's this piece of shit?"

"It's a Toyota," I said. "And it's got four-wheel drive."

"Why didn't you get a Land Cruiser?"

"I couldn't find a Land Cruiser."

been paralyzed by the virus, near the city of Kano in the volatile northeast of Nigeria. Boko Haram was in the midst of a deadly bombing campaign there. The receptionist at our hotel warned us not to leave the premises. But we did.

David got a picture of the boy, possibly one of the last polio victims in Africa, being carried by his father. Most of the image is out of focus except for the boy's small left hand draped around his dad's neck. David's photo did what countless press releases and scientific reports on polio hadn't: It captured the fragility of a child, the tenderness of a father and the tragedy of

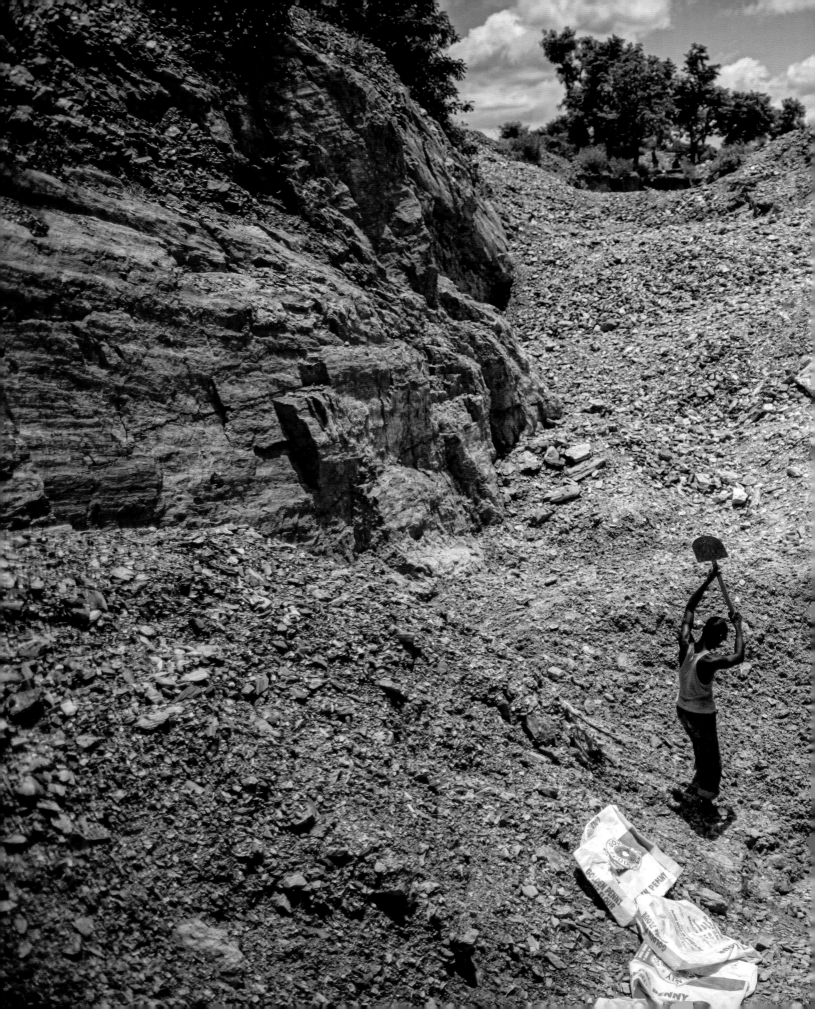

An open-pit gold mine near the town of Bagega in northern Nigeria. As the global price for gold rose dramatically in the early 2000s, farmers started excavating hillsides and chasing underground veins of ore on land they didn't own. September 2012.

ABOVE: Gold deposits in this part of Nigeria are trapped in soil heavily laden with lead. Mining and processing the ore released lethal levels of lead dust into the air. September 2012

BELOW: A man emerges from a hand-dug gold mine. The tunnels are only wide enough for one man to work in the shaft at a time. September 2012

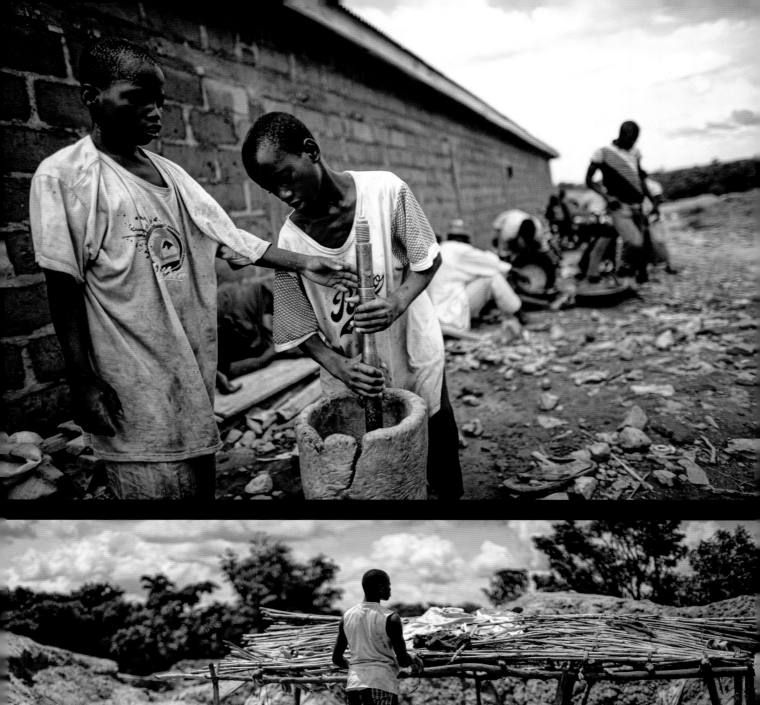
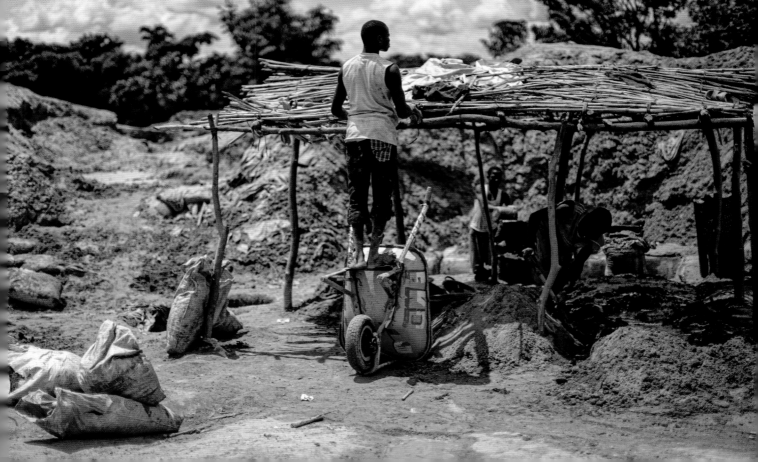

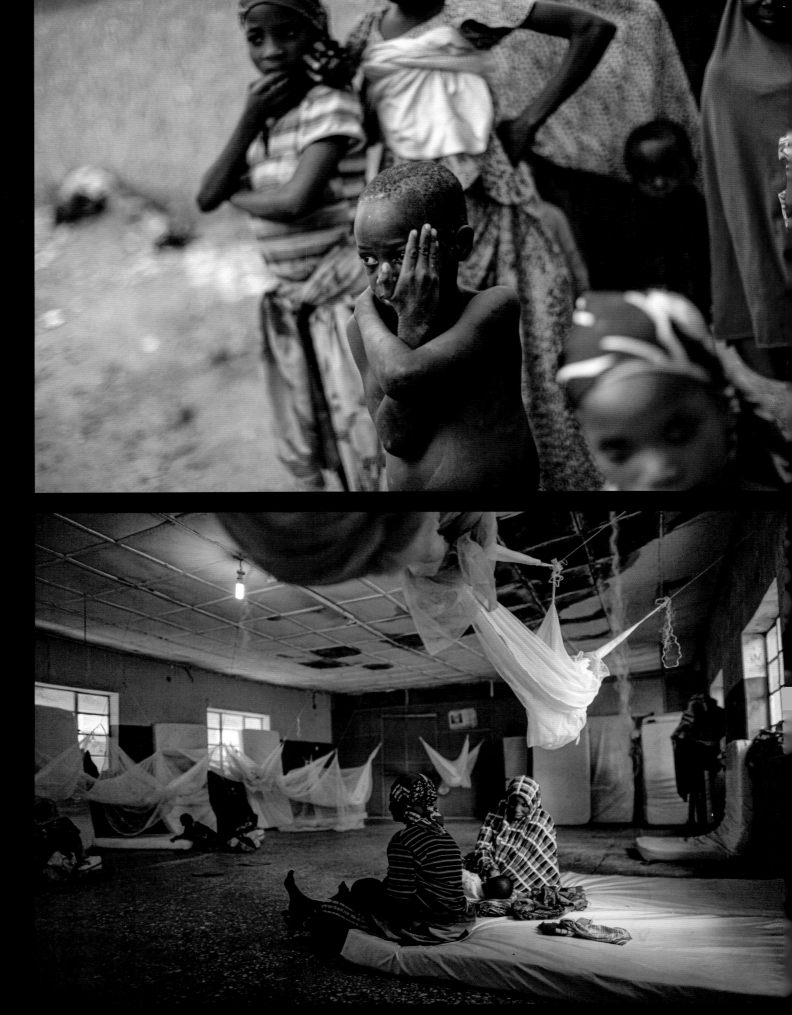

ABOVE: The deposits of gold in Nigeria are buried with lethal amounts of lead, and manual extraction processes cause the lead to be released into the air. Children's nervous systems are more susceptible to lead poisoning, leading to hundreds of deaths. September 2012. BELOW: Women and their children wait for medication at the clinic in, Nigeria. September 2012.

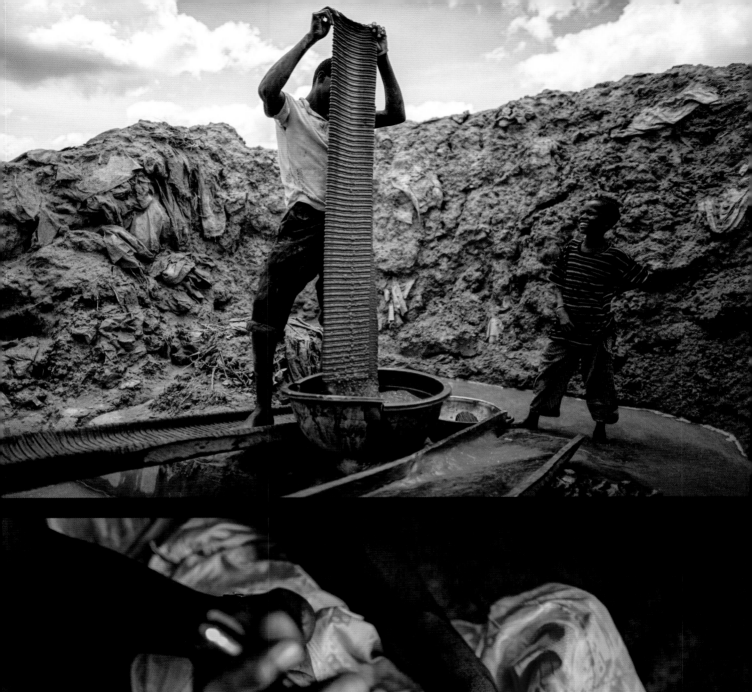

A man naps at a scooter and tricycle shop run by polio victims in Kano, at that point one of the few places in the world that still had active transmission of polio. September 2012.

HOME. "Normal" always depends upon where one is standing.

David wrote that in a little travelogue about encountering a pet reindeer in the back of a pickup truck in Alaska. He was always insisting that he couldn't write, but it obviously wasn't true. He had a nuanced way of saying things — in pictures, in writing and in the way he spoke.

By the time I met him, he was already known as a badass war photographer. He walked in the Washington office having just dodged a literal bullet on assignment in the West Bank; Israeli security forces had fired a rubber bullet straight through his telephoto lens. Obviously the guy was hardcore. My overeager questions were met with gruff one-word responses. But it didn't take long for him to warm up.

His photos revealed a profound sensitivity and sense of humor. He couldn't have made pictures like his, otherwise — and probably wouldn't have worked so well in a mostly female photo department like ours.

There are photos of David on display at NPR, scenes from far-flung locales that show the public side of him and the work he cared about so much. But some of my favorite photos of him are the personal ones. Reclining in an office chair, wearing my electric pink winter hat. Dutifully coloring a snowman at a holiday gathering with all his 20-something colleagues. And, the best, taking a picture of his haul from a holiday gift swap: a variety pack of multicolored nail polish.

We all took turns editing his photos when he was in the field. This often involved hours-long conversations on the phone — he could out-chit-chat us all. When he'd return from an assignment, he'd get to the office early and pace around, looking for candy and anyone willing to shoot the shit. He'd sip coffee from a cheap mug from a local hotel, and hover over your shoulder until you stopped what you were doing to listen to his stories. His laugh was surprising —almost a giggle.

And then he'd hand over his hard drive. It's a rare and vulnerable thing for a photographer to give an editor complete access to an unedited take. It was like unwrapping a gift every time: that precious frame of a father with his carefree daughter, both recently arrived refugees from Syria; those dignified portraits of civil rights activist James Armstrong; and yeah, that pet reindeer in a pickup truck. Editing was easy.

Working with him was, too. He was ready to go anywhere at any moment to photograph anything. And no matter what the assignment or location — a bus stop, a farm, a factory — he found the beauty in it, and helped us to see it, too. And David was willing to try anything to get people to connect with these stories: a tilt-shift lens in Haiti, video portraits in Afghanistan, a pop-up portrait studio at a homeless veterans camp.

David was both thoughtful and brave; he was someone to look up to, especially for the younger colleagues on his team. I mean, he once tried eating a marshmallow Peep that had been sitting on someone's desk for a year. It was a dare, and he was no chicken.

— Claire O'Neill

Outside Mountain View, Ark. August 2008.

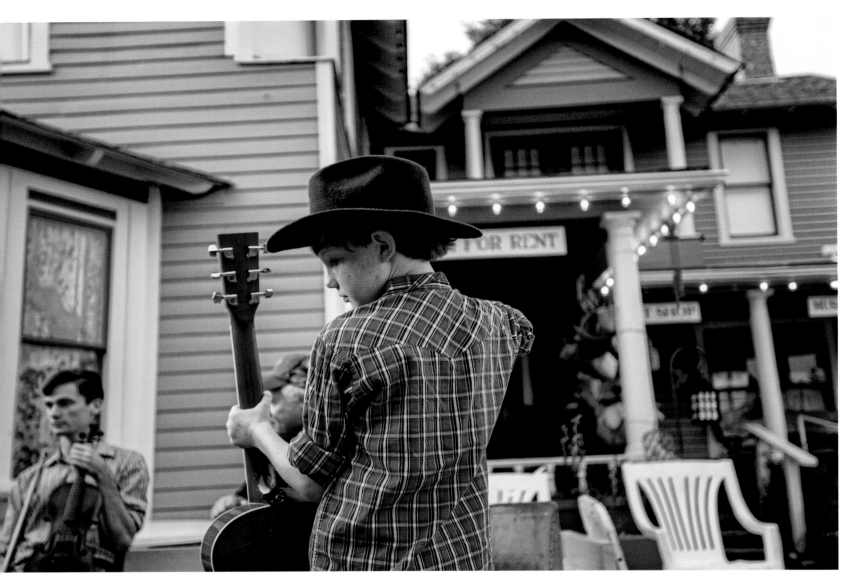

The town of Mountain View, Ark., is home to a popular annual
folk festival, but is also a place where local musicians lead
the effort to preserve the traditional music that is passed
down through generations. August 2008.

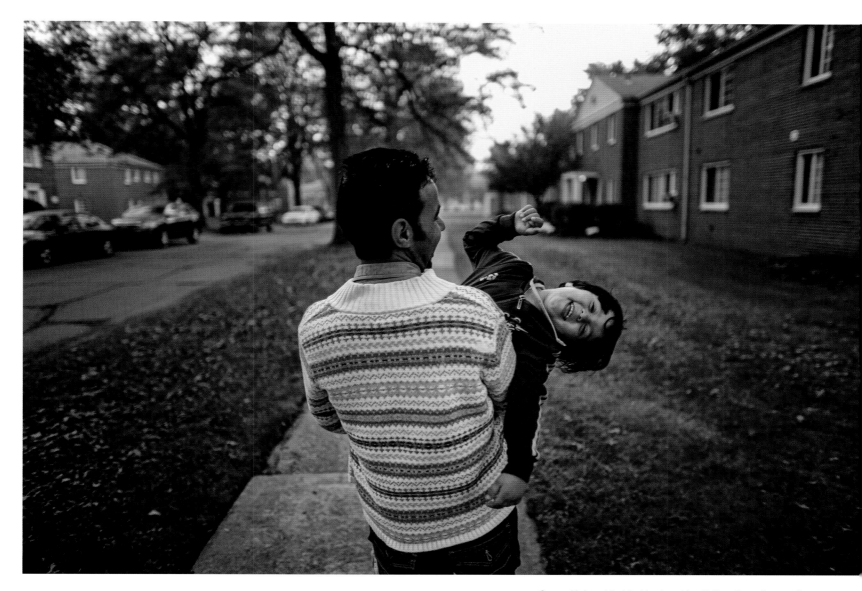

Omar Al-Awad holds his daughter Taiba, 4, as they walk
to their home in Toledo, Ohio, where they were resettled
after fleeing Syria and living in a Jordanian refugee
camp for two years. October 2015.

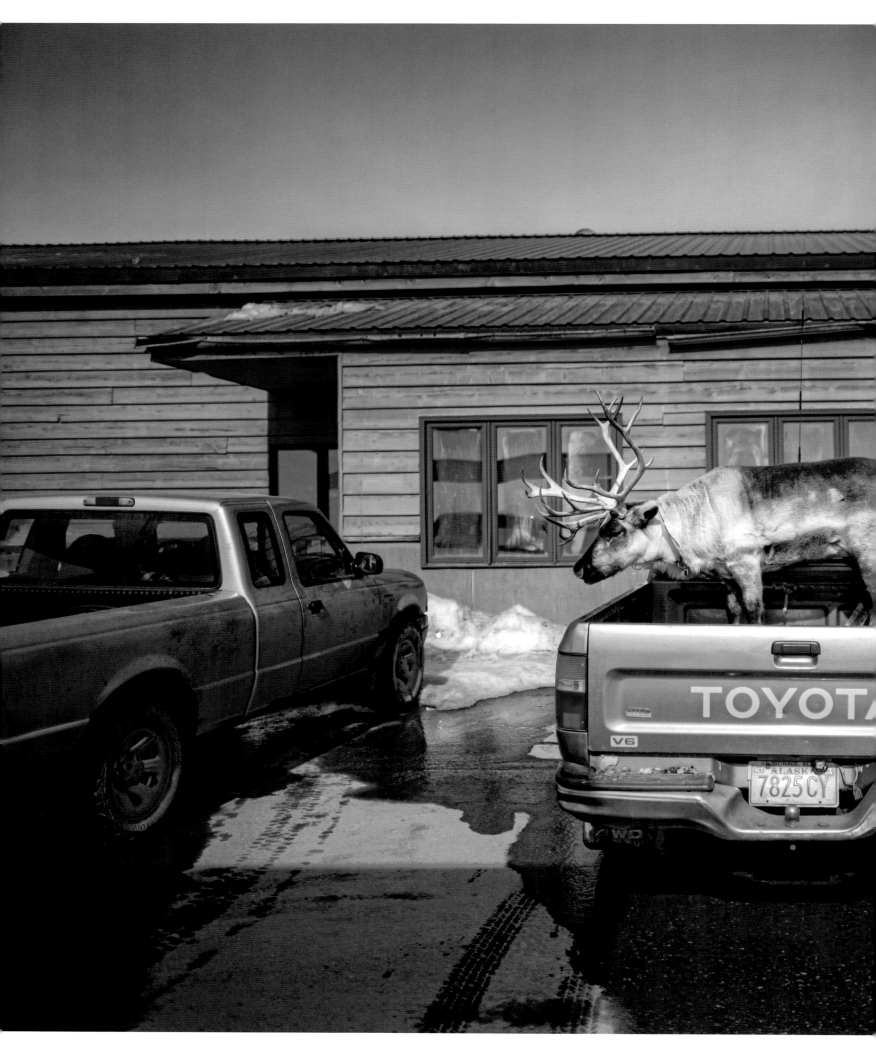

"Velvet Eyes" — a pet reindeer
belonging to Carl Emmons — stands
in the back of a pickup truck
outside a market and gas station in
Nome, Alaska. April 2013.

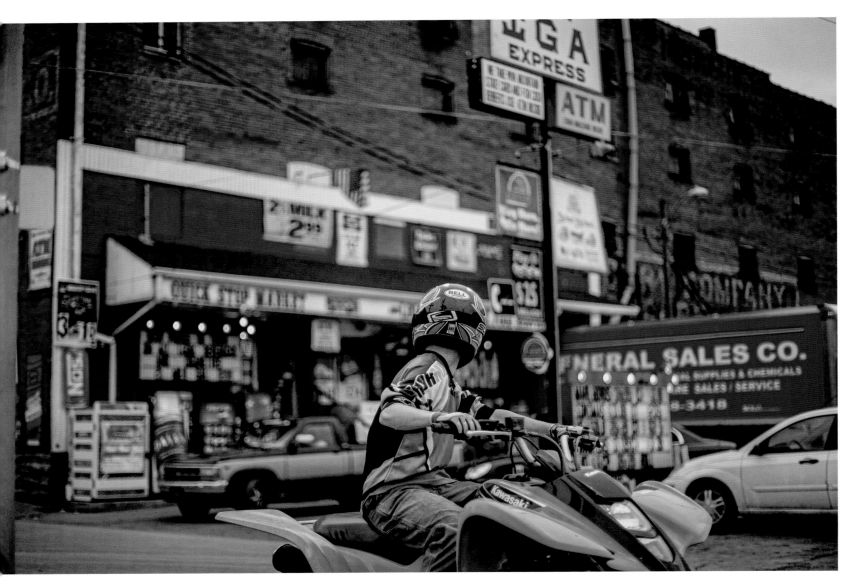

All-terrain vehicles are a common sight and legal on the streets of Logan, W.Va. Hundreds of miles of trails cut through the mountains of the state, creating one of the largest off-highway-vehicle trail systems in the world. October 2008.

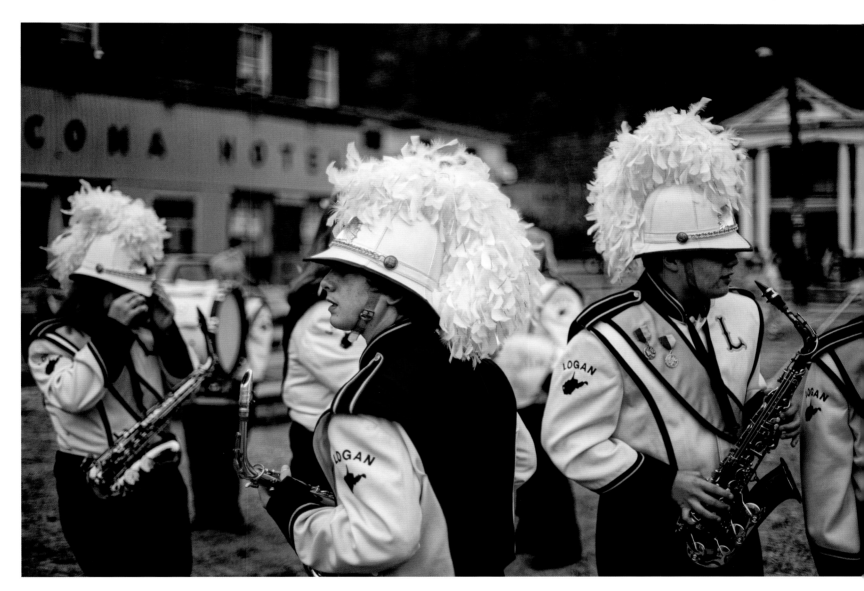

The Logan High School Marching Band members visit
after performing at a kickoff celebration for a new
state building project in the center of Logan, W.Va., a
small coal mining town with fewer than 2,000
residents on the Guyandotte River. October 2008.

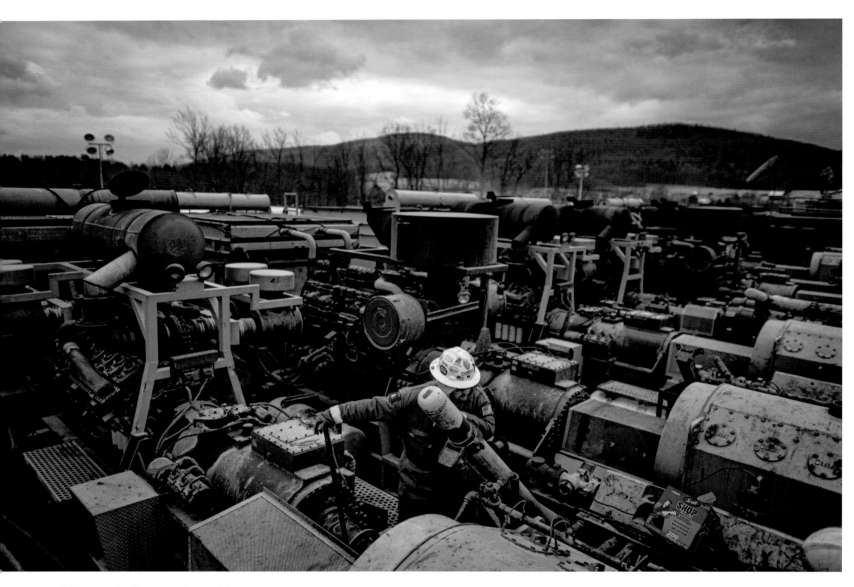

A Chesapeake Energy worker maintains
equipment used for hydraulic fracturing in
Towanda, Pa. February 2012.

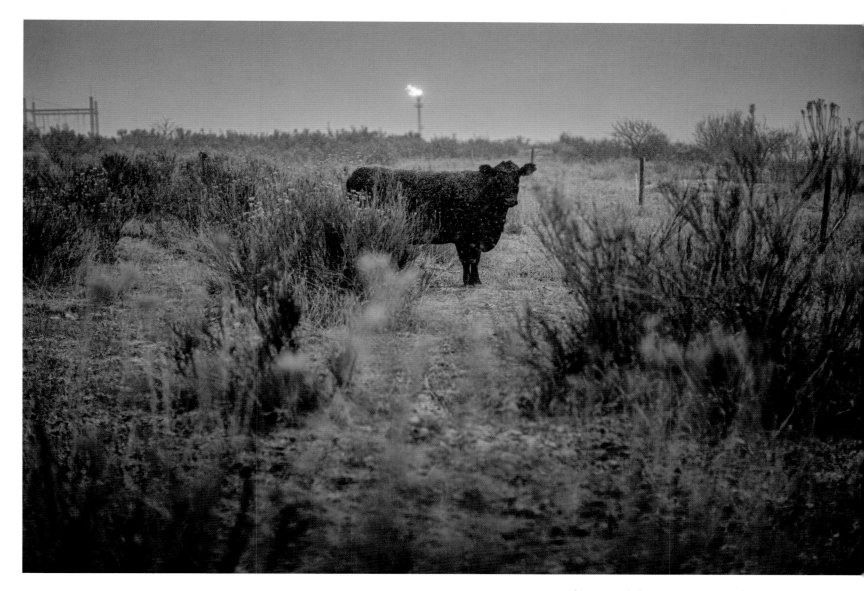

A cow stands in a pasture as a gas flare burns in the distance at a gas treatment and compression facility near Parachute, Colo. March 2012.

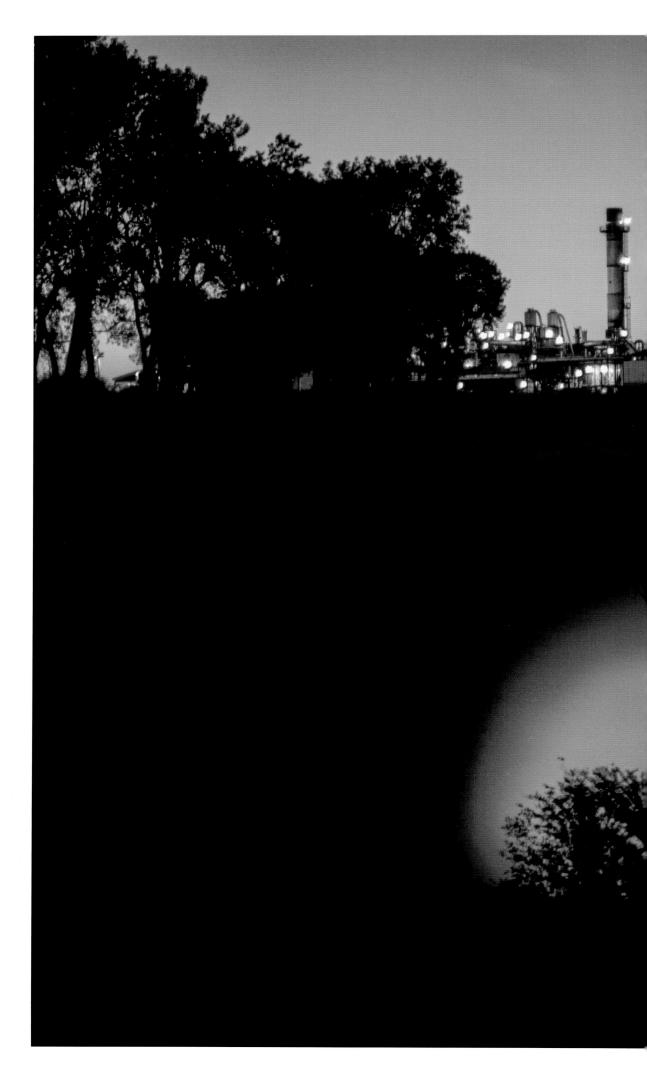

The Continental Carbon
plant, on the southern
outskirts of Ponca City,
Okla. October 2011.

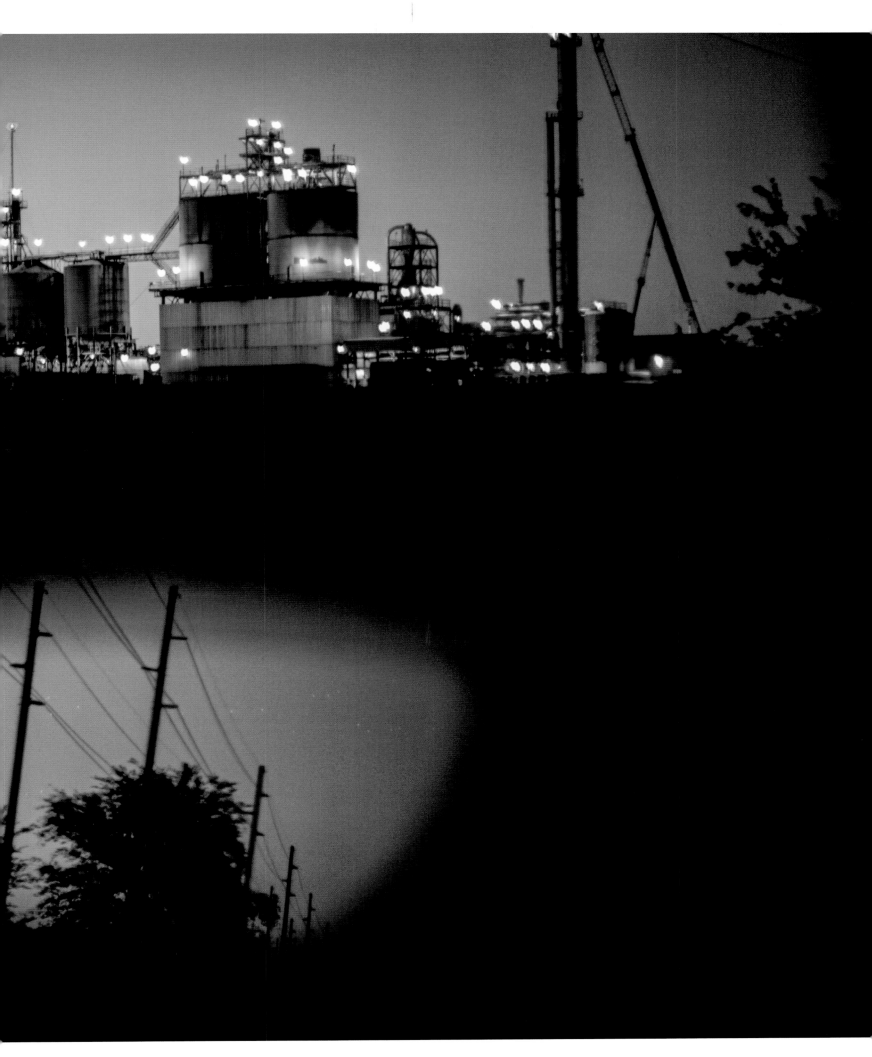

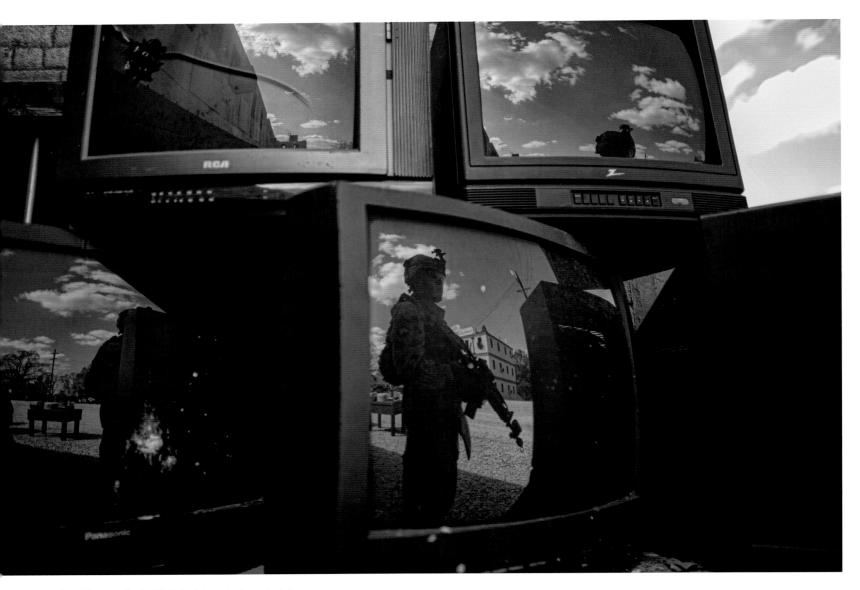

A soldier is reflected in televisions during a training
course, designed to emulate an Afghan village,
at Fort Polk in Louisiana. February 2012.

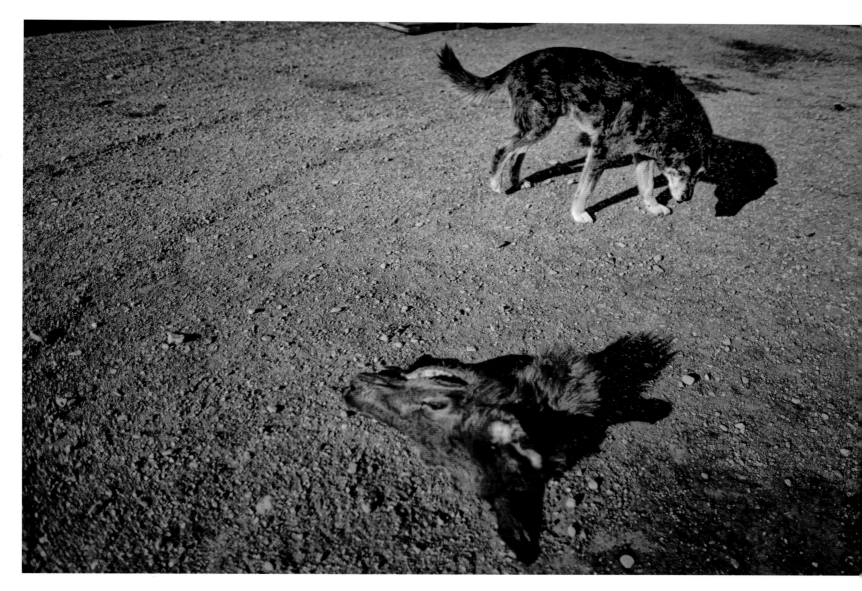

Eric Graham's dog examines an elk head. Graham works for the Blackfoot Challenge, a coalition of landowners, ranchers, hunters, environmentalists and biologists in Montana dedicated to conservation. October 2013.

Members of the Old Order Amish community of
Lancaster County, Pa. September 2008.

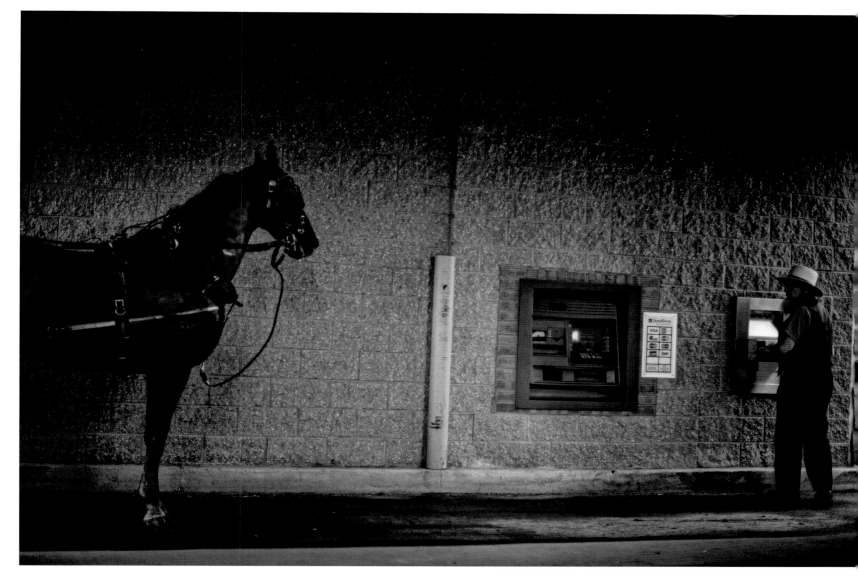

An Amish man uses a drive-through window at a bank
in Lancaster County, Pa. September 2008.

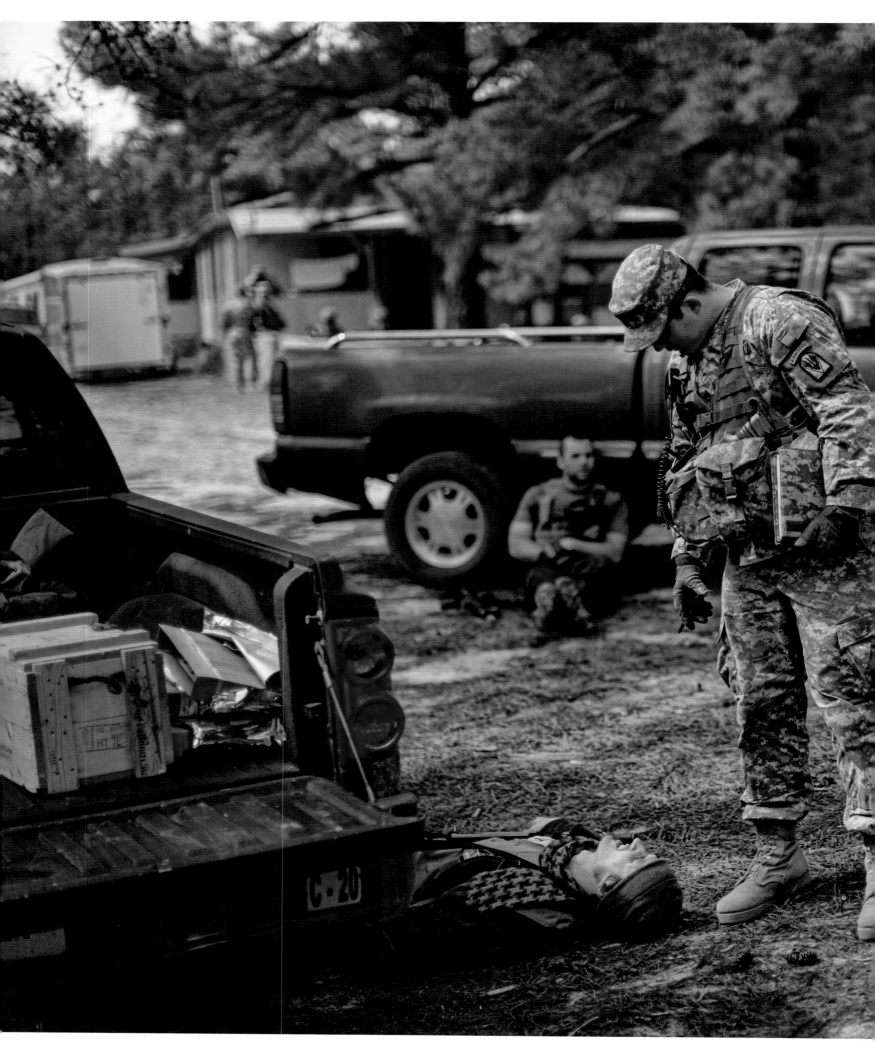

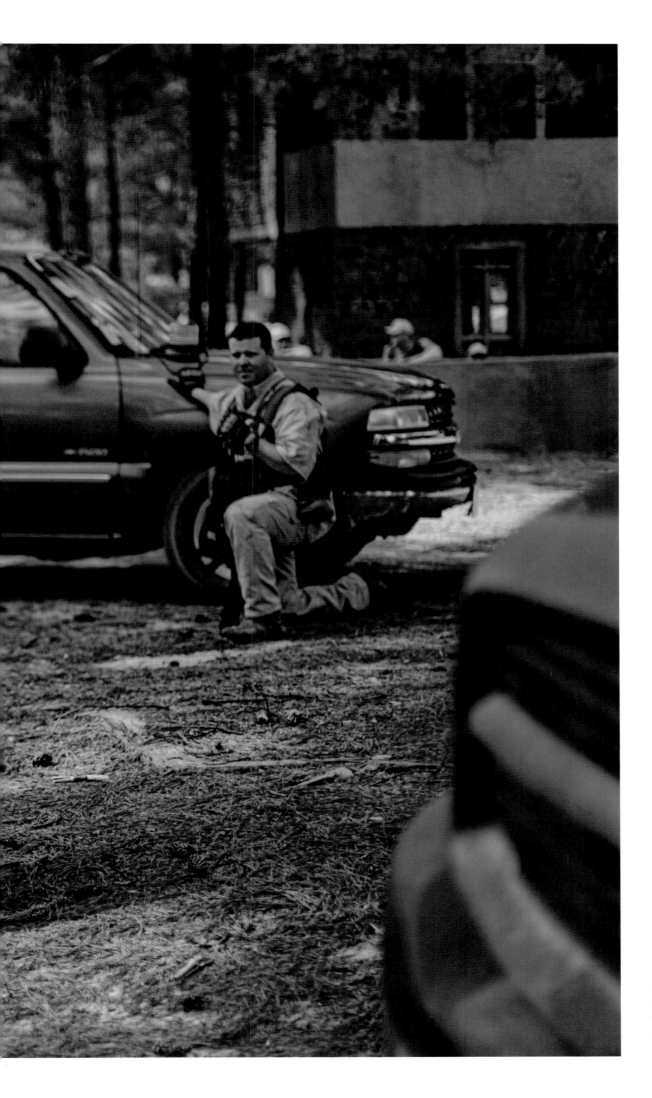

A Army trainer examines the
scene after a mock battle in a
fake village at Fort Polk
that the soldiers call Marghoz.
Louisiana, February 2012.

A well-recognized foot soldier in the civil rights movement, James Armstrong carried the American flag across Selma, Ala.'s Edmund Pettus Bridge as state troopers beat back marchers in what became known as Bloody Sunday. Armstrong was instrumental in civil rights activities in Birmingham and also ran a barbershop there for 50 years. November 2008.

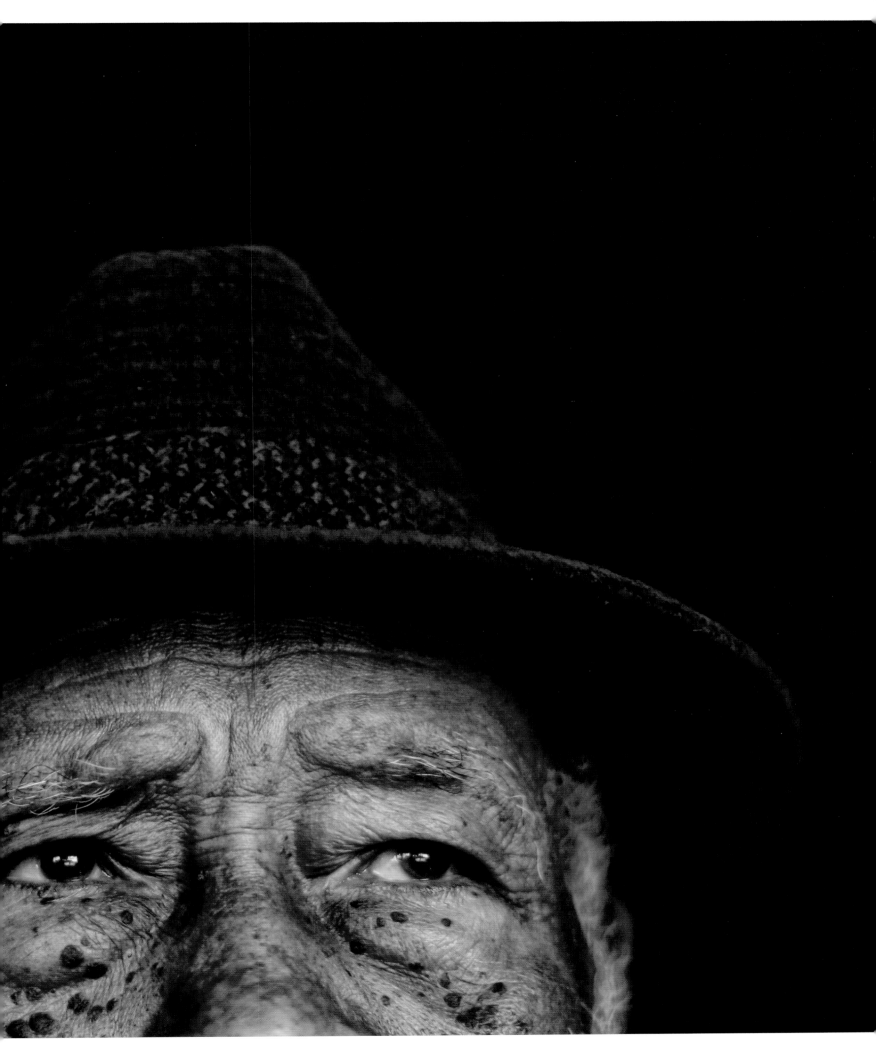

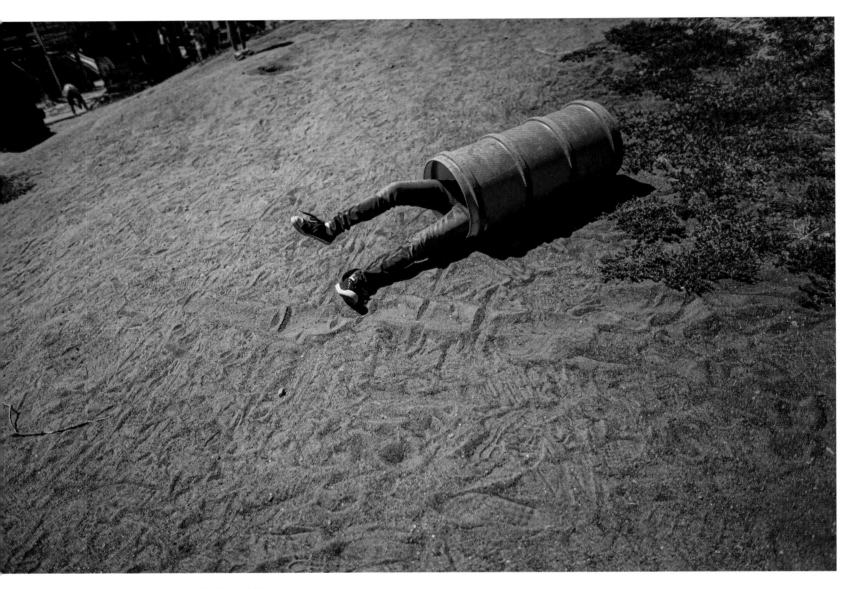

A child plays in a barrel at the Berkeley Adventure
Playground, where kids "play wild" in a half-acre
park with a junkyard feel. California, July 2014.

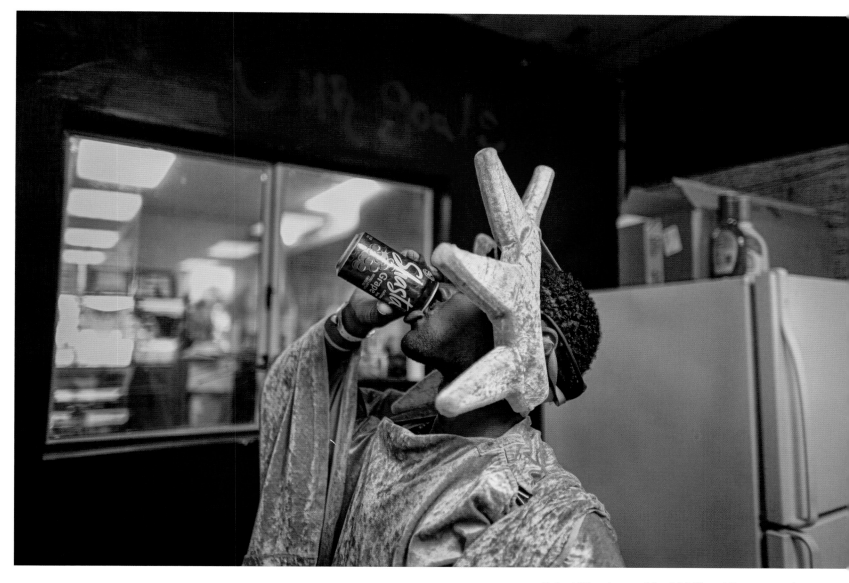

Robert Oliver is one of the 24,000 part-time seasonal workers hired by Liberty Tax Service to drum up business by dancing and waving at cars. Oliver, 27, has been dancing on the sidewalk outside a Los Angeles office for three years. April 2013.

Rocks on the shore of the Lackawanna River in Duryea, Pa., are discolored by iron oxide and sulfur compounds — pollutants left behind by past coal mining in the state. February 2012.

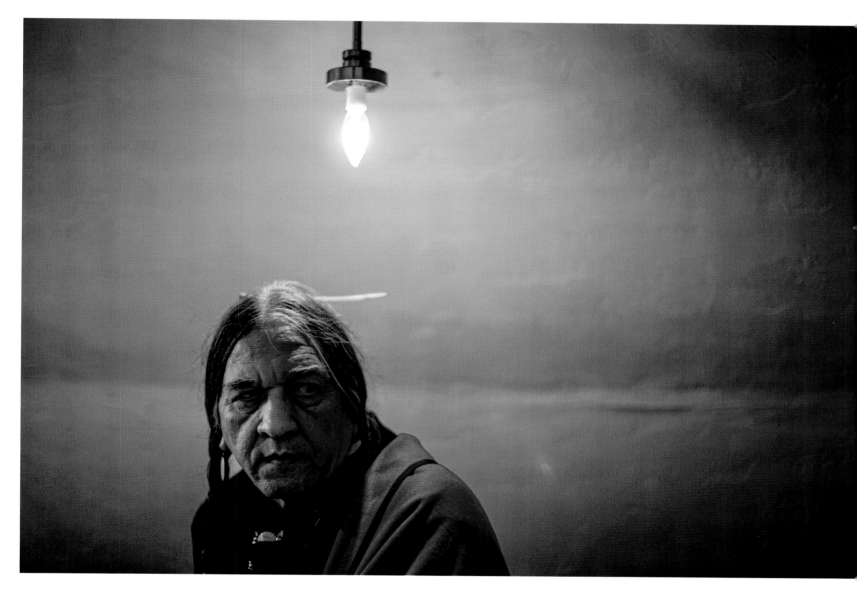

Dan Jones, a Ponca tribal official. Jones' tribe spent
years fighting the Continental Carbon Co., whose black
dust emissions polluted their community in
Ponca City, Okla. October 2011.

DISPATCH: RUSSIA BY RAIL

Trans-Siberian Railroad
December 2011

My trip through Russia with David brought him to a different kind of war zone.

Our enemies were the cold (temperatures well below zero did some funky things to a Polaroid he was experimenting with), the authorities (by now you know one. David Gilkey would not take kindly to Russian security telling him he can't photograph a train platform) and cabin fever (during 24-hour-plus legs on a Trans-Siberian train David got, shall we say, impatient … my wife, Rose, reported that he would come to her while she was reading a book and beg like a little brother for her to entertain him. Of course his charm always won her over).

The greatest challenge? Capturing the nuance of Russian life, which David did with his unique eye for telling moments and his curiosity about people and what drives them. He captured landscapes, through frost-covered windows or while tromping through snow, that somehow painted this country as not such a dark place, a country in frigid, unforgiving circumstances but holding out hope that light may one day shine. But the faces — always the faces with David — are truly memorable to me. We visited Yaroslavl, a city that had lost its professional hockey team in a plane crash. The city, which saw the team as family, now pinned its future hopes on a youth hockey program. After hockey practice, David quietly ducked into the locker room and caught a young player, with dark earnest eyes and pumpkin-orange hair, getting dressed after practice, staring back at David with what I saw as a mix of curiosity and "what are you chasing me for?!"

I loved the boy's confidence and fearlessness. When I think of Russia's hopes for a brighter future, I very often think of that photo.

David's incredible work in Russia is the only reason I forgive him for the boots.

David and I had traveled across the U.S. together in 2008, and for a few days, our editors had us stop in Texas in case a hurricane hit the Gulf Coast and we were needed to cover it. David went into full military mode — with a trip to Walmart. He insisted we spend $900 on supplies — power generators, cartloads of batteries, food, water, rain gear and boots. When the storm passed, we tried to return all the gear to another Walmart, only to be told you can't return clothing. So I was stuck with a pair of boots I never used — until going to Russia.

I was wearing them when David and I visited the small village of Sagra in the Ural Mountains. The snowpack was slippery, and the damn boots David had forced me to buy several years before performed badly. I fell on my face at every turn, leading locals to nickname me *loch* — Russian for "dope." David neither defended me nor took blame for the choice of footwear. He just laughed. A lot. Oh, and he photographed me on my ass.

I miss that laugh.

— David Greene

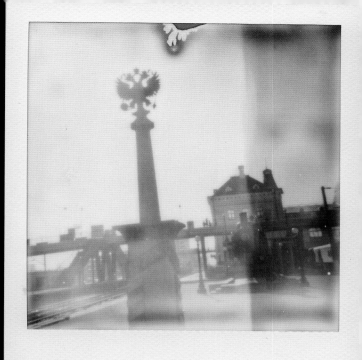

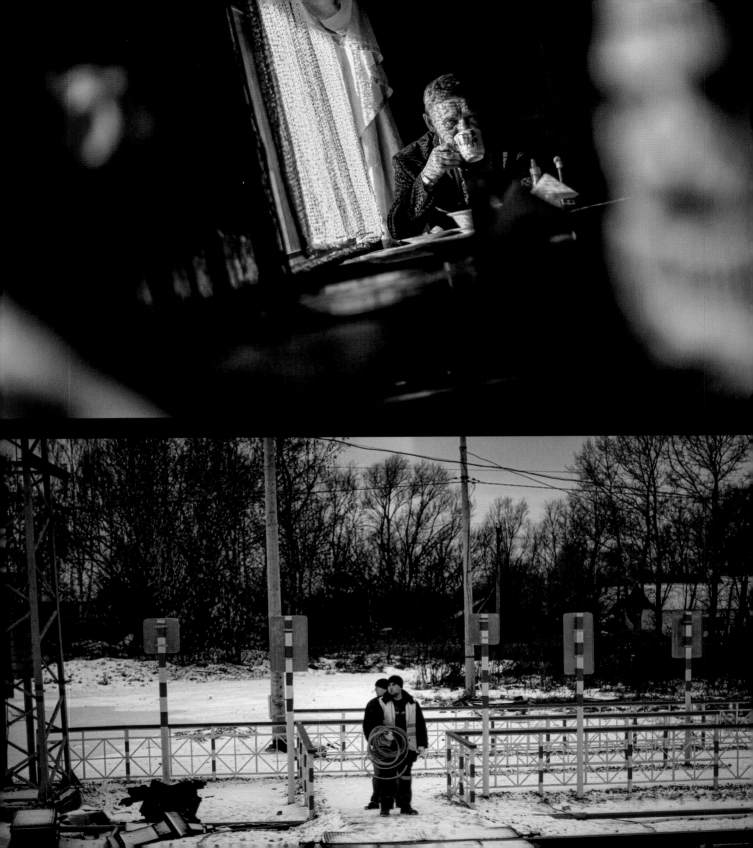

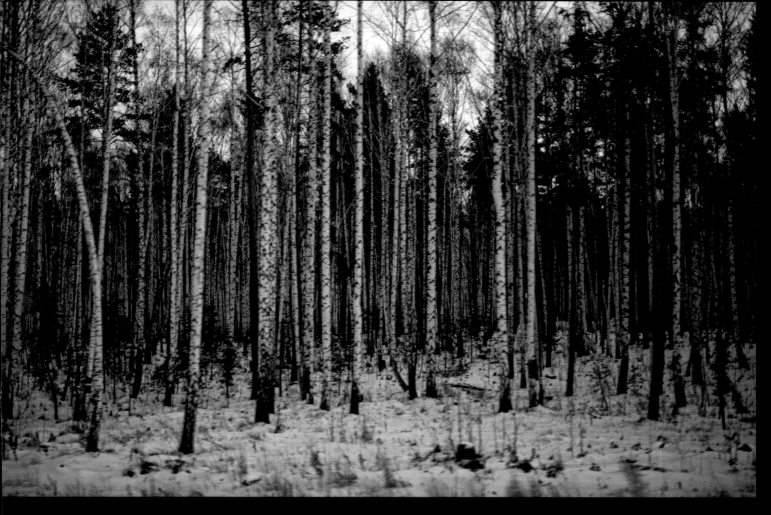

ABOVE and BELOW: The train passes through one of the world's largest forests — the Russian taiga — and kisses the shoreline of the world's largest freshwater lake, Baikal. December 2011.

Buildings give way to trees as trains pull out of Moscow's Yaroslavsky station and head east into the vast forest. December 2011.

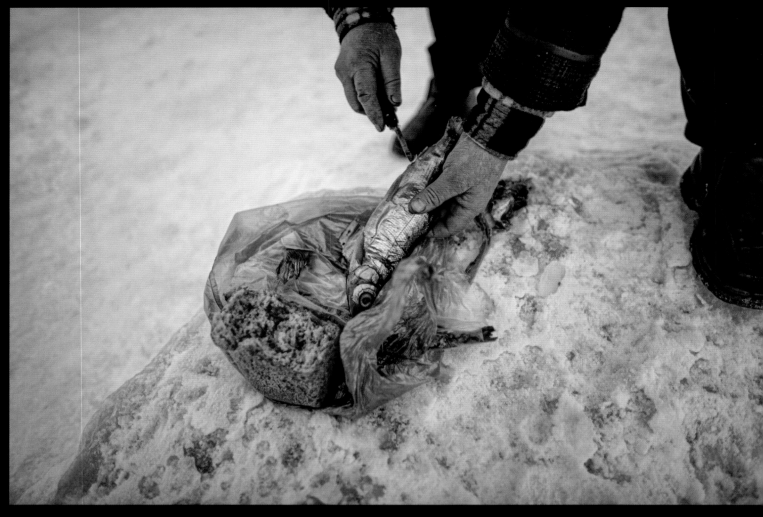

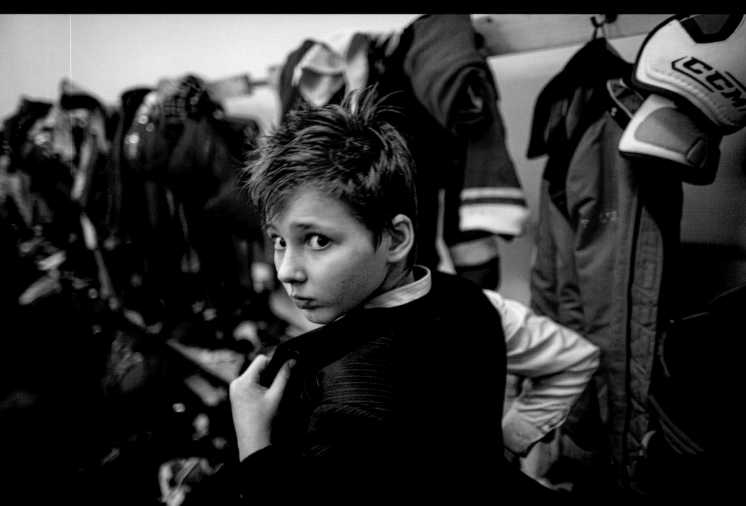

ABOVE: Yuri Bronnikov prepares cold-smoked omul on a snowbank on the shores of Lake Baikal. December 2011. BELOW: A boy in a youth hockey program changes after practice at an ice rink in Yaroslavl. After the city's professional hockey team was killed in a plane crash earlier that year, the young players were part of the town's hope for the future. December 2011.

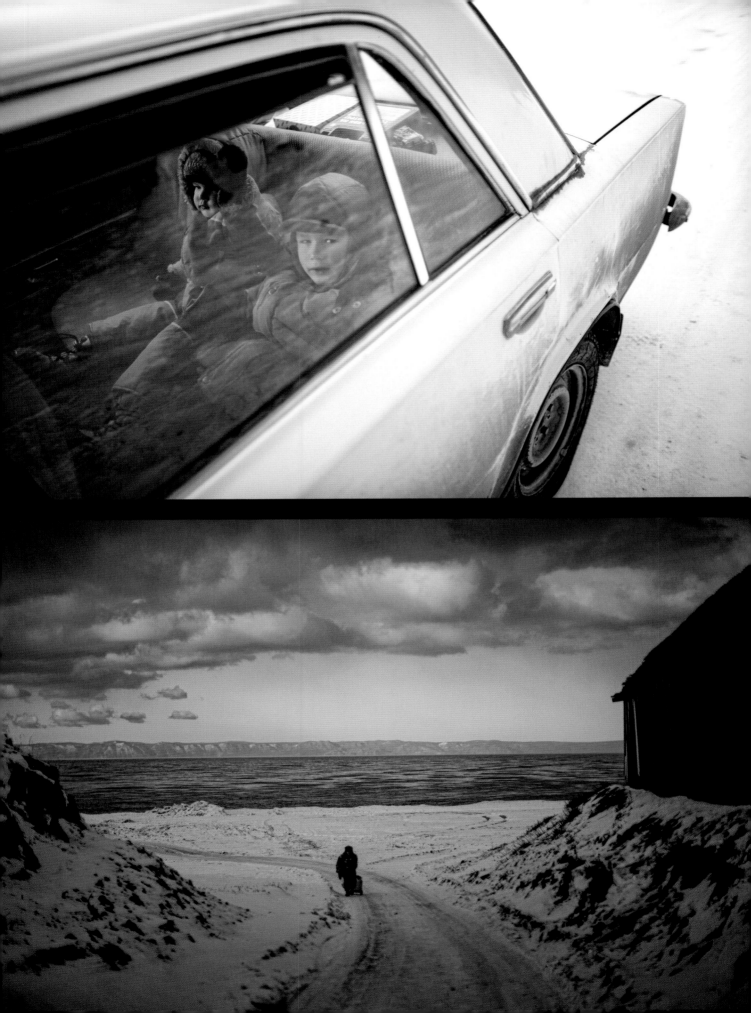

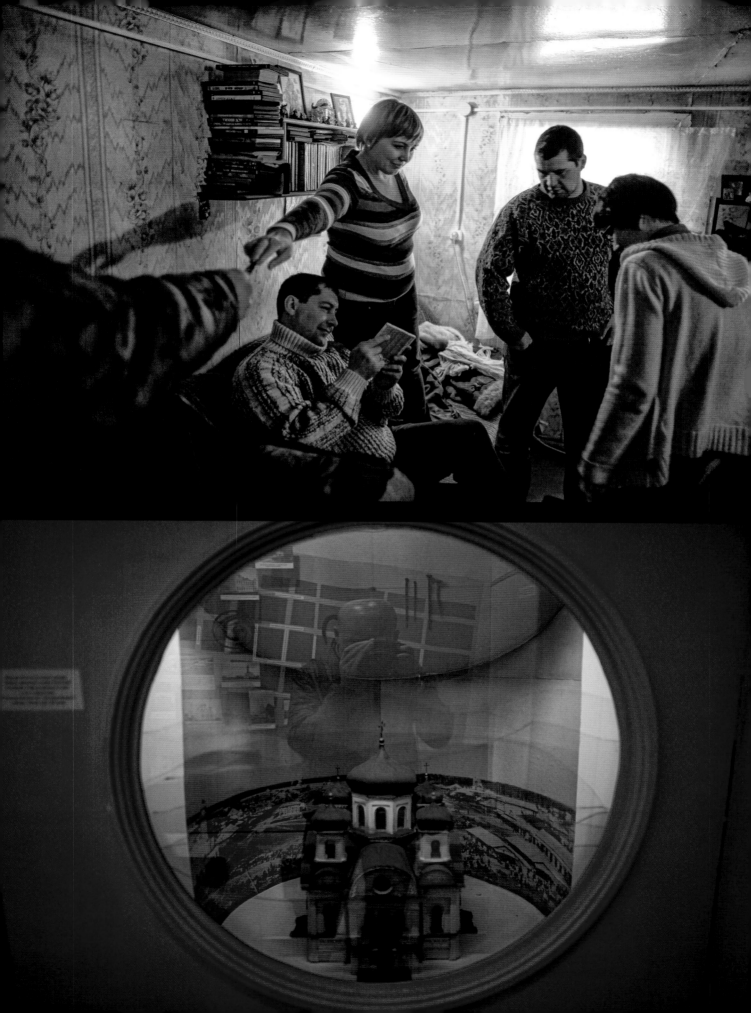

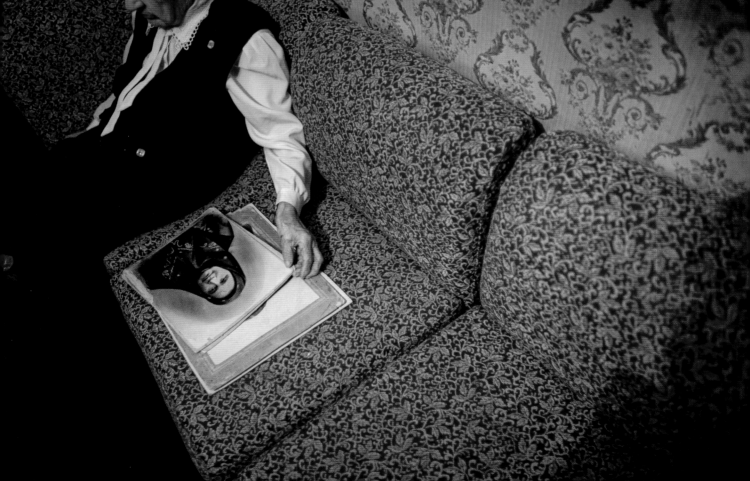

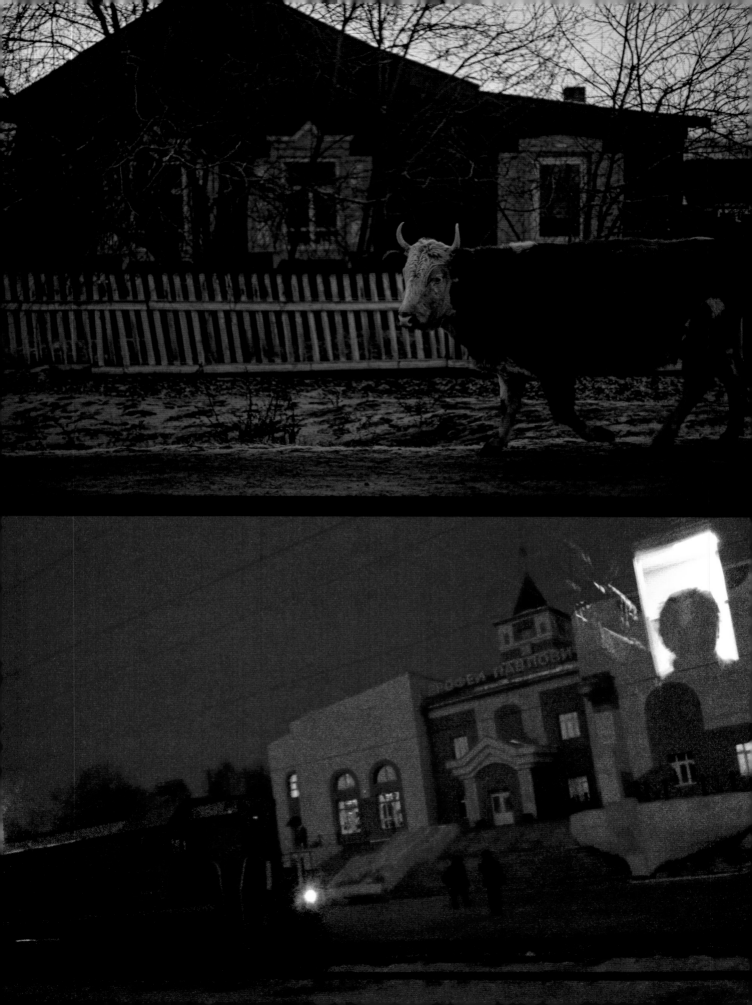

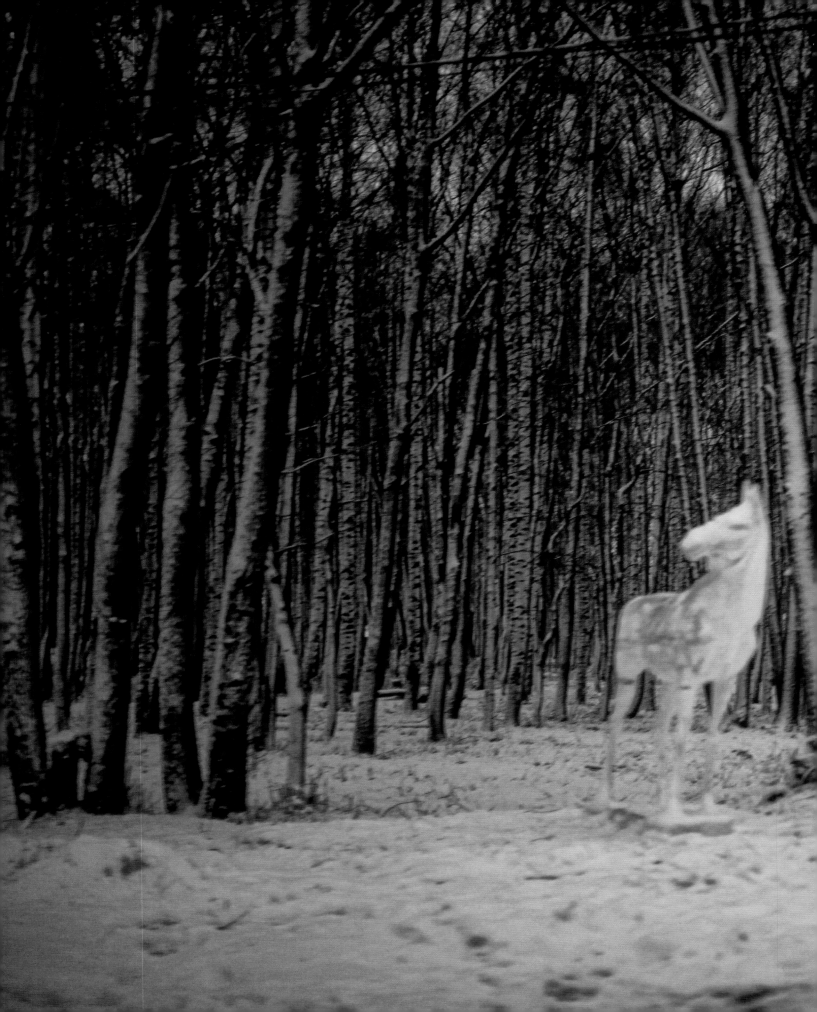

AD RIVER

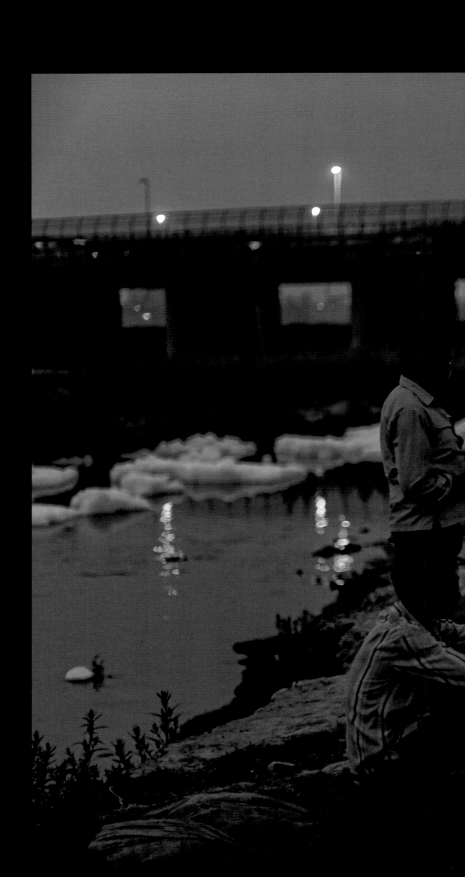

rs to get David to come to Pakistan
au there in 2009. He'd protest. That
ross a sunburned face. He'd swipe his
-shaven head, wrapped in Ray-Bans,
hat said "American Special Forces."

"I wouldn't last five minutes there."

probably right about Pakistan. How-
veled to India in the spring of 2016.
to accommodate my pestering about
d a story in mind about a river that
olluted it is said to be "dead."

"sounds good," and off we trekked to
s, a sacred river known as the Yamuna.
e Himalayas, but it flows out of New
India, which is saying something.

— David's photographs managed it.
y images of the cremation of a young
nbers of her family — cremations are
s — gathered by the riverbank for the
neral pyre. They huddled in the glow
ckling, as dusk disappeared into eve-
cal waste drifted past like so many
in the searing heat and utterly at
commend the soul of the deceased

ere emblems of the way people were
There was an awful beauty to them.
humanity in utter hellishness.

anor and linebacker frame masked
he key to his craft. He could come
rarely said a word in the field when
And you were reluctant to interrupt
. Though I don't think he thought of
ved the collaboration and the cama-
nd loved seeing it all come together.

the night to produce a mother lode
endless cups of coffee while we cap-
lways had a gracious word for who-
e or food or water.

ilkey and India, where the humanity
very day, were made for each other.
e already plotting his return to voy-

— Julie McCarthy

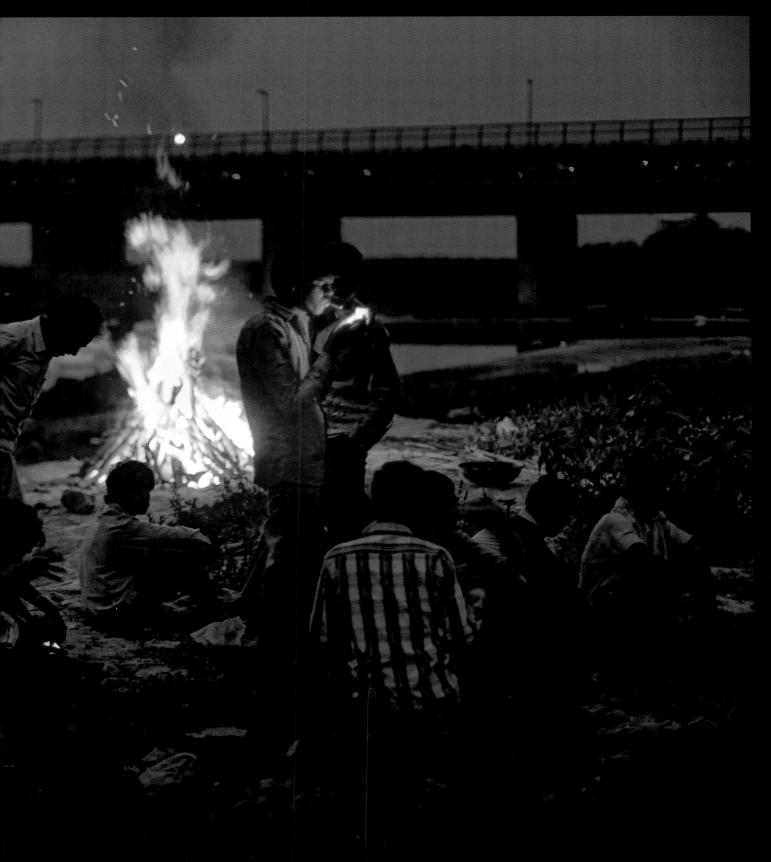

Men gather near the fire of a cremation along the banks of the Yamuna River, flecked with floating industrial waste, against the backdrop of the Wazirabad bridge. New Delhi. April 2016.

AFGHAN HEART. We saw David Gilkey as an American with an Afghan heart. From his first trip here in September 2001, he made lifelong friends. On the outside he was the quintessential all-American guy. To the Afghans he spent time with, nothing about him felt foreign. His sense of humor matched ours, his sense of curiosity and adventure matched ours.

He loved to hear stories of Afghans he photographed: risking their lives to vote — and then carrying ballot boxes toward the capital on a plane, jeep or donkey; struggling to escape war, or gearing up to fight; playing bushkazi, our violent version of polo; or just going about their daily lives in Kabul. We told him our stories of survival and he shared his own from Africa and the Middle East, and from many battles here in Afghanistan. David was one of us.

For years David visited our family home. He was like an extra brother, so much that we'd act like teenagers whenever he'd arrive in Kabul on an assignment. We would greet him with a punch on the arm — a hard one! Sometimes we'd end up wrestling — as the NPR staff watched in disbelief. Then we'd settle in to the latest crude Afghan jokes, and he'd tell us about his upcoming assignment with excitement in his eyes. We met him in Washington, D.C., several times too, but it seemed to us that he was bored and could not wait to get back.

On his last trip to Afghanistan, David came to our house as usual. For the first time, when we greeted him with a little bit of wrestling, he asked us not to be too rough with him — he said he was getting old. David was 35 when he first came to Afghanistan. Now he was 50.

We had our regular Afghan feast — it was melon season and David ate bowl after bowl of a watermelon salad that our family prepared. Afterward, sitting in the courtyard, he told us about his upcoming assignment. We said goodbye never thinking it would be his last trip.

Days later, we heard about David's death alongside another good friend, Zabihullah Tamanna. Friends and family, and even people David had photographed, reached out. Men who never expressed emotion called — like one of NPR's long-time drivers, his voice trembling — to say *besyar bachei kaaka bood*: He was a very gallant man.

It felt like a nightmare — hard to believe it was real, even months later when the Gilkey family sent us some of David's ashes. We decided to spread them in one of his favorite places, the famous Panjshir Valley, about a two-hour drive north of Kabul. During the trip, we tried to stay cheerful and recalled some of the funniest Afghan jokes we had shared with him. We felt him looking from above and laughing hard. We parked the car at a spot where, on a picnic years before, David had jumped into the freezing water of the roaring Panjshir river.

We said a prayer and spread his ashes beneath the towering mountains that dominate the rugged landscape of the valley.

Rest in peace brother!

— Najib Sharifi and Shafi Sharifi

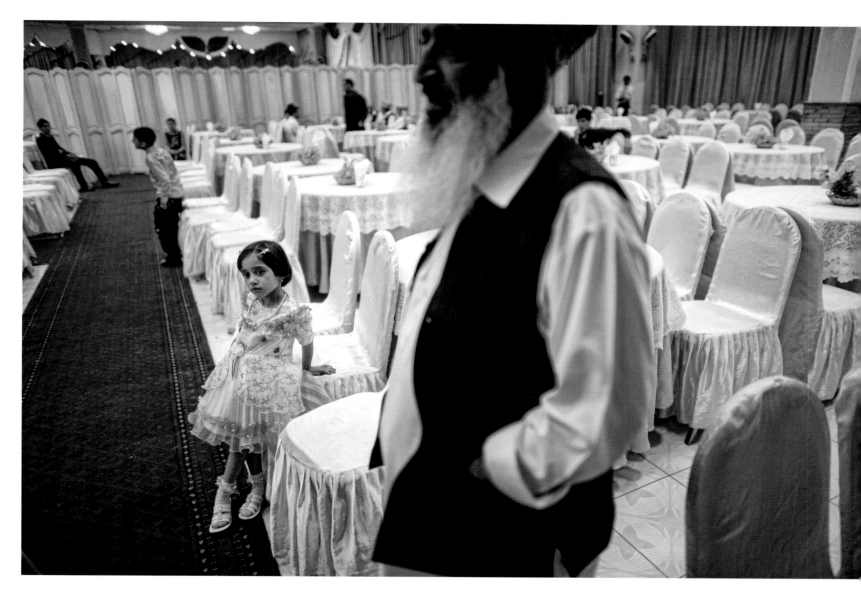

A girl waits for her father to get her after she accidentally entered the men's side of a wedding hall. Kabul, Afghanistan, July 2009.

The lights from a street, filled
with commercial wedding
halls, are reflected in
a framed poster of a bride.
Kabul, Afghanistan, July 2009.

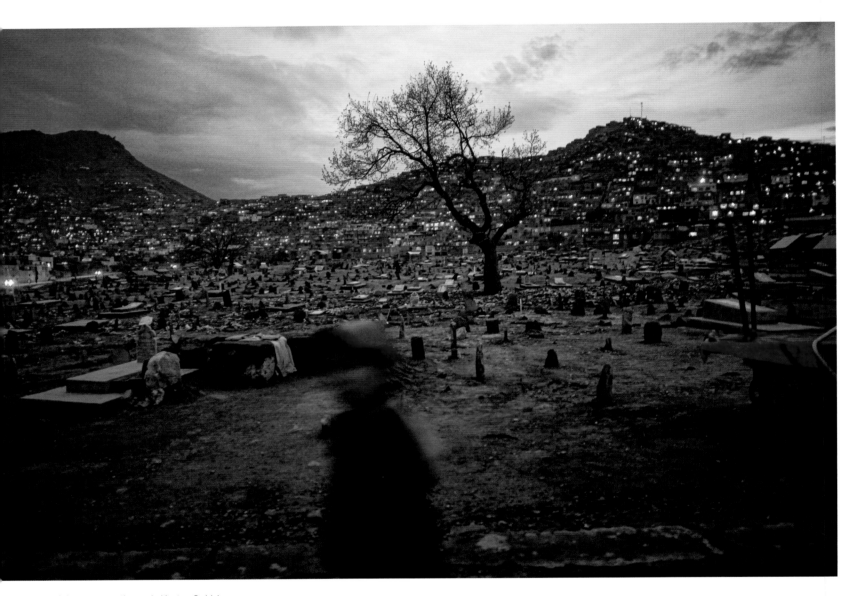

A boy moves through Kart-e-Sakhi
cemetery as the evening lights shine
on the western side of the capital city.
Kabul, Afghanistan, April 2012.

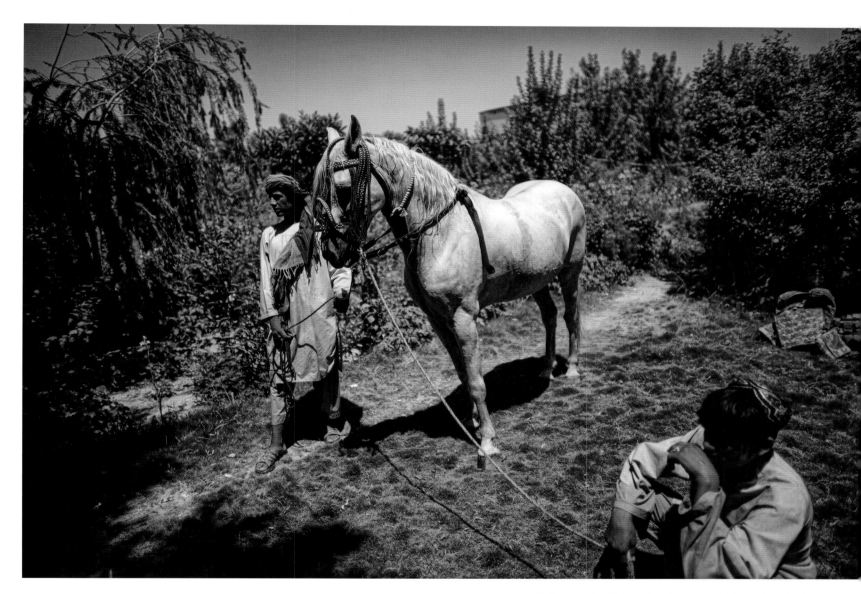

Taliban leader Mullah Omar's horse, which local warlord Haji Ghani says he took and now keeps at a nature park on his compound in Senjaray. The Taliban holds sway in the district, and the 101st Airborne's task is to bring security to the area — potentially with Ghani's support. Zhari District, Kandahar province, Afghanistan, July 2010.

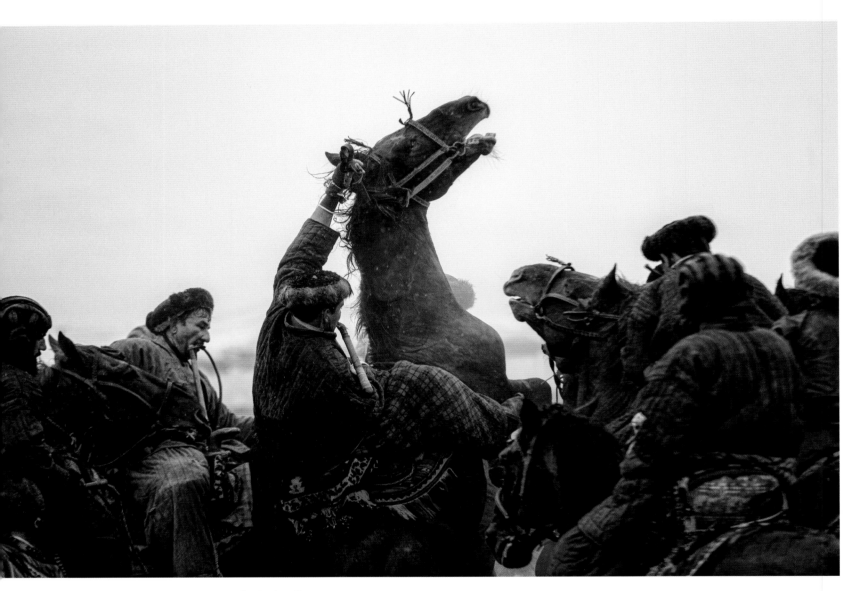

Horses and riders collide as they grab for the headless
animal carcass that serves as the "ball" in a game
of buzkashi. A centuries-old game, buzkashi is
Afghanistan's national sport. Sheberghan, Jowzjan
province, Afghanistan, March 2014.

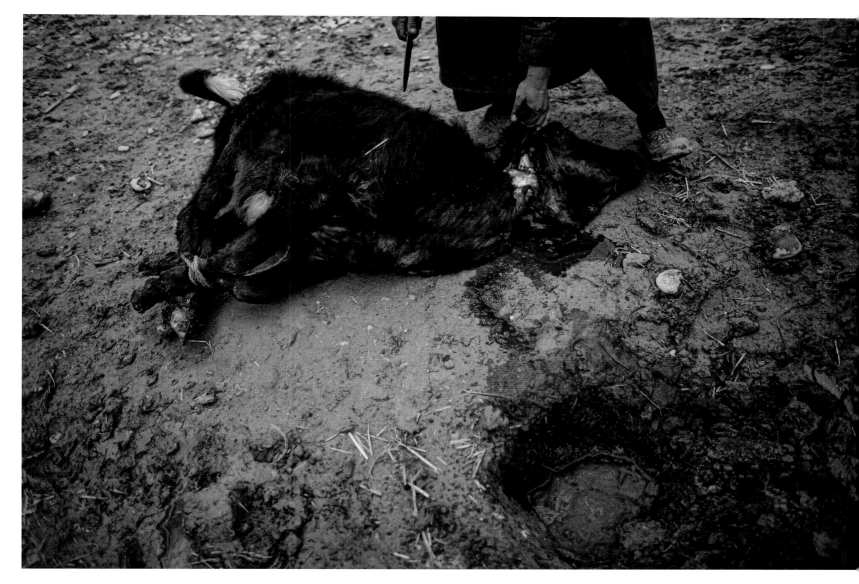

A calf is killed — its head and hooves removed —
in preparation for a game of buzkashi in Sheberghan.
Jowzjan province, Afganistan, March 2014.

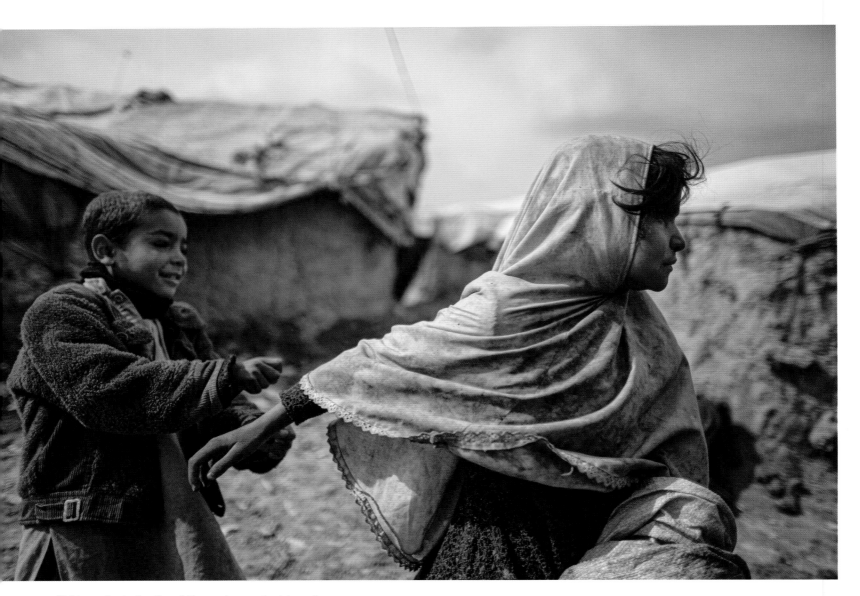

Children play in the Nasaji Bagrami camp for internally displaced people on the outskirts of Kabul, where about 360 families live without electricity or running water. Kabul, Afghanistan, March 2014.

I mean,

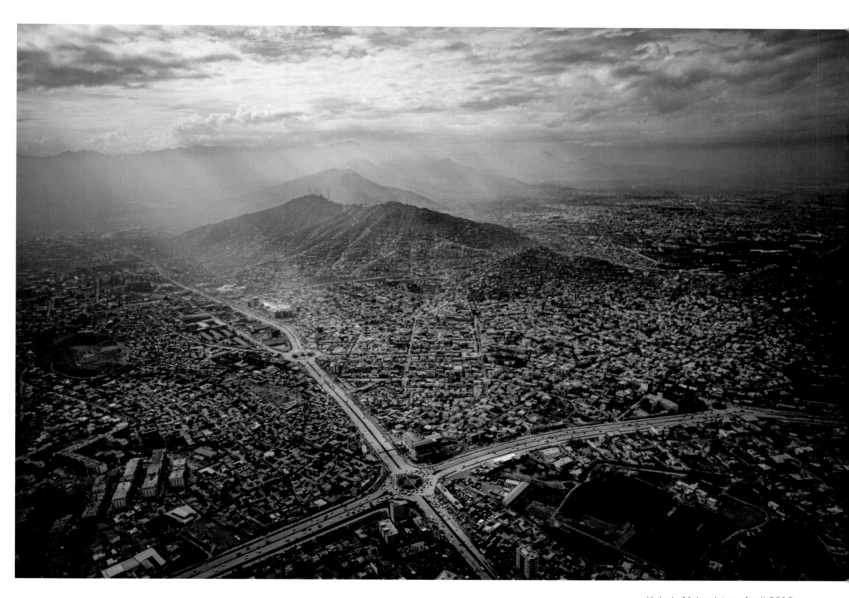

Kabul, Afghanistan, April 2012.

I'm always just trying to simplify the picture so people can understand it. I'm not out walking the streets looking for beauty in any of it. If you just walk up and you take a picture of something, I'm not sure you get it. So it's a matter of using light and using composition and using the skills that you have as a photographer to better simplify the image.

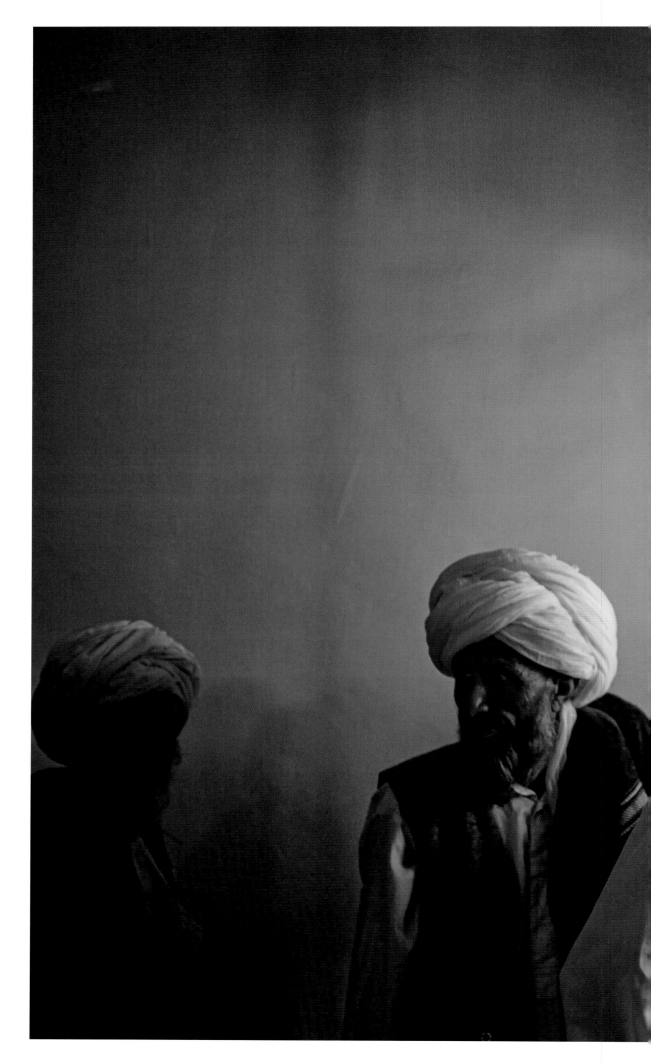

Tribal elders leave a shura, or traditional meeting, with U.S. Special Forces soldiers near the U.S. Army's Firebase Thomas. Herat province, Afghanistan, May 2009.

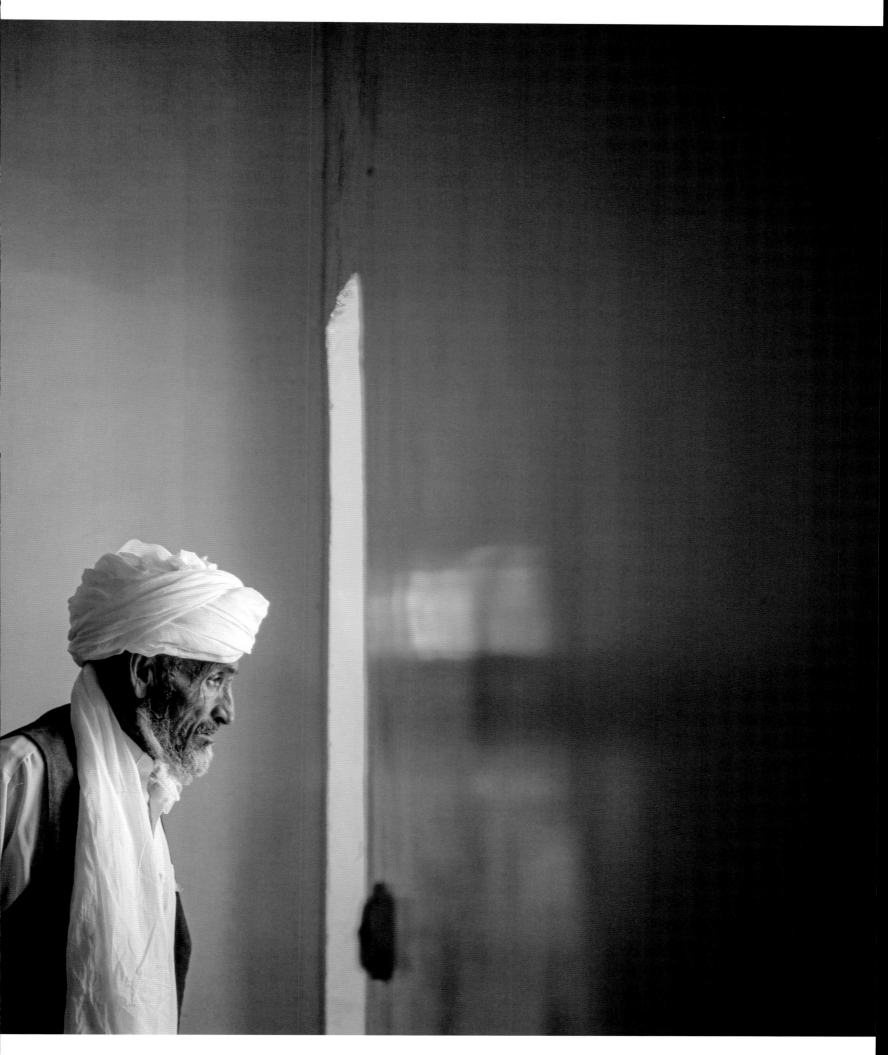

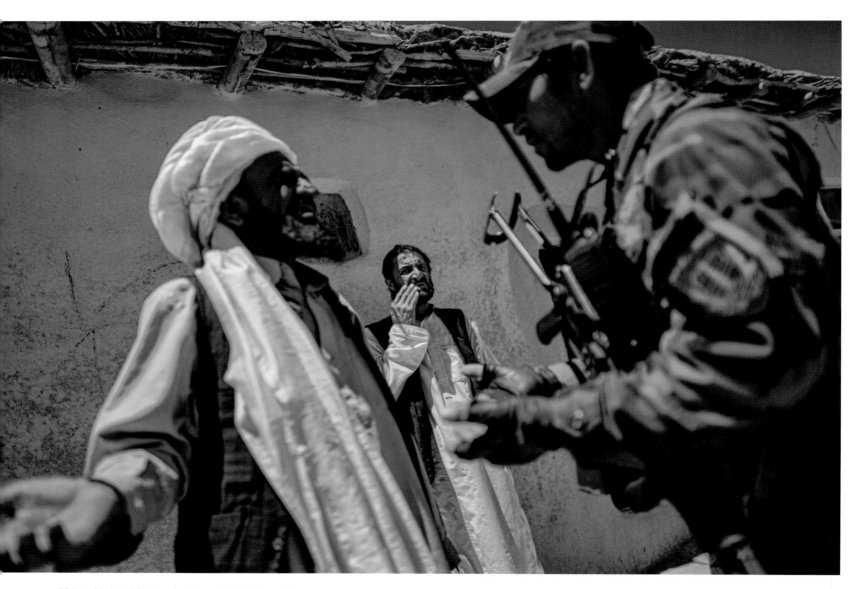

Afghan National Army soldiers and intelligence officers
question the father of a suspected Taliban collaborator.
Ghazni province, Afghanistan, May 2012.

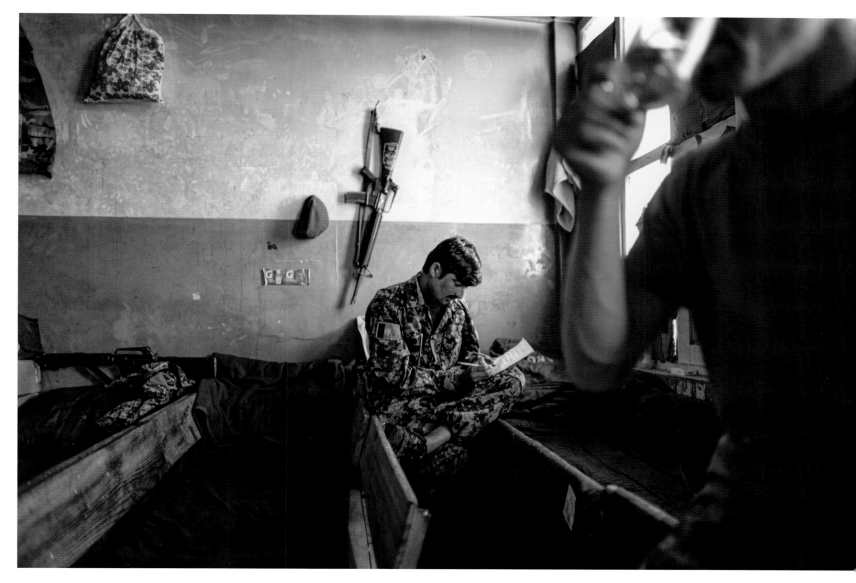

An Afghan National Army soldier writes a letter in his barracks.
These soldiers are being trained to take over security
control of the area by U.S. troops with the 82nd Airborne.
Ghazni province, Afghanistan, May 2012.

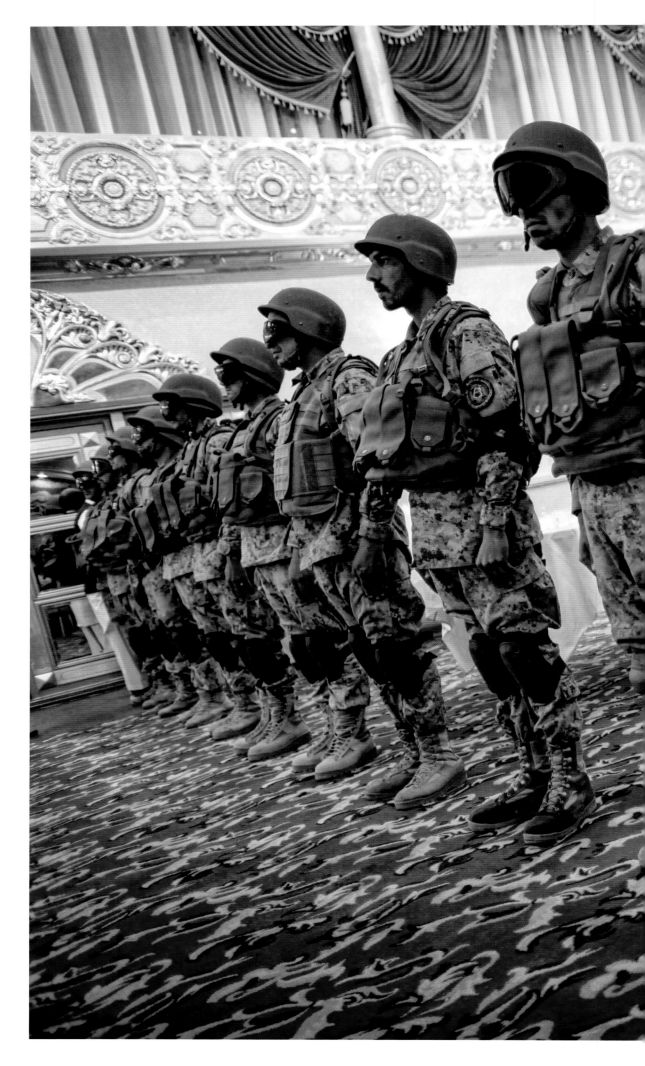

Afghan special forces soldiers attend an event for their disabled comrades at the Intercontinental Hotel in Kabul — not by their government but by a civil society group promoting pride in the new democratic Afghanistan. Kabul, Afghanistan, April 2012.

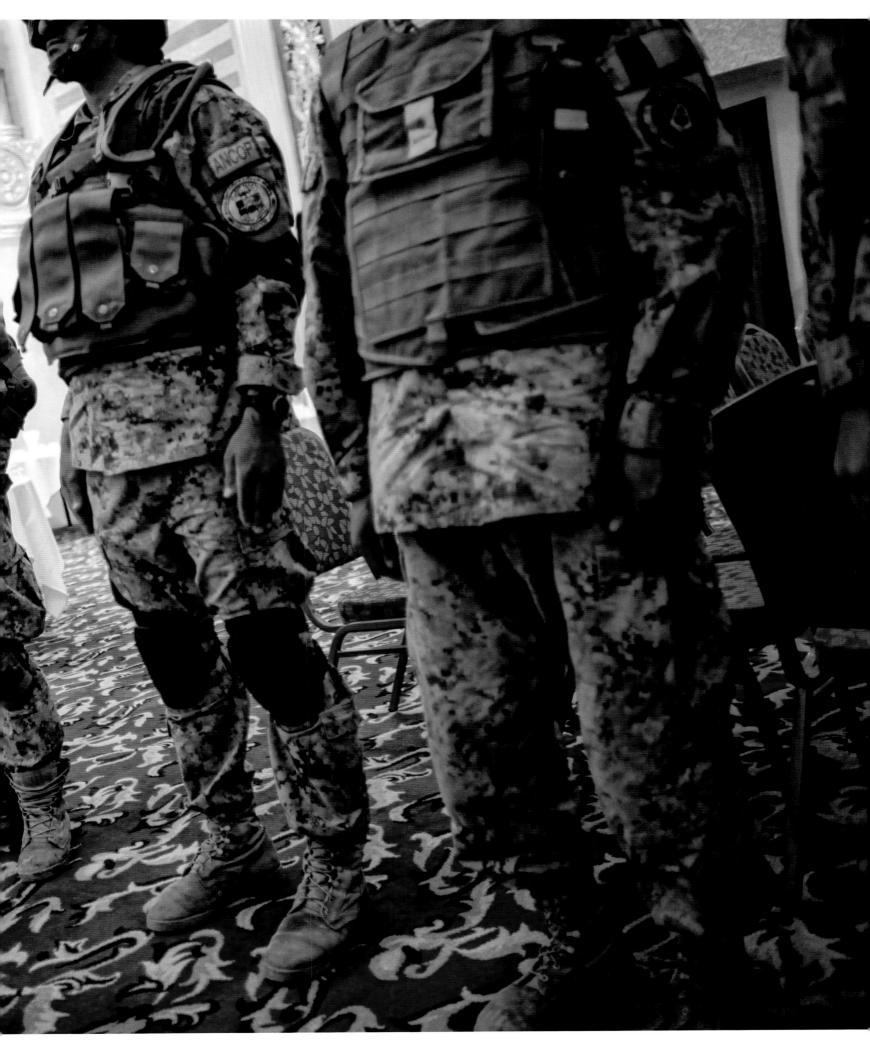

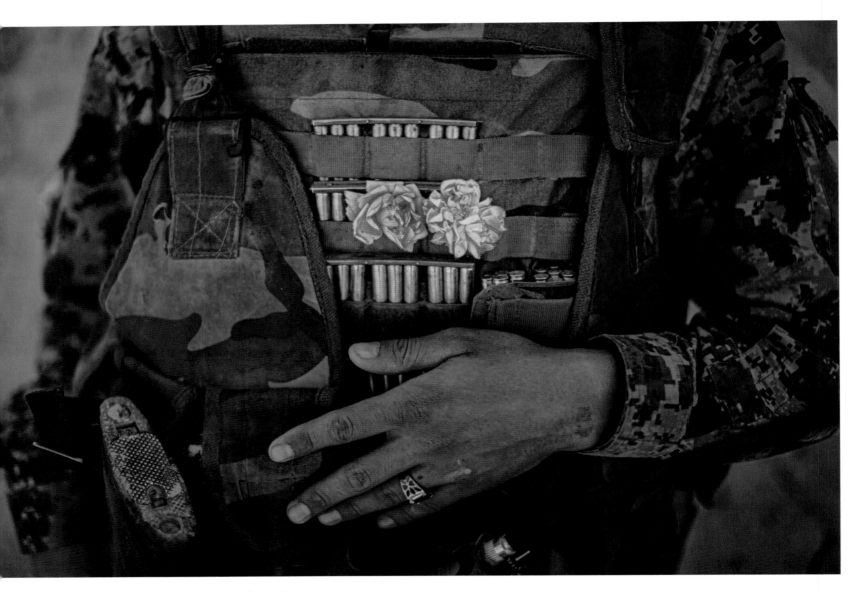

An Afghan National Army soldier tucks flowers in
his flak vest while on patrol with U.S. troops
with the 82nd Airborne, near the village of Babaker.
Ghazni province, Afghanistan, May 2012.

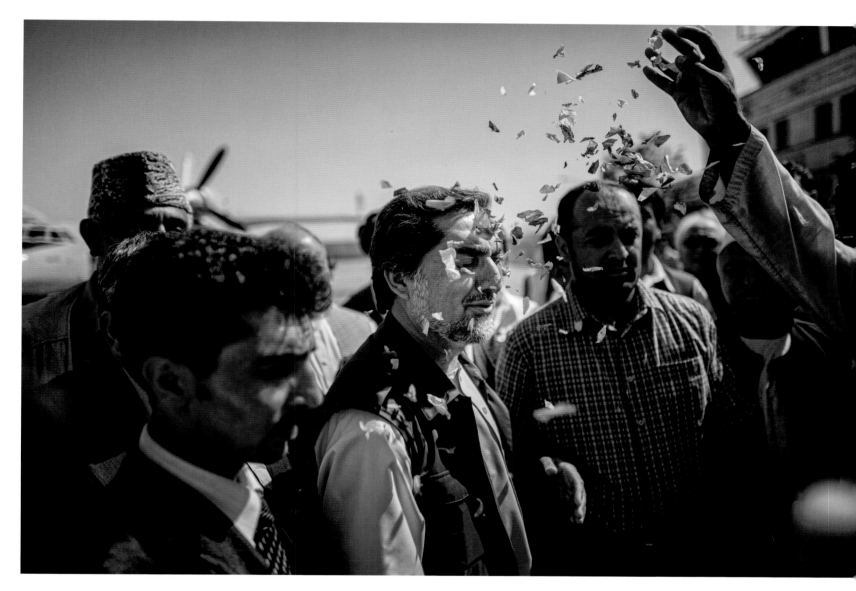

Supporters of Afghan presidential candidate Abdullah
Abdullah shower him with flower petals as he
arrives at the airport in Herat for a campaign rally.
Herat province, Afghanistan, July 2009.

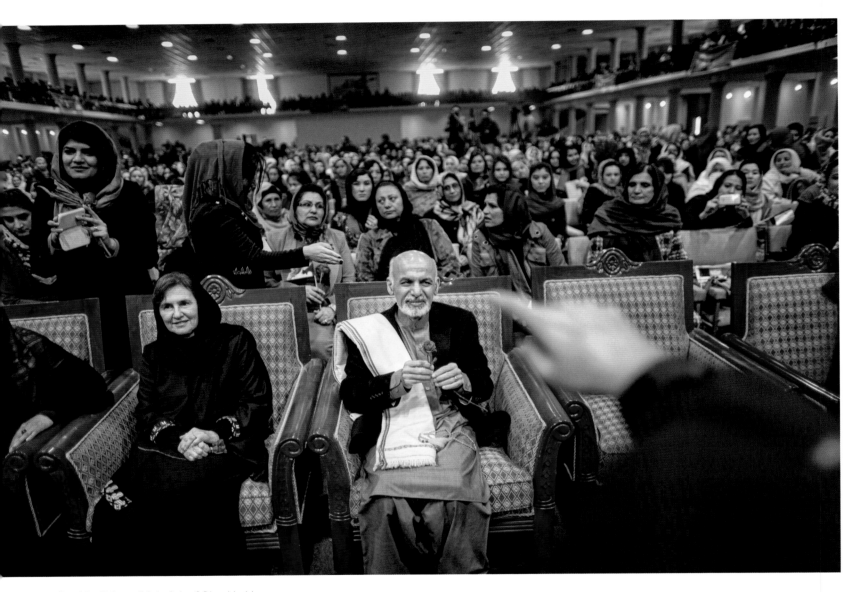

Presidential candidate Ashraf Ghani holds
a rose during a campaign rally in the Afghan
capital. Kabul, Afghanistan, March 2014.

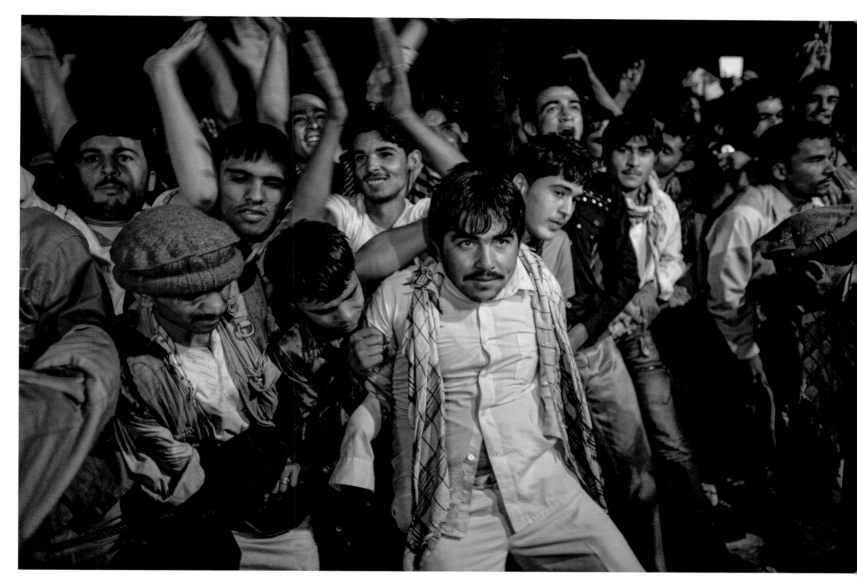

A man holds back excited fans of Afghan heartthrob and pop music star Farhad Darya during a free get-out-the-vote concert at Kabul Stadium. Kabul province, Afghanistan, August 2009.

Thousands of Afghan Ismailis, a
minority sect of Shiite Islam, prepare
for a presidential campaign rally for
Hamid Karzai in Dar-e-Kayan. Baghlan
province, Afghanistan, July 2009.

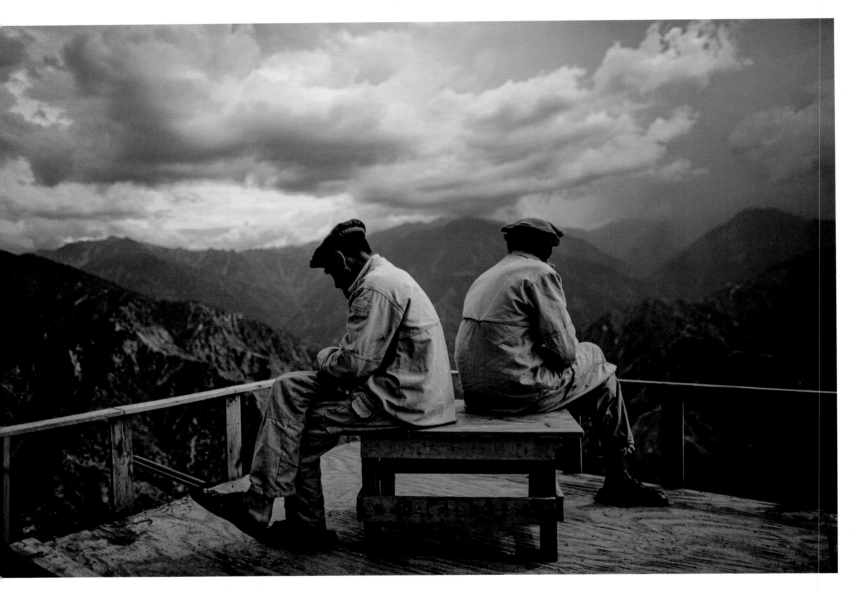

Afghan Security Guards watch the Kunar River
Valley from Observation Post Mustang, a vital strategic
position along a key smuggling route for
insurgents coming from Pakistan. Kunar province,
Afghanistan, September 2011.

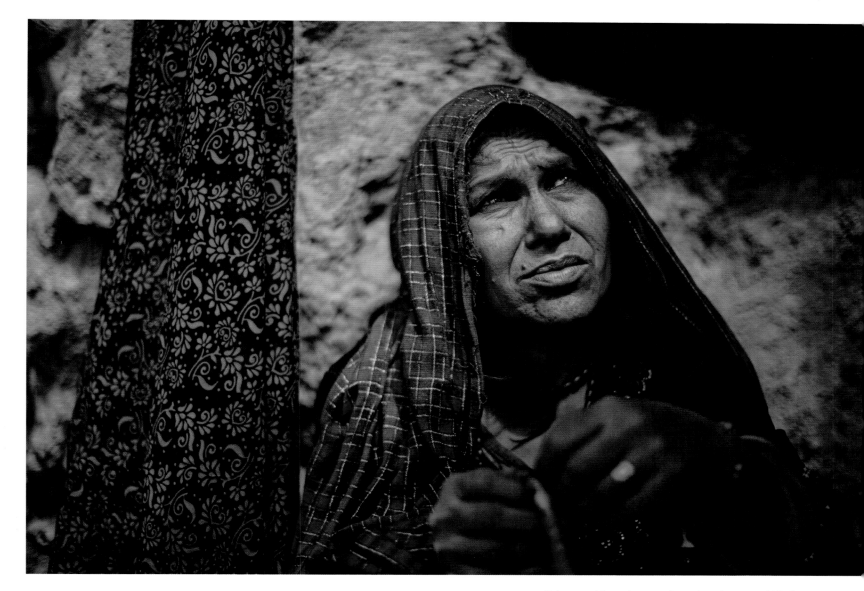

Zahra used to make carpets and work as a maid before becoming addicted to heroin. She lives with her 10-year-old daughter — also an addict — in Kamar Kulagh, a makeshift village of addicts on the outskirts of Herat. Herat province, Afghanistan, April 2014.

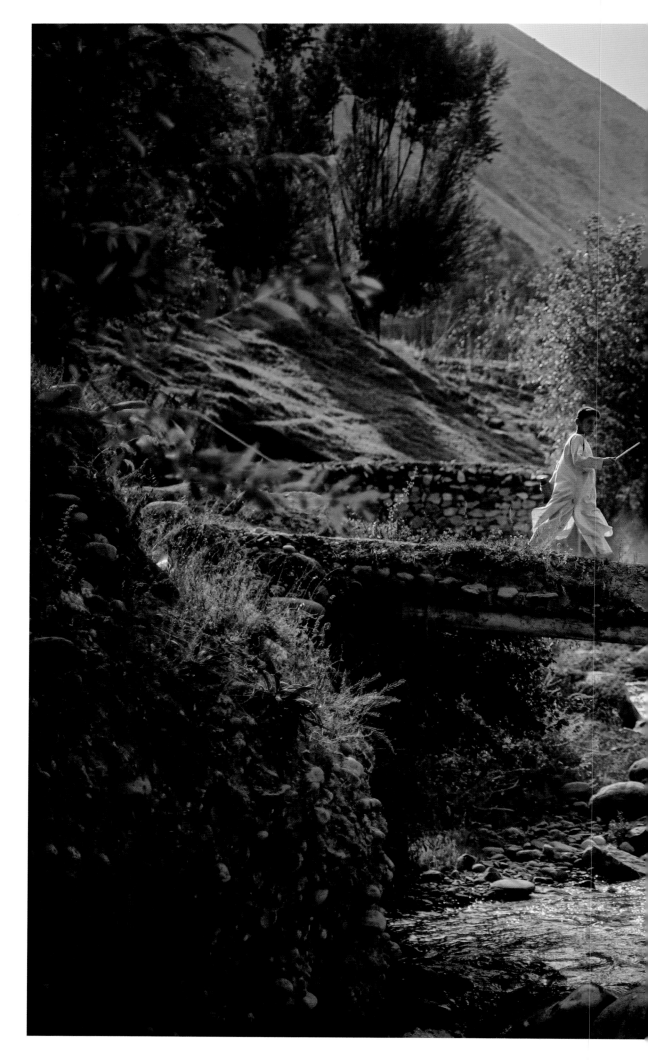

A boy drives a donkey carrying unused election ballots across a stream on their way to the village of Quali Kuana in the Yangam District. The Afghan Independent Election Commission is using donkeys to deliver voting materials to remote areas of the country for the second democratic election since the U.S. invasion in 2001. Badakhshan province, Afghanistan, August 2009.

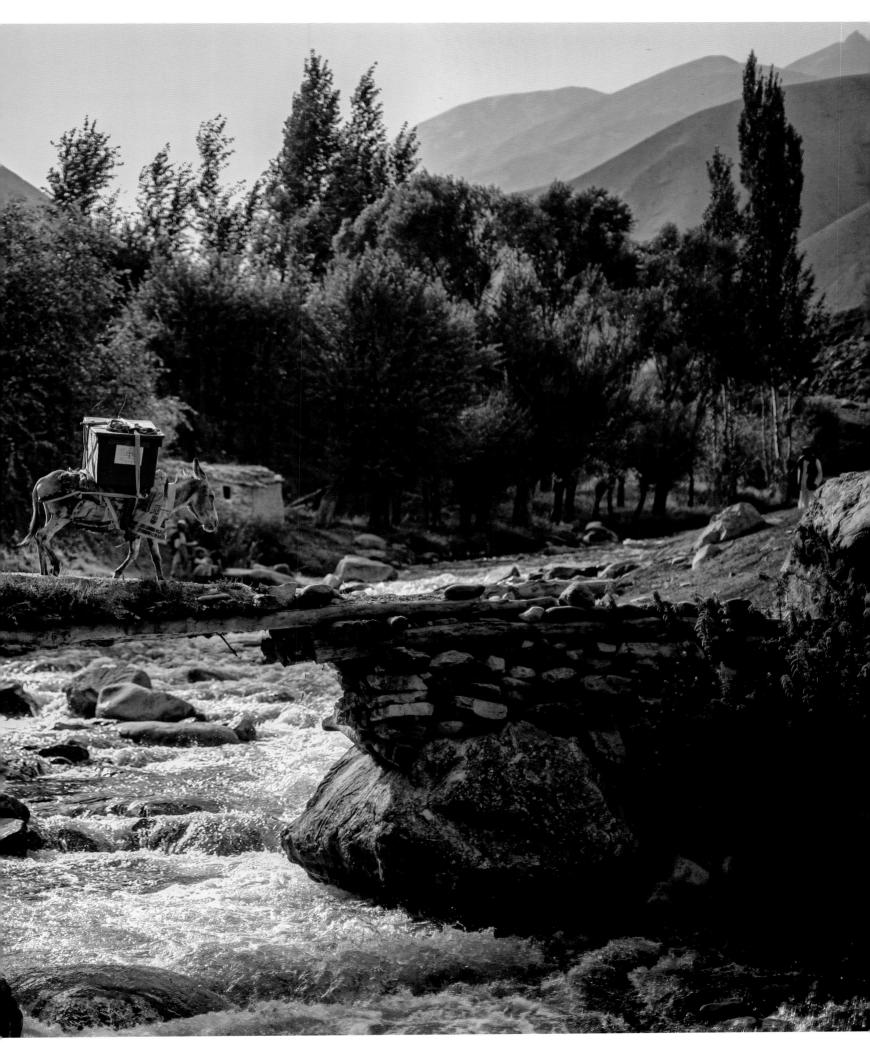

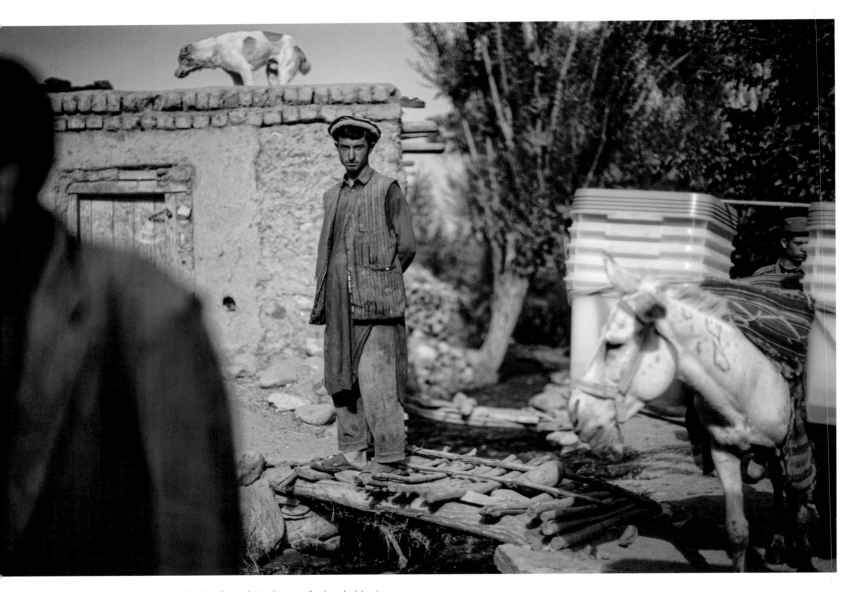

Election materials are unloaded at the private home of a local elder in the village of Quali Kuana, where they will be guarded by the Afghan National Police. The ballots will be escorted back to Kabul via donkey and truck. Badakhshan province, Afghanistan, August 2009.

You try to capture emotion in it and show that this is a personal thing to the people here.

It's not just smoke on the horizon.

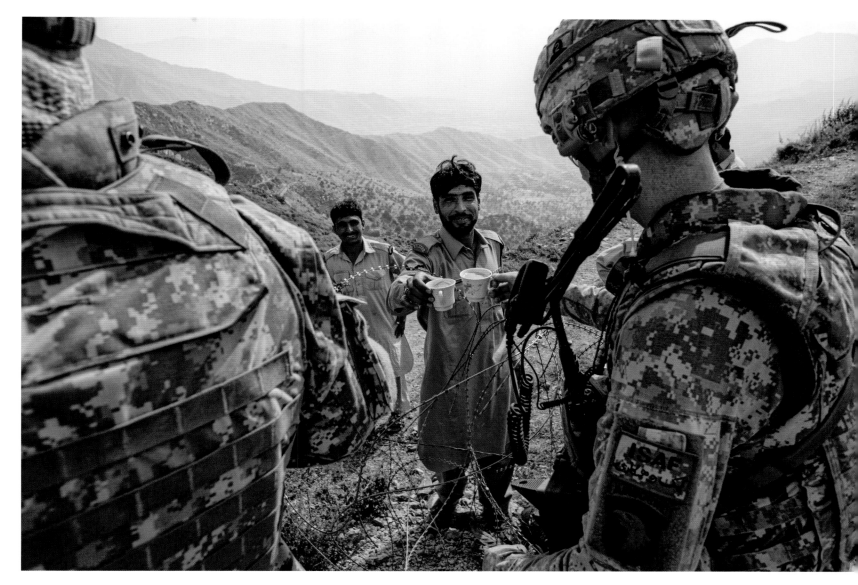

A member of Pakistan's Frontier Corps passes tea across the border to U.S. Army Lt. Kenneth Kovach. Kovach and his squad were sent there to secure a U.S. helicopter that had been disabled by insurgent fire while dropping off Afghan forces at a recently abandoned CIA base along the Ghaki Pass. Kunar province, Afghanistan, October 2010.

I hope that maybe some of the chances that you take — or the risks that you take in order to get a picture like that — that somebody would understand, "Wow! These people are not that different from me."

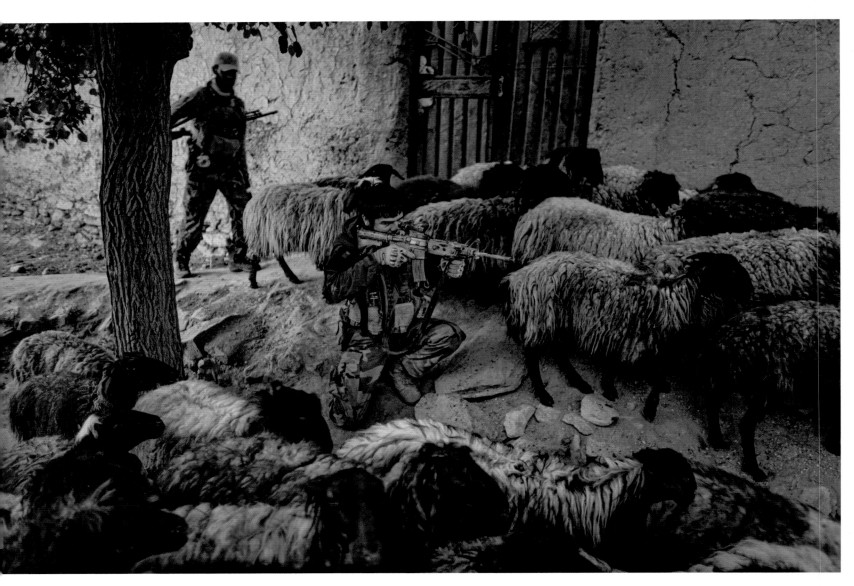

Afghan National Army special forces watch a potential ambush area
while a herd of sheep and goats passes during a patrol in Kasan.
The U.S. Army Green Berets, along with the Afghan special forces,
have been training Afghan local police to take the lead in their village's
stability and security. Wardak province, Afghanistan, May 2013.

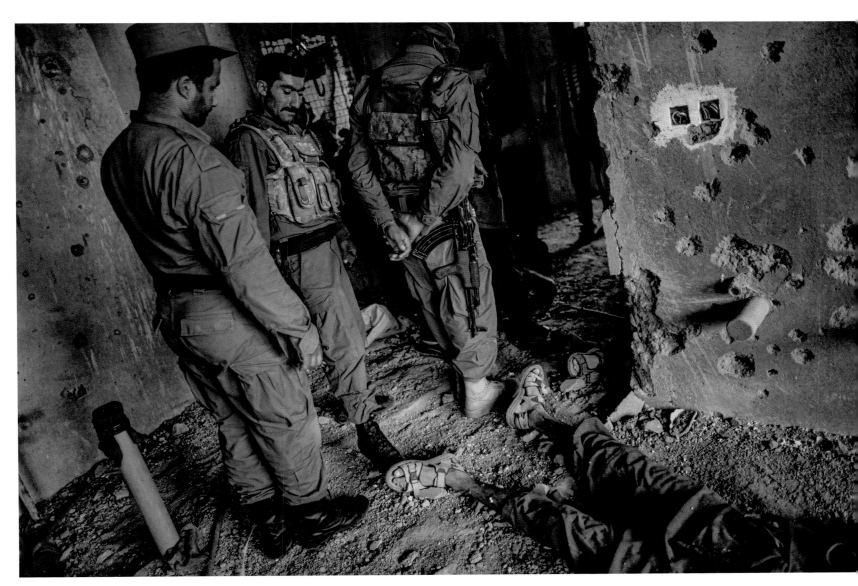

Afghan security forces examine the dead body of a fighter on the 10th floor of a building from where, a day earlier, Taliban had attacked the U.S. Embassy and International Security Assistance Force headquarters. The coordinated assault on the Afghan capital ended after a daylong gun battle that included suicide attacks that left 14 Afghans dead and six foreign troops wounded. Kabul province, Afghanistan, September 2011.

Soldiers with the U.S. Army's 1st Infantry Division and Afghan National Army troops climb the treacherous mountains overlooking the Khost-Gardez highway while on a mission to disrupt insurgent fighters from the Haqqani network near the Pakistani border. Paktika province, Afghanistan, June 2011.

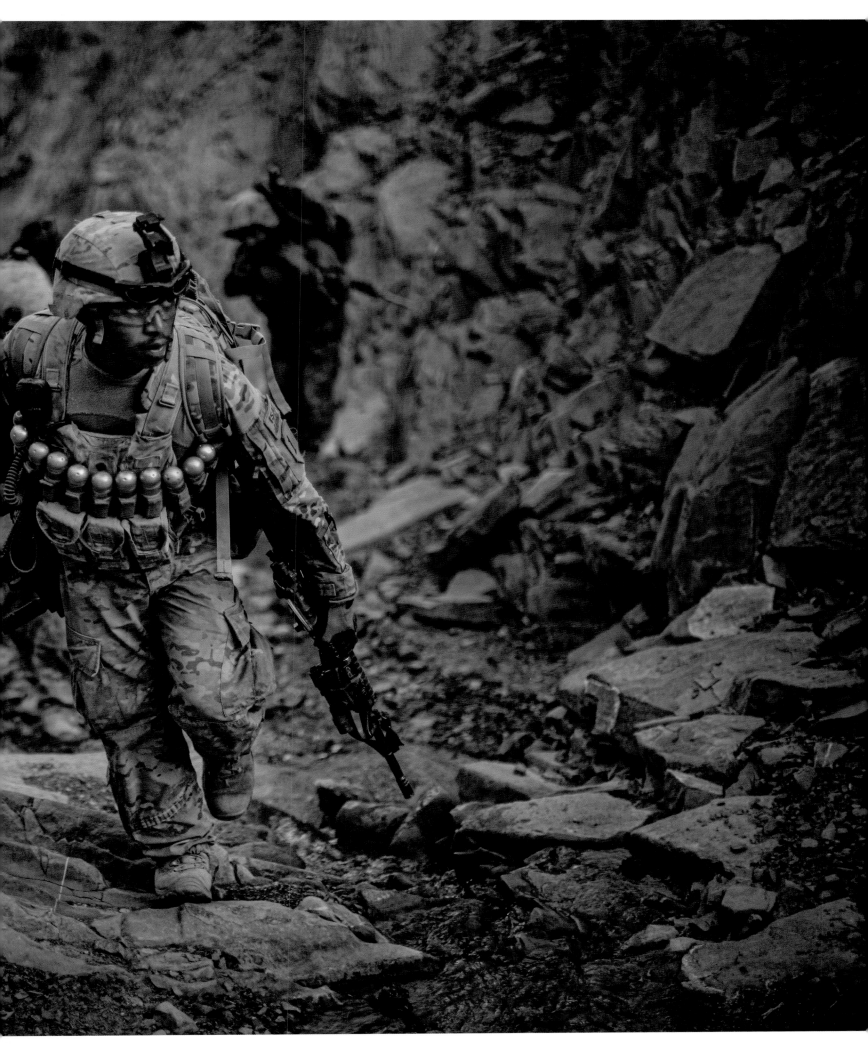

Army soldiers conduct a "Zombie Run," scavenging
supplies inside Camp Leatherneck, a 1,600-acre
abandoned American military base. Helmand province,
Afghanistan, May 2016.

It's not a scene that is there for television.
It is not a scene that is there for photographers or journalists.
I understand the message needs to come out, but I think there's also a line that we walk of being respectful of the people.

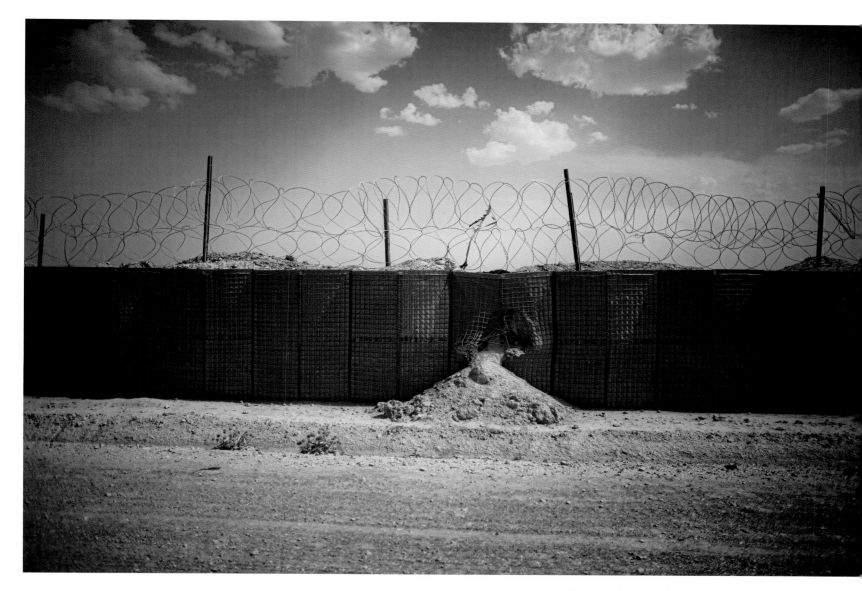

Topped with razor wire, a punctured earthen wall
hemorrhages sand at Camp Leatherneck.
Helmand province, Afghanistan, May 2016.

Of the living and the dead. You have to put yourself in somebody else's shoes. What if that was us?

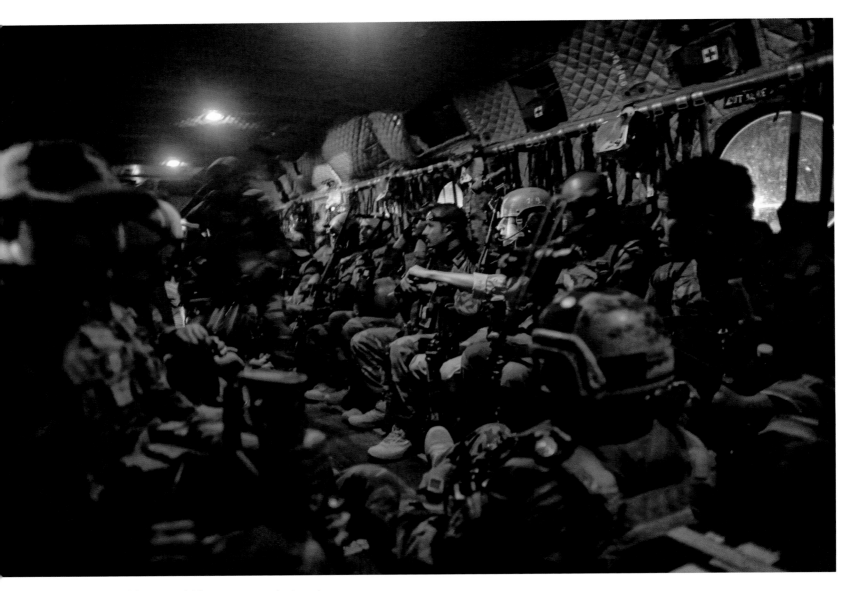

Afghan National Army special forces commandos board a
U.S. Army Chinook helicopter at Kandahar Airfield
before a nighttime operation in a Taliban-controlled
village in the Shah Wali Kot District. Kandahar
province, Afghanistan, May 2016.

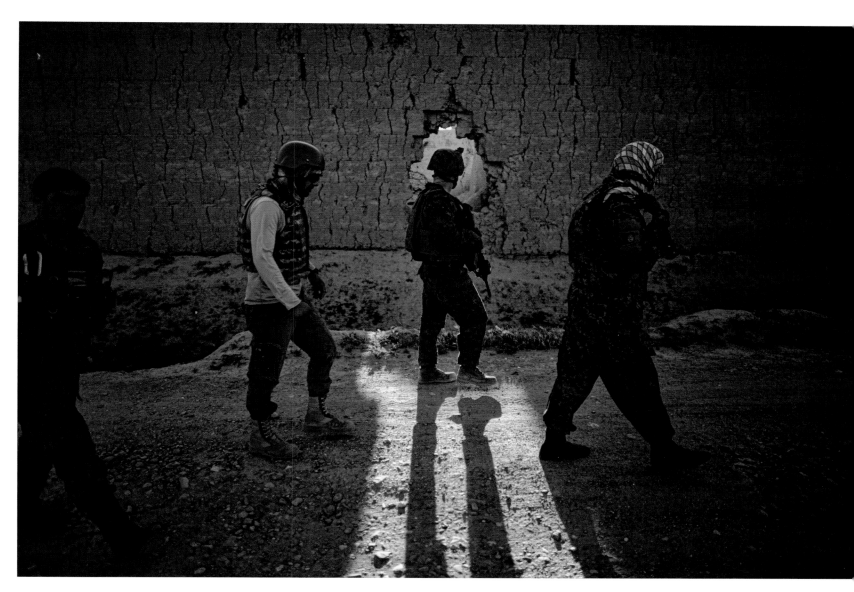

Georgian Army troops, U.S. Marine trainers and
Afghan forces patrol the outlying area of Bagram
Airfield in the Shomali Plain north of Kabul.
Parwan province, Afghanistan, May 2016.

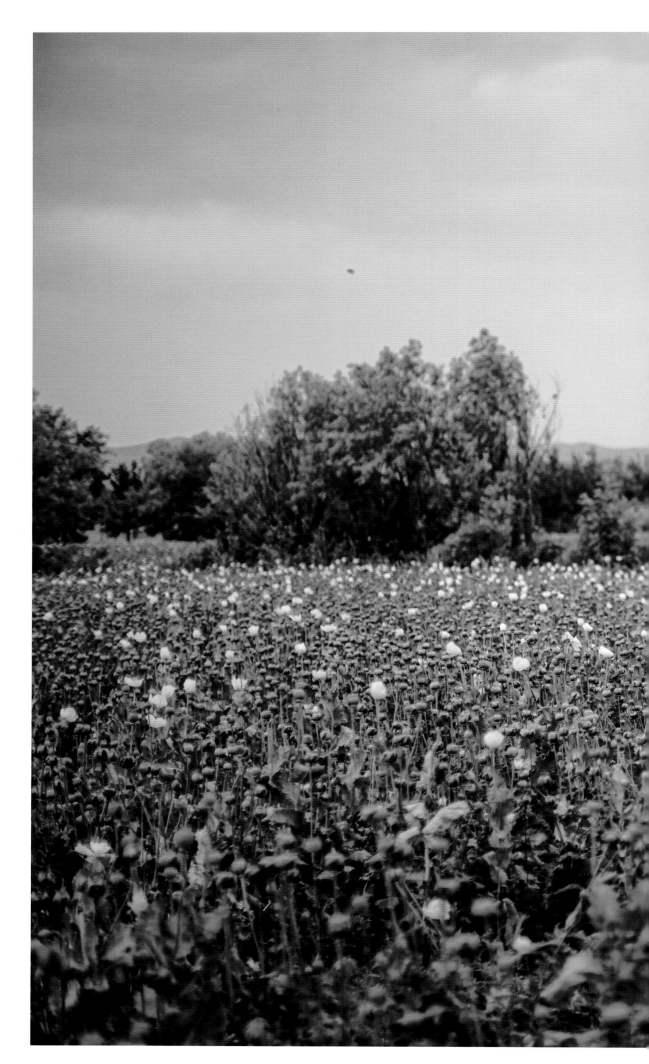

A girl stands in the middle of a poppy field as she watches U.S. Marines pass by on patrol near Sangin. Helmand province, Afghanistan, May 2011.

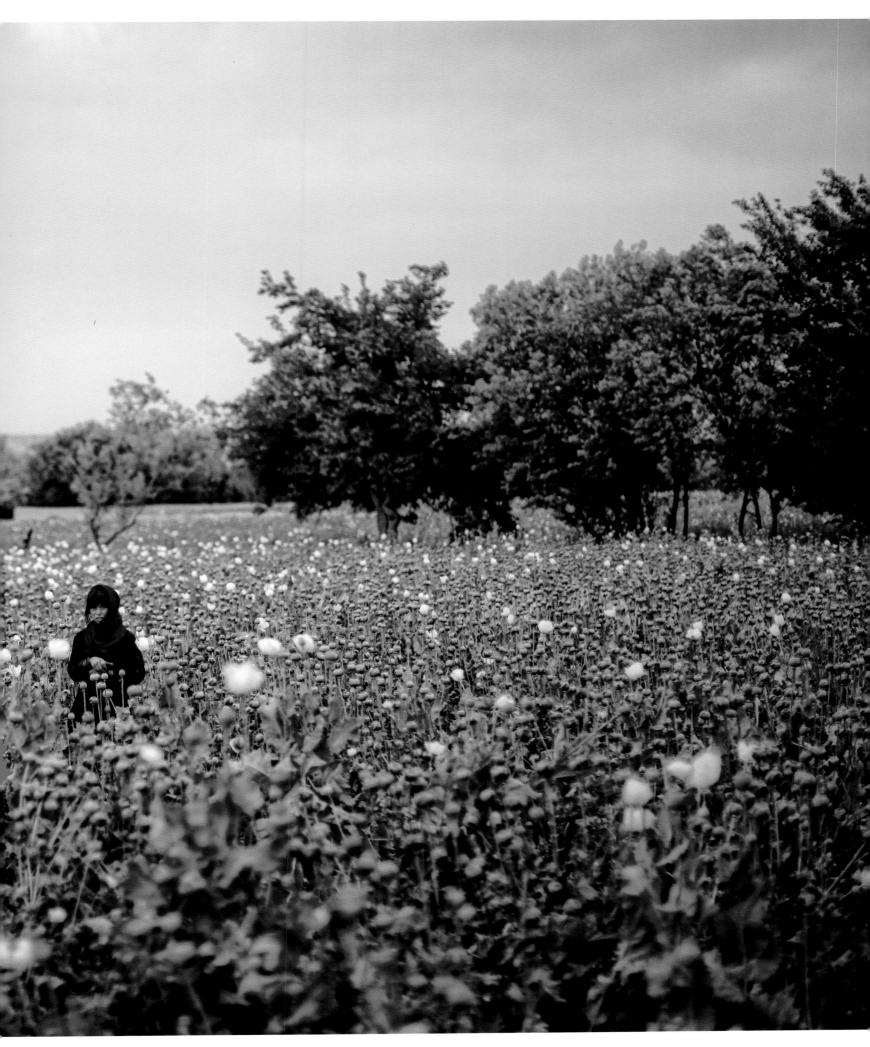

RETROGRADE

Retrograde. It seems an unfitting term for America's longest war, but it's the word of the moment for the U.S. military when it talks about Afghanistan. In plain terms, it means something like moving backward as other things move forward — or just opposite the normal flow.

For almost 13 years I have been in the normal flow of journalists — and later the military — to Afghanistan, covering the war that followed Sept. 11. When I first arrived in the fall of 2001, there was no such thing as being "embedded." Journalists depended entirely on local Afghan drivers, fixers and translators.

The official military embed program really began in 2003 with the start of the Iraq War. And from that point on — for better or for worse — that was what you did if you wanted to cover combat operations involving U.S. forces. Cumulatively, at this point, I've spent nearly four years living with soldiers and Marines in Iraq and Afghanistan.

And on an embed, you really do live with them. Every aspect of your daily life is the same as it is for the troops you are covering. They dig a hole in the dirt to sleep in: you get in, too. They eat a two-year-old MRE (Meal Ready to Eat): *bon appétit*. Maybe the only difference is that as a journalist, you don't carry a weapon.

So we journalists, too, became a part of the bigger bureaucratic system, coming and going from the intimacy of the smallest mud-walled outposts to the anonymity of beehive bases like Bagram and Kandahar Airfield.

Year after year, I've watched the bases change just like the men and women occupying them. The pace at which they have been built — and then expanded before even being finished — has been astonishing.

But my most recent visit was different. The bases are shrinking, retrograded for their next occupants: Afghans who have almost none of the resources that their predecessors have. Many bases will be abandoned entirely. Some will be razed and returned to the desert or farmland without a trace. This retrograde includes weapons, vehicles, people, everything.

I suddenly realized: I will have to retrograde as well. I will retrograde my 13 years of work in Afghanistan. Retrograde my memories. Retrograde my life. But by definition it means moving backward as other things move forward. It seems illogical, but these photos are for me a start: I'm keeping a little piece of the past so as to better move forward.

I photographed the little things I had stopped seeing. All the things that made life so miserable. I want to remember that. Not for journalistic or historical purposes, but because these places have become so personal.

Life in a rock pile. The view of nothing. Hot water, not for showering, but for drinking. Dirt walls, cement walls, mud walls. Never flushing a toilet. The blue sky over a gray world below. Coming and going. The simplicity of it all can actually be charming.

— David Gilkey, 2014

David Patrick Gilkey was born January 5, 1966, in Oregon. His first job in photography was with the *Boulder Daily Camera*. In 1994 he moved to Johannesburg to work as a freelance photographer for Knight Ridder News. He was hired as a staff photographer at the *Detroit Free Press* in 1996 where he covered the war in Kosovo and the wars that followed the attacks of September 11. In 2007 he joined NPR News, where he worked until he was killed in Afghanistan on June 5, 2016.

In 2004, Gilkey was named Photographer of the Year by the Michigan Press Photographers Association. He received a 2007 national Emmy Award for the video series *Band of Brothers* about Michigan Marines in Iraq. Gilkey's work on the 101st Airborne Division's "Black Hearts" in Kandahar won the 2010 Sigma Delta Chi Award and recognition from Picture of the Year International. He contributed to an NPR investigation of traumatic brain injuries in the military that received both a George Polk Award and a Dart Award in 2010.

In 2011, Gilkey was named Photographer of the Year by the White House Photographers Association. He earned 36 distinctions from the WHPA from 2009-2016, including nine first-place awards. Also in 2011 he won the Robert F. Kennedy Award for International Photography for "Haiti: A Year in the Shadow of Destruction." In 2012 Gilkey was the first civilian photographer to receive the Marine Heritage Foundation's Sgt. Maj. Dan Daly Award. He was part of a team that won an Emmy in 2014 for NPR's *Planet Money*. He received the Edward R. Murrow Award in 2015 — the first time it was presented to a multimedia journalist. Gilkey helped win NPR a Gracie Award in 2016 for a series on teenage girls worldwide.

The Pulitzer Prize doesn't accept submissions of pictures that are on the radio.

Quil Lawrence, text editor covers veterans for NPR. He met David in Afghanistan in 2001, and they worked together there and in the U.S.

Alyda Gilkey is a retired middle school teacher and librarian. Her husband, Dr. Richard Gilkey, served as director of educational media for Portland, Ore., Public Schools for 20 years. He died in 2018.

Tom Bowman (middle) is NPR's Pentagon correspondent. He regularly travels to Iraq, Syria and Afghanistan. Tom and David were riding in the same Afghan Army convoy when David was killed.

Graham Smith (right) is a senior producer, editor and reporter at NPR. He did embeds with David in Afghanistan, and they reported on Ebola in Sierra Leone together.

Jason Beaubien is NPR's global health and development correspondent. He and David reported on numerous natural disasters and other stories worldwide.

Eric Westervelt is an NPR correspondent. He previously served as Pentagon correspondent and bureau chief in Baghdad, Jerusalem and Berlin. He and David covered Gaza and the West Bank together.

Claire O'Neill is an art director at *The New York Times*. Before that, she was a multimedia and video producer at NPR. She and David created a pop-up photo studio for homeless vets in San Diego.

David Greene is the host of NPR's *Morning Edition.* He was previously Moscow correspondent. His book, *Midnight in Siberia*, drew from his journey with David on the Trans-Siberian Railway.

Julie McCarthy (center) has been an international correspondent for NPR since 1994, covering Europe, Africa, the Middle East, South America and South Asia. She is currently Southeast Asia correspondent. She worked with David in India.

Najib Sharifi (far right) is a former producer at NPR's bureau in Kabul. He is a medical doctor and president of the Afghan Journalists' Safety Committee. He met David shortly after the U.S. invasion of Afghanistan.

Shafi Sharifi (second from left) is a former producer at NPR's bureau in Kabul. He currently works as a senior executive in Afghanistan's telecom industry. His family hosted David countless times in Afghanistan.

Also pictured: Shoaib Sharifi

Bonnie Briant, designer (standing at right), is based in New York City. Her work has been recognized by *Time* magazine, *Photo District News*, Aperture/Paris Photo Book Awards and POYi.

Ariel Zambelich, photo editor (seated at right), worked extensively with David as the supervising editor of photography for NPR Visuals. Currently she is working as a photo editor, art director and community organizer in New York City.

Chip Somodevilla, photo editor (seated at left), became friends with David at the *Detroit Free Press* and covered the Iraq War with him. He is now a staff photographer for Getty Images News based in Washington, D.C., covering U.S. politics.

Also pictured in back: Jane von Mehren, from Aevitas Creative Management, and Quil Lawrence

ACKNOWLEDGMENTS. Dick and Alyda Gilkey's dedication to their son's legacy made this book a reality — they also came up with the title. Jane von Mehren at Aevitas Creative Management worked tirelessly to represent the project, and Craig Cohen at powerHouse saw its potential. At NPR, Jon Hart, Kristen Hartmann, Briana Thibeau and Chris Turpin provided essential close air support. Susan Vavrick lovingly copyedited the book.

Many people helped in ways great and small including Lynsey Addario, Nicole Beemsterboer, Pancho Bernasconi, Carlos Boettcher, Emily Bogle, Aimee Syms Carney, Michael Carney, Sandy Ciric, Andrew Cutraro, Bryan Denton, Gabriella Demczuk, Greg Dixon, Coburn Dukehart, Monika Evstatieva, Mito Habe-Evans, Derek Kinne and Laura Gilkey Kinne, Sarah Han, Desiree Hicks, Tyler Hicks, Brian Jarboe, Keith Jenkins, Michelle Johansson, Gina Lambright, Becky Lettenberger, Michael Lutzky, Brian McCabe, Martin Medeiros, Heather Murphy, Dion Nissenbaum, John Poole, Rose Previte, Joe Raedle, Helen Richardson, Moises Saman, João Silva, Shari Thomas, Evan Vucci, Ivan Watson, Spence Wilson, Nancy Youssef, Raquel Zaldivar, and the NPR Visuals team past and present.

All of us would like to extend our deepest sympathy to the family of Zabihullah Tamanna. Zabi was a gifted journalist, dedicated to bringing his beautiful country a brighter future. We are eternally grateful for his friendship to David on their last assignment.

Pictures on the Radio:
The Work of NPR Photojournalist
David P. Gilkey

All photographs ©2007-2016 NPR
David P. Gilkey © 2020 Quil Lawrence
Pictures on the Radio text © 2020 Alyda Gilkey
All other texts © attributed authors

Page 2: A dust storm approaches a U.S. Marine base in Sangin. Helmand, Afghanistan, May 2011.
Page 4: Cutting grass along a mountain trail. Badakhshan, Afghanistan, August 2009.

Published in the United States by powerHouse Books,
a division of powerHouse Cultural Entertainment Inc.
32 Adams Street, Brooklyn, N.Y. 11201-1021
e-mail: info@powerHouseBooks.com
website: www.powerHouseBooks.com

First edition, 2020

Library of Congress Control Number: 2020936715
ISBN 978-1-57687-951-1

Designed by Bonnie Briant
Text editing by Quil Lawrence
Picture editing by Chip Somodevilla and Ariel Zambelich

Printed and bound by Asia Pacific Offset, Ltd.
10 9 8 7 6 5 4 3 2 1
Printed and bound in China

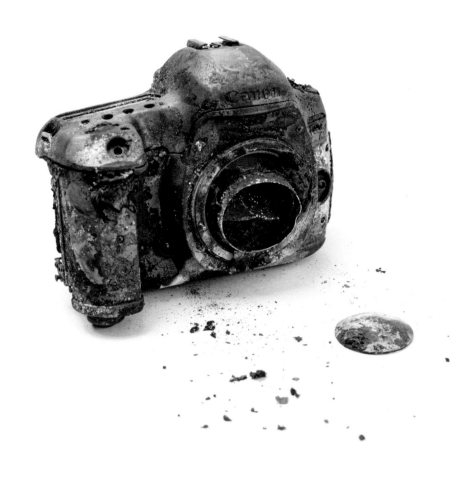

One of the two cameras David Gilkey
had with him on his last assignment.
Photo by Ariel Zambelich